ENDORSEMENTS

"I know of no other study that gives a language for the soul like *Waiting on the Lord*. I was twelve when my Dad left, leaving a 'wait' in my soul that spilled over into every area of my life. The Lord graciously used this study to kick off a journey of healing in me, bringing His light and truth to areas of my soul that I had closed off for decades. The freedom and joy of knowing and receiving my true identity as His daughter was worth the soul surgery. Our every wait is found satisfied in Him!"

—*Jenny Venghaus*, Houston, Texas

"*Waiting on the Lord* came at just the right time in my life's journey of looking for love in all the wrong places. The years left me in a season of waiting for healing and waiting to know God's love. Susannah taught me how to wait under the wings of our Father who loves endlessly and heals completely. No longer was I a slave to that which I waited for. Songs of deliverance were written on my heart as He parted my seas and drew me in. Be blessed and forever touched as Susannah walks you through your waiting, knowing that He makes the wait worth it!"

—*Stephanie Ross*, Beaumont, Texas

"*Waiting on the Lord* is a beautiful and brilliant journey through God's Word. Jesus spoke to me every day of this Bible Study. What I love about Susannah's teaching is her broad understanding of the epic true story of God combined with her deep insight and intimacy with Christ. If you desire to grow in your knowledge and experience of the breadth and height and depth of God's love, then *Waiting on the Lord* is your study and Susannah Baker is your teacher. Enjoy God's presence!"

—*Kelly Matte*, Wife of Greg Matte,
Pastor of Houston's First Baptist Church

"*Waiting on the Lord* isn't a cutely-packaged 'girl's study lite.' It is a serious, deep, inductive, and reflective study that exposes the author's honest struggle to dig deep into the Word of God and the person of Christ, and to speak truly about what she's found. Even if I didn't know and love Susannah as I do, I would recommend *Waiting on the Lord* to you. Offer yourself, your questions, your heart to this journey into the waiting process. Your guide is kind and true, and the One at the end of all your waiting is nothing short of glorious."

—*Leigh McLeroy*, author of *The Beautiful Ache*,
The Sacred Ordinary, and *Treasured*

Waiting on the Lord

FINDING THE ONE WHO IS WORTH THE WAIT

Second Edition

My soul waits in silence for God only;
From Him is my salvation.
PSALM 62:1

Second Edition

SUSANNAH BAKER

LUCIDBOOKS

Waiting on the Lord

Second Edition
Copyright © 2018 by Susannah Baker

Published by Lucid Books in Houston, TX
www.LucidBooksPublishing.com

Scripture quotations taken from the New American Standard Bible® (NASB), Copyright © 1960, 1962, 1963, 1968, 1971, 1972, 1973, 1975, 1977, 1995 by The Lockman Foundation
Used by permission. www.Lockman.org

eISBN-10: 1-63296-194-6
eISBN-13: 978-1-63296-194-5
 ISBN-10: 1-63296-193-8
 ISBN-13: 978-1-63296-193-8

Special Sales: Most Lucid Books titles are available in special quantity discounts. Custom imprinting or excerpting can also be done to fit special needs. Contact Lucid Books at info@lucidbookspublishing.com.

To my husband, Jason, who waited for me and who eagerly waits
for the appearance of the One he loves.

And to the women of The Increase, whom I dearly love.
Hold on to Jesus; He waits for you.

Table of Contents

How to Use This Study

Thank you for joining me on the journey of *Waiting on the Lord!* The layout of the study for the next eight weeks is fairly simple. For each week of study, there are five days of homework corresponding to the topic discussed during the weekly lesson. All Scripture in the study, unless otherwise noted, is taken from the New American Standard Bible (NASB). An outline corresponding to the teaching session for each week can be found at the end of each week of homework. All teaching sessions can be found on the website www.susannahbaker.com and can be downloaded for free using the code and instructions found at the back of this book. Video sessions for group use are also available for purchase at www.susannahbaker.com.

While the study can definitely be done and enjoyed without listening to the teachings, I urge you to listen to them if at all possible. Topics are discussed in the teachings that are not covered in the homework and are important to your growth and understanding to each area of waiting. All of the teaching sessions are approximately an hour in length, so if time is a factor, your small group can listen individually to the lessons during the week to have adequate time for discussion and prayer during your weekly meeting time together. At the end of the study is a Small Group Guide if you are using *Waiting on the Lord* in a small group format. The questions come directly from the homework and teaching sessions.

A few more words about the homework:

- Throughout the study, you are asked to look up words in the original Hebrew or Greek in a concordance. Ideally, I would love for you to learn to use a concordance if you do not already do so. You can use an online concordance for free of charge at *www.bible.crosswalk.com*, or you can purchase a concordance at a Christian bookstore or online. Please don't let the thought of using a concordance intimidate you. This tool will open up Scripture to you in an entirely new way, and you will never regret learning how to dig deeper in the Word of God. But if using a concordance is simply not an option for you, I have provided the word and its definition in the margin of the homework for you to reference.

- At certain times in the homework, a question or group of questions will have a ⛵ symbol beside it. This symbol is a sign to you that the question(s) are an opportunity for you to pause, reflect, and take time to go deeper with the Lord. You might want to save these questions to answer during a time where you can really be still, think, and hear what the Holy Spirit is saying to your heart. Some of these questions might be hard to answer, but I urge you to take the time to let the Holy Spirit work on the hard-to-reach places in your heart and soul. It is during these times you will see the most lasting growth and change take place.
- This symbol ⛵ sometimes represents an action I am asking you to take as well. Several times through the study, I ask you to write down a specific Scripture on an index card to meditate upon or memorize. You might want to grab a stack of index cards beforehand and put them in a place that is easy for you to access during your times of study. As your cards grow in number, consider hole punching the corners and putting them all on a ring you can carry with you and keep for easy access. They will serve as a reminder and testimony to you of the good work God is doing in your heart as you learn to wait well on Him.
- Last, this symbol ⛵ can also represent a time of prayer. Throughout the study, I have provided space for you to process your heart and emotions before the Lord in honest confession, praise, or petition. At times I have provided a prayer for you to use if you would like a little direction, but please do not ever feel boxed in by the words I have penned. There is always space provided for you to write your own prayers, and again I urge you to take the time to pray and write out these prayers during a time you can really be quiet and still and hear from the Lord. Learning to pray and hear His Voice in some of these areas of waiting is what makes all the difference in the healing of our hearts and learning to wait well on Him.

Throughout each aspect of this study, may you be given food and strength for the journey ahead as God speaks to, ministers to, and heals your heart in powerful and lasting ways.

Finally, I want to issue a huge thank-you to all of the dear friends and family who prayed for Jason, the girls, and me throughout the many different seasons of waiting, studying, and writing. I thank my God every day for the gift of co-laborers like you. Also, thank-you to Jenny Venghaus and the original Shelter and Increase women; without you, this study never would have occurred in the first place! For my mom and mother-in-law who have modeled "waiting" before me with the very character of Christ, thank you. I will never be the same because of how you have chosen to wait. And Lillian, Lizzie, Caroline, and Mia Grace, you were well worth the wait of wanting and praying for children—I am so thankful for each of you. Thank you to Jason who faithfully wars with prayer and unconditional love on my behalf. And Jesus—You are the completion of all of my waits; until the break of day, when the shadows flee away, I will go my way with You, wherever you lead (Song of Songs 4:6).

Introduction

Several summers ago, our family spent two glorious weeks in the mountains of Idaho. While there, I had the opportunity to do some hiking. One hike up the side of Bald Mountain was particularly special. It was just me on the trail (my husband graciously volunteered to watch our girls for a few hours so I could sneak away), and while putting one foot in front of the other and soaking in the scenery around me, I began meditating on the verse, "How lovely on the mountains are the feet of him who brings good news" (Isaiah 52:7).

Some people hear the call of the ocean, but I have always heard the call of the mountains. The hard work of climbing along with the satisfaction of summiting and experiencing the views at the top are symbols to me of God's invitation to experience beauty and intimacy with Him in the midst of mundane and hard moments. Mountains represent high places, lonely places, and places that are difficult to traverse and climb. Yet their summits represent fulfillment, satisfaction, intimate communion, and breath-taking beauty.

In your season of waiting, many of you are hiking up mountains. You may have started in a group, but like in any climb, you've found the group to thin out pretty quickly and you are climbing, most likely, alone.

If you are like me, throughout your climb, you've experienced thirst, shortness of breath, hunger, and moments when you think, "I cannot go on. How in the world am I going to make it to the top?"

I've never climbed your specific trail; each of us has our own tailor-made trails and tears and tests. I am simply one hiker on the path, telling another where I have found healing, rest, food, water, and some incredible views along the way.

But I've summited some mighty fine mountains, and I am here to tell you, the feast waiting at the top of the peak and the views of the valley and surrounding mountains are worth every step of the climb.

The good news I share with you today and throughout this study is that the mountains that seem insurmountable during your seasons of waiting (and when are we ever through with waiting until we draw our last breath?) are beautiful mountains with beautiful views for all those who choose to climb and to wait on the Lord. So enjoy the scenery along the way—the summit, my friends, is coming.

return
revive
raise us up

Why the Wait

Hosea 5:14–15, 6:1–3

I. **Four Basic Waits**

 A. The Wait for _____

 B. The Wait for _____

 C. The Wait for _____

 D. The Wait for _____

Our job in all of our waits: "So let us know, let us _press on_ to _know_ the Lord." Hosea 6:3

❑ "press on"—"to _____, to _____, to _____"[1]

II. **Pressing On—What It Looks Like**

 A. **It looks like** _____ (Hosea 5:14; 6:2)

 "We creatures say, 'While there is life there is hope,' but our Creator will never suffer himself to be so limited. . . . With Lazarus [Jesus] deliberately stayed away until death had established its reign, so that Martha and Mary might know him as resurrection life. So the first answer to many prayers may, therefore, be the reign of death. The last spark of life may be quenched and faith and hope left alone with the dead—and with the God who raises the dead. Do not be dismayed if the first answer to some of your prayers is a revelation, not of the power of God to make alive, but of his might to slay every hope outside of himself." Lilias Trotter, _Until the Day Breaks_[2]

 ❑ Job 13:15—"Though He slay me, I will hope in Him."

 B. **It looks like** _____ (Hosea 6:1)

 ❑ We are delivered from _____ to our circumstances into _____ by the Mighty Hand of God.

 ❑ "bandage"—"to _____, to _____, to _____, to _____"[3]

 ❑ Our bandages envelop us in _____; He delivers us into real, fulfilling relationship with _____.

 • Now: Isaiah 61:1

 • One Day: Isaiah 30:26

 C. **It looks like** _____ (Hosea 6:2–3)

- ❑ Resurrection comes:
 1. Always to our _____
 2. Sometimes to our _____
- ❑ The Law of Death and Resurrection: "Truly, truly, I say to you, unless a grain of wheat falls into the earth and dies, it remains by itself alone; but if it _____, it bears much _____." John 12:24
- ❑ He will come to us like the _____, and like the _____ _____.

D. It looks like _____ (Hosea 6:3)

- ❑ "know"—*yada*—"knowledge gained through the _____"[4]
- ❑ Waiting is _____ _____ where we are invited to _____ and be _____.

III. Waiting—The Posture of the Soul

- • Isaiah 40:30–31—"Though youths grow weary and tired, and vigorous young men stumble badly, yet those who _____ for the Lord will gain new strength; they will mount up with wings like eagles, they will run and not get tired, they will walk and not become faint."

 1. *Qavah*—to bind together by _____, to collect, to be gathered together, to be _____, to meet
 2. We must learn to wait _____ God rather than simply waiting _____ Him.

- ❑ True Waiting is the _____ of the soul to God (Psalm 62:11–12).
- ❑ True Waiting looks like a _____ (Isaiah 40:31).
- ❑ True Waiting sounds like a _____ (Revelation 3:20).

WEEK ONE

Waiting for Significance

DAY ONE
Fearfully and Wonderfully Made

Waiting. For most of us, that word conjures up an old, familiar ache—an ache of loneliness, sadness, hardship, and sometimes even pain. Perhaps it's because we've waited for a spouse to change, or a husband to appear and sweep us off our feet, or a child to hold, or a dream to be fulfilled.

Or perhaps it's a wait to go to your eternal home, to see Jesus face-to-face, to be with our friends and family who have gone before us, and to have all the old aches and pains healed once and for all.

At all times, we are all waiting for something, and the wait often seems dark, purposeless, and unbearably long. But if we will peel back the shadows and even, just for a moment, pierce the darkness with a ray of light, we will see behind our wait not some*thing* but some*one* carrying us in the midst of it, holding us close, and whispering our name. For what we are all really waiting for is nothing less than the person of Jesus, the fulfillment of all of our waits. And He promises over and over and over again in Scripture that no matter how long the wait or the impossibility of what we wait for, we will be eternally satisfied if we continue to wait upon Him.

Over the next nine weeks, we will look at some of the different things we wait for as women—things like friendship, a home, fruitfulness, and healing, just to name a few. But before going any further in the journey of waiting, I want us to think about something for a moment.

When someone invited you to do this study or join their small group, or the cover and description caught your eye in the bookstore or on a website, most likely something in your heart gravitated toward a response of "Yes, that study would be helpful because I am waiting for _____ in this season of my life."

Take a few moments to think about exactly what it is you are waiting for in this season of your life. Or maybe you happen to be in a season where you are not really waiting on anything in particular. Whatever your response is—if you are waiting on ten things or nothing in particular—please write it in the space below and be as honest and specific as you can:

You are going to have a chance to answer the exact same question at the end of this study, and I think many of us will be surprised to see how our answer has changed, or even, perhaps, grown. But I want to spend the first week of our time together looking at the core of all of our waits—the wait for significance.

As far back as we can remember, most of us probably heard the question from more adults than we would like to count: "So, (fill in your name), what are you going to be when you grow up?" And regardless of our answer, in our young, childlike minds, we believed we could grow up to be anyone or do anything. But perhaps more importantly than that, we grew up thinking that whenever we did grow up, what we grew into would be incredibly, extraordinarily *significant*.

So when I graduated from college, ready and waiting to be significant, I found myself substitute teaching in a high school health class of second semester seniors who could have cared less about hygiene or anything else health related.

Many years after graduation, I am still waiting for a call to tell me the grand news that I have been anonymously elected for significant greatness by the waiting world. But the phone hasn't rung today, and I'm not holding my breath for it to ring tomorrow either.

This week is about the search for something Milton called beauty, C.S. Lewis called the weight of glory, and others call identity, greatness, or significance—your place in this wide world where your greatest gifts and the world's greatest needs collide.

What did you want to be when you grew up?

Do your childhood dreams line up with what you are doing now? Why or why not?

Does what you do now make you feel significant? Why or why not?

I have struggled with significance. I mean really struggled. From an early age, there was an inner drive in me, a push that told me I had to be someone extraordinary, outstanding, superb . . . GREAT.

The roots to that inner drive were long and deep, some godly and some not so godly. I have tried to slake the thirst for significance at the fountain of worldly status one too many times. In fact, I can remember as a high school sophomore, junior, and senior going home after an award's night that the entire school was required to attend and coming home empty-handed every single time. I cried myself to sleep those nights, and those tears were bitter tears, tears that came straight from a heart that longed to be recognized and significant.

The wait to be someone or to do something significant can be long and arduous, especially when the world doesn't exactly commend what Scripture tells us is significant.

Psalm 139 is a beautiful and often familiar passage in Scripture. Try to look at it with fresh eyes today, and read verses 1–3 and 13–15. Fill in the blanks below from verse 14:

> "I will give thanks to Thee for I am _____ and _____ made; _____ are Thy works, and my soul knows it very well."

Look at verse 13. When did God make you "wonderful"?

What basis does the psalmist give in verse 14 for the fact that he is "fearfully and wonderfully made"? Explain below:

Notice that the psalmist, King David, *doesn't* say, "When I became king *then* I became great." Or, "When I conquered enemies, or slayed Goliath, or fed the hungry, or made the grade, or passed the test . . . *then* I became significant." On the contrary. From the beginning, David's significance had nothing to do with the created and everything to do with the Creator. What made David great was not his skill or performance later on in life; it was the fact that the very Creator of the universe gave him life, made David in His Image, breathed into him His breath, and skillfully wrought with immortal Hands his mortal flesh, bone, body, soul, and spirit. That, my dear sisters, is what makes each one of us great as well. Our significance lies in the fact that the Uncreated One has stooped down to make His created ones great.

My junior year of college, my grandmother gave me a copy of A.W. Tozer's classic book *The Knowledge of the Holy*. I devoured the truth and holiness found in those pages, but one paragraph in particular stood out and revolutionized the way I saw myself and who I was created to be. Each chapter begins with a prayer, and the prayer before Chapter Five, "The Self-existence of God," says:

> Lord of all being! Thou alone canst affirm I AM THAT I AM; yet we who are made in Thine image may each one repeat 'I am,' so confessing that we derive from Thee and that our words are but an echo of Thine own. We acknowledge Thee to be the great Original of which we through Thy goodness are grateful if imperfect copies. We worship Thee, O Everlasting Father. Amen.[5]

That prayer changed me. All of a sudden, my questions about identity and significance were answered in the phrase, *I AM*. When God revealed to me throughout the pages of Scripture who He was, then I was able to know who I was too. As Tozer professes, only God is God, but we are grateful, if imperfect, copies. Our significance is not found outside of ourselves in anything that we accomplish; it is found in knowing God, simply because God is, and we belong to Him.

Isn't that a relief? Doesn't that take the pressure off? Our wait for significance is over—we *are* significant, simply because the great I AM has made us so.

What things outside of yourself are you relying upon to make you significant?

Is there anything specific you are waiting upon to give you significance (i.e., a job, a spouse, a home, a relationship, a friend)?

Today, close by praying A.W. Tozer's prayer and lay the things you wrote above at the feet of Jesus, confessing that all of your significance is found in *Him*. Acknowledge that you are significant simply because He is the Great I AM, and you are the sheep of His pasture, the work of His Hands (Psalm 100:3; Isaiah 64:8).

Pen your prayer below. Ask for the Holy Spirit to come and breathe the breath of the Great I AM into your spirit. Your wait for significance is over; you are His, you are significant, and you are loved.

The Enemy of Rejection

I will never forget going to a Christmas brunch with my family the year that Jason and I were married. As I mingled with different people before the brunch began, I found myself in conversation with a family whose children graduated from the same high school I did. To say the least, my years in high school were not the typical rah-rah-cheerleader-pep-rally-fun-with-friends-football-game experience every American girl dreams about. The high school I attended was extremely focused on academics, making the grade, and achieving Ivy League status. For much of my time there, I felt like a duck out of water. I never felt as though I made the grade, and I definitely never felt significant.

So in those first few years of graduating from college, whenever I ran into anyone from my old alma mater, I felt as though my tongue stuck to the roof of my mouth. I loved the college I attended, but it wasn't an Ivy League institution, and my jobs after college definitely did not fall into the category of finding the cure for cancer, saving the world, or roaming the high and lofty halls of academia while pursuing a higher degree. To be specific, for the first four years after college, my jobs included substitute teaching, working in the stock room of a large retail store, and nannying for a family of three children. Therefore, running into anyone from my old high school made me sick to my stomach. Why? I was not, to put it mildly, "significant." That is to say, nothing I was *doing* fell into the category of significance from a worldly standpoint.

So at the Christmas Brunch, as I stood with my brother Taylor and made small talk with one particular family, I could feel my stomach churn, for I knew the dreaded questions were coming. And sure enough, they did. Question number one: "So, Susannah, where did you go to school?" "Texas A&M," I replied. Question number two: "And what was your major?" "English," I said. In case you didn't know, Texas A&M is not a liberal arts university and is definitely not known for its higher pursuits in the literary world. The "A" stands for "Agriculture" and the "M" stands for "Mechanical" . . . bummer. "Oh," the family murmured. Question number 3: "And what do you do now?" "Um," I said, (this was between my substitute teaching phase and my nannying phase) "Right now I don't have a job. I just got married and am probably going to nanny for a family in the spring."

Silence. No comment from the family.

"And Taylor," they said, politely shifting their gaze to my stellar younger brother who was attending the much more appropriate liberal arts university, Wake Forest, "Where are you in school?" And Taylor laughed and talked for the next fifteen minutes with the family about his school, his major, and his significant possibilities after school, like law school or seminary.

I don't remember much more about the brunch; I think I shrunk behind my dad (Jason wasn't there) and tried to avoid all other conversations at any cost.

Rejection—the enemy of significance. For many years, its grip tried to snuff out life and joy in me at any cost. But the older I grew, the more I realized that the devastation of this particular enemy was not anyone's fault but mine. I began to realize I was allowing another person or position to define my worth rather than finding my worthiness in Christ. In other words, I was worshiping an idol, bowing before the created rather than the Creator. And believe me, that hunched-over position of caring too much about what other people said, did, or thought, was no way to live. In fact, it was a sure, slow, poisonous way to die.

Let's look at what the Word of God says about the ancient enemy of rejection. What is God's main message to Moses in Exodus 34:10–14?

What enemies does God say He will drive out of the Promised Land on His people's behalf?

We don't have time to look at each of the enemies God promised to drive out of the Promised Land, but I want to look at one in particular—the Canaanite. **Turn to Genesis 9:18–27.** Now I know this particular incident in Scripture is a bit graphic, but I think there is a powerful lesson we can learn from looking at the father of the Canaanites, and specifically, where the word "Canaanite" originates.

Who was the father of Canaan?

Without going into too much detail, what was his sin?

Verses 25–27 are where I really want to focus. Does Noah give Ham a curse or a blessing?

What exactly is the curse?

Now the word used here for "curse" in Genesis is only one of at least five other Hebrew verbs with the same general meaning. This verb specifically means "to bind; to hem in with obstacles; to render powerless to resist."[6] In fact, it is the same verb God uses in Genesis 3 to curse the serpent, the man, and the woman in the Garden of Eden.

Scripture is pretty clear that the father of Canaan was cursed, bound, hemmed in, and rendered absolutely powerless in subjection to his two older brothers. I don't know about you, but after having gone through numerous battles with rejection, that seems like a pretty accurate description of what rejection does to its victims. The times in my life when I have felt the most powerless, bound up, and trampled upon are when I have felt rejected.

This picture of rejection is the picture not only of the people who populated the Promised Land but also of the name of the Promised Land itself before the Spirit of God and the people of God took up residence there. The land and its people were not a place flowing with freedom, blessing, and rest; they were a people and a place hemmed in by slave-like rejection and fear.

We are not called to wipe out our physical enemies like the Israelites were called to do (in fact, we are called to love our enemies and to pray for them, see Matthew 5:44). But we *are* called to wipe out the enemies of the cross of Christ that wreak havoc and keep us hemmed in and bound up on the inside in the land of our hearts. And don't you find it interesting that while the first enemy God says He will wipe out is the Amorite (a word which means "prominence"[7] and has its roots in pride), the second enemy He wants to get rid of represents a curse of rejection. The Lord knows that as long as we are paralyzed and powerless through the enemy of rejection, we will never be free to find our worth and significance in Christ or to fully give Him our worship and praise.

On behalf of His people, God wants to break the curses of this world so that we can be free to worship Him rather than hemmed in or bound up, blessed to love others rather than cursed, and loved and fully satisfied and significant in Christ rather than rejected.

If we had time to look at all the other enemies of the Promised Land mentioned in Exodus 34, we would find that they represent pride, fear, unforgiveness, rebellion, and defilement, which are all representatives of a life lived apart from the glory of God and focused inwardly on itself. And if there is one enemy to true significance in the Kingdom of God, it is self. We have got to get over *ourselves* in order to be truly significant.

Read Jesus' words in Matthew 16:24–26. What is the main message found in these verses?

How does Jesus' definition of significance compare to the world's definition?

Think back to yesterday when I asked if what you were doing now makes you feel significant. Do Jesus' words in Matthew 16 change your perspective? If so, how?

We must lose ourselves in order to be found. To gain life, we must die. To be great, we must be last. Plain and simple, as women who love Jesus, we must be found living in obedience to the cross of Christ rather than to the hollow, empty systems, ideologies, and idols of this sin-cursed world.

Turn back to Exodus 34 and re-read verses 11–14. On what condition in verse 11 does God promise that He will drive out the Israelites' enemies?

In verses 12–13, how does God tell His people to protect themselves from their enemies?

And finally, in verse 14, what is the reason God gives them for going to such radical measures?

In Exodus 34:14, God gives Himself a new name: "Jealous." Rather than His jealousy being a bad thing, the jealousy of God always points us to the *love* of God. He loves us too much to let us prostrate ourselves before any other altar but His. He loves us too much to let us find our significance in anything apart from Him. He loves us too much to let us be ravaged, cursed, bound up, hemmed in, and destroyed by the gods and enemies of this world like pride, rebellion, or rejection. That is why He demands total and complete allegiance from His people to *Himself*.

In our obedience, as we learn to love Him and Him alone, little by little, aligning our hearts fully with His love, His purposes, and His ways, we see that *God* does the driving out and slaying of our enemies who long to rob, kill, and destroy the life that living in the Promised Land of Jesus Christ brings. Tomorrow we will look more specifically at how He does exactly that through the light of the cross of Christ. So hang on until tomorrow—the promise of victory is coming!

As a closing note, when I was with my brother Taylor recently, I read to him what I wrote about the incident mentioned in the beginning of today's lesson, and we laughed together, thankful we have both come a long way since that Christmas Brunch conversation. God is so good. He is faithful and able to slay the enemy of rejection we have battled for so long.

The Victory of the Cross

Yesterday we learned that the sons of Canaan were cursed with rejection—rejection from blessing and rejection from God. But you and I are not children of Canaan. If we have professed Jesus to be Savior and Lord, we are children of *the Lord!* Today, we are on a journey to discover rich, life-changing truths within God's Word. I prayed today that many of you would be set free from the crippling enemy of rejection and healed so that you may know your worth and deep, deep *significance* in Christ.

The prayer I prayed for you comes from Paul's prayer for the church in Colossae. Fill in the blanks from Colossians 2:2–3:

> I pray that your "hearts may be _____, having been knit together in love, and attaining to all the wealth that comes from the _____ _____of understanding, resulting in a _____ _____ of God's mystery, that is, *Christ Himself*, in whom are hidden all the _____ of _____ and _____ (emphasis mine)."

What an awesome and powerful prayer! May God encourage your heart with the wisdom, knowledge, and full assurance of the treasure we have in Jesus Christ today. Let's get started.

Stay in Colossians and turn back to chapter 1. Throughout high school and college during days of struggle with rejection, I would often turn to the book of Colossians, so much so that it is labeled in my Bible as "The place where I run." So put on your running shoes, and let's run together this familiar and significant route.

Read Colossians 1:13–18.

In this passage, Paul, the author of Colossians, paints for us a beautiful picture of who Christ is and what He has accomplished. Verse 16 tells us several important things about Christ.

What was created by Him?

Why were all things created?

What does verse 17 tell us about Christ's role and place in creation?

Verse 18 tells us that Christ is the head of the church and the beginning, the first-born from the dead; what reason does Paul give us for this?

Now, keeping all of those truths in mind, read Colossians 2:8–15. Let's look at verses 13–15 first and then go back to 8–12. Look at the phrase "certificate of debt consisting of decrees against us" (v. 14).

To find out what certificate Paul is talking about, while keeping one hand in Colossians, turn to Ephesians 2:14–15. What does verse 15 tell us is our "enmity"?

So does this mean that the Law God gave Moses for His people is evil, causing us to be evil? To answer that question, before going back to Colossians, turn to one more place and read Romans 7:7–8, 12–13, and write your response in the space below:

What this passage tells us is that the Law is not evil; *we* are! The Law stands as a piercing light, showing us where there is sin and evil in our hearts. It also stands as a judge or tutor, showing us where we have continually failed to uphold God's holy and righteous law.

Now turn back to Colossians 2:13–15. Keeping the passages from Ephesians 2 and Romans 7 in mind, what is this "certificate of debt consisting of decrees against us" Paul is talking about here in verse 14?

What does this same verse tell us Christ has done with our certificate of debt or the sin the Law has exposed in us?

Verse 15 is even more specific. What are the two things Christ has disarmed on our behalf, and what did He do to them?

Dear friends, this is an amazing passage! Not only does this passage tell us that Christ died for us *while* we were still sinners, buried under the weight of a list of debts and failures piled up against us, but it also tells us He has taken every ruler, authority, voice, and judge that could condemn, shame, mock, strip, reject, and demolish us, and *nailed them to the cross!*

At the very place where Satan hoped to have the ultimate victory by shaming Christ and shaming us, Christ shamed him! Christ not only took upon Himself the deadly blow for sin, He also took the deadly, crippling, paralyzing nature of our rejection and shame, and the certificate of debt against us that says, "You have failed!" and He nailed them to the cross. Hallelujah!

So when the enemy tries to tell us we stand condemned, accused, or rejected, where do we run? To the cross! For the cross of Christ is the only place that tells us, "Yes, you have failed, but *I* have overcome. And in My conquering of your failures, you now stand complete." So why do so many of us still struggle with rejection and shame? Why all the heartache?

Read again Colossians 2:8–12. Look at how Paul warns the church in verse 8 against captivity.

What are some of the "traditions of men" and "elementary principles of the world" that consistently take you captive? (i.e., For me, it would be that my significance rests in my education, my accomplishments, my schedule, or my productivity.)

How do we battle these "captors" of philosophy and the traditions of men? Write Colossians 2:10 below:

Now say it out loud—and MEAN IT!!!

My friend, do you realize this is now the third time we have seen the phrase "rule and authority"? Colossians 1:16 tells us all rulers and authority were created by Him; Colossians 2:10 tells us He is the head of all rule and authority; and Colossians 2:15 tells us He not only disarmed the rulers and authorities but also made a public spectacle or display of them on the cross.

So if Christ is above all rule and authority, and we are complete in Christ, who or what can stand against us?? Who can accuse us?? What ruler can shame us?? What authority can tell us we are rejected?? What Law can preach to us that we are still in debt?? NO ONE and NOTHING. Christ disarmed and publicly shamed every single ruler or authority that could try.

Go back to Colossians 2:10. Is there any part of us that is not complete or whole when we are in Christ?

What part of you feels consistently incomplete or that it doesn't measure up to the standards of the world around you?

Why do you think that this is?

So what's the remedy? The word "complete" in verse 10 means "to make full, fill. Particularly, to fill a vessel or hollow place."[8] If Satan uses rejection to curse, bind, hem us in, or render us powerless to resist his lies and poison, Christ's life in us does the very opposite! His life frees us and *fills* us. In fact, by implication, Christ's life *searches out* the empty, hollow places in our hearts and fills them up to overflowing. This is why we do not have to live under the curse of rejection or shame any longer.

Remember Colossians 1:17–18? Is there anything in all of creation that is above, outside of, or in first place before Christ? In other words, is there any part of His created realm where His fullness does not or cannot fill? No!

So why are our hearts so easily taken captive by the empty, hollow traditions of men? Quite simply, it is because you and I do not believe the Word of God or walk in the power of the Spirit of God. We look around us, wanting to be filled, accepted, approved, and loved from the outside in. But the Spirit of Christ fills from the inside out, and His Word tells us there isn't an empty place inside of us that has not or cannot be made complete because of His love. If we feel incomplete in any way, it is because we are believing a lie of the enemy, plain and simple.

Tomorrow we are going to look further at how to break free from the enemy of rejection by believing in the Word of God, but today I want you to bask—bask in the incredible, wonderful, irrevocable truth that Christ has conquered and defeated our enemies once and for all. Our job is to simply stand in the light of *His* glorious victory, fullness, and significance. In Him, my friend, you are complete.

The Enemy of Pride

I have good days, days when I am strong and able to trust the Lord that He is the Significant One and that all of my significance rests in Him. But I also have hard days, days when the "insignificance" of changing diapers and singing silly songs or staying inside for days on end because my little one has a fever brings me to my knees. And sometimes I wonder, "God, are You there? Are you remembering? Are you still working, even when I cannot see?" And God always answers in the most extraordinary ways, for He is infinitely patient with me, faithful to teach, encourage, exhort, and remind me that the wait *is* the destination as I learn to find my significance in Him.

But why the struggle? Why do I still struggle when I know about Christ's victory on the cross and the fullness I have in Him? Most of the time, I think it is because even though I know the message of the Gospel in my head, I need to preach that same message to my heart—not once a week, but every day. For along with rejection, the enemy of significance that creeps into my head and heart is the sometimes overt, but most of the time subtle, enemy of pride.

As we continue on in our study of significance, turn with me to Colossians 2:16–19. As you read, keep in mind the passages from yesterday telling us that Christ is not only over all rulers and authorities but has disarmed and made a public spectacle of them, declaring that He is Lord of all.

According to verse 16, how are the Christians in the church of Colossae allowing themselves to be judged?

Keeping one hand in Colossians 2, turn to James 4:12. According to this passage, who is our judge, and why does He have the authority to judge?

Now turn back to Colossians 2 and think about your wait for significance.

Why is it so hard? I believe it is because we allow other people and other things to judge us as opposed to the Lord Himself and His Word. Speaking for myself, the most condemning "judge" I listen to is not the voice of friends or family or academia or media; it is my own voice, my own heart, and my own thoughts.

What about you? Who is your greatest "judge"? Is it the Lord and His Word, or is it someone or something else?

If it is not the Lord, then why do you allow other people or things to judge you besides Him? Really think about your answer, and then write in the space below:

What happens when we do allow others to judge us? Fill in the blank from verse 18:

"Let no one keep _____ you of your prize."

When we exalt our thoughts or others' thoughts above who Christ says we are or what gives us our true significance, we are defrauded of our prize! (If you don't know what your prize is, don't worry; we will look at that tomorrow.) Paul says we become "inflated without cause" by "the fleshly mind, and not holding fast to the head" (v. 19).

The "inflated flesh" or "fleshly mind" can work in two different ways. The first and most obvious way is that we end up thinking too much of ourselves: we are boastful, proud, arrogant, vain, and self-righteous. We demand our own way with little or no respect for others. But the second way, which is more subtle, is that we think too little of ourselves. We listen to the lies of "self-abasement" (v. 18), and roll around in the filth of rejection, fleshly "insignificance," self-pity, self-sorrow, and self-focus. Although we think little of ourselves, our focus is still on self, self, self! We, too, demand our own way; it's just that it's done through the channels of teary self-pity and quiet withdrawal as opposed to outright demands.

So let's be honest and call both ways what they are: PRIDE. Whether we think of ourselves as too significant or too insignificant in the Kingdom of God, we place ourselves and others above the rule and authority of Christ, purposely turning away from the message of the cross, while all the time losing our grip on our Head, the One who holds us all together.

When are the times that you struggle with thinking too much of yourself?

Why do you think that this is?

Read Psalm 103:13–18. Copy verse 14 below:

When you are tempted to struggle with inflated flesh by thinking too much of yourself, remember that you are DUST! That's right, dust. The next time you go outside, pick up a clod of dirt and remember that this is both where your flesh came from (Genesis 2:7) and to where it will return (Ecclesiastes 12:7). We have nothing to take pride in or to boast about, for we are here today and gone tomorrow; our life is but a vapor (James 4:14). This knowledge should be enough to humble the greatest king. But at the same time, we draw our significance from the fact that the God of the Universe has noticed us, breathed His life into us, and created us in His image. That alone is enough to ennoble the poorest beggar.

The psalmist gives us another remedy for inflated flesh. Look carefully at Psalm 103:17–18. Who does God lavish His lovingkindness and righteousness upon?

The prophet Micah tells us, "He has told you, O man, what is good; and what does the Lord require of you but to do justice, to love kindness, and to walk humbly with your God?" (Micah 6:8) The key to having eternal, everlasting significance is to walk humbly with God. That means getting rid of all pride and all inflated flesh. That means losing yourself in making *God's* Name great rather than your own.

But the reward God gives us is everlasting: He shows His mercy to generation after generation of those who keep His covenant and obey His commands. Your willingness to obey and walk in humility without concern for your own name or earthly significance gives you far more significance in the Kingdom of God than any effort you could spend on building up your own name or establishing your own earthly kingdom.

When are the times that you struggle with thinking too little of yourself?

Why do you think that this is?

Turn to Psalm 8:4–9. In verses 5–8, the psalmist has listed the ways that God has "taken thought" of us and "cared" for us. What are they?

When you are tempted to think too little of yourself, begin thanking God for all of the ways He thinks of you, remembers you, and cares for you. In verse 5, we are even told that we wear a crown of "glory and majesty," yet the psalmist ends by making it very clear who the Majestic One is—the Lord, our Creator God! We are to be incredibly confident in who we are as the beloved and glorious children of God, but we are also always to remember who the one true God is. As pastor and author Tim Keller says, "Humble people in Christ have a new confidence not based on their performance but on the love of God in Christ (Rom. 3:22–23). Thus, they are no longer looking at themselves all the time. Christian humility is not thinking *less* of yourself, it is thinking of yourself less. It is self-forgetfulness."[9] In other words, we are not to wallow in "fleshly insignificance" (also known as pride) but in "self-forgetfulness" (also known as humility).

Whether you struggle with thinking too little or too much of yourself (and for me, it's both—it just depends on the day), you would do well to remember to preach to yourself the message of the Gospel. You are only dust, yet you are made in the image of God. Your life is but a vapor, here today and gone tomorrow, yet you are crowned with glory and majesty, created to rule over the works of God's Hands. You are a sinner, fallen and full of pride, yet the expression of God's vast love for you is the death and resurrection of His Son, Jesus Christ, in whom you have fullness of life and redemption. You and I have all the significance we could ever ask for, want, or imagine, if we will choose to daily walk humbly with Him.

Spend a few moments confessing your sin of thinking too much and too little of yourself, and receive the forgiveness He has for you. Lines are provided for you below to write out your own prayer as well. Then walk confidently today, knowing that your significance is sure as you rest in the only Significant One.

Lord, many days I think too much of myself, lifting up my eyes and my heart to concern myself with matters that are too great or too difficult for me. But many days, I think too little of myself, forgetting that I am Your child, held by Your hands and loved with an everlasting love. Forgive me for forsaking my true significance by walking in both forms of pride. I ask for the humility of heart to remember that You are God and I am not; my job is to simply rest in You and find my significance in being Your child.

"O Lord, my heart is not proud, nor my eyes haughty; nor do I involve myself in great matters, or in things too difficult for me. Surely I have composed and quieted my soul; like a weaned child rests against his mother, my soul is like a weaned child within me. O Israel, hope in the Lord from this time forth and forever" (Psalm 131:1–3).

Amen.

To Rule and Reign

When Lillian, our first child, was born, Jason and I were both in awe of the gift of grace God had given us. But for the most part, while Jason's life stayed the same, my life changed dramatically. While he still left for the office every morning, going to a "significant" place to do "significant" work, my life went from working on a vibrant, active church staff and mentoring and teaching a passionate group of young single adults to the quiet audience of one. Instead of writing, teaching, editing, and ministering, I was up to my elbows in changing dirty diapers, playing peek-a-boo, and reading the same simple board books over and over again. And while I loved my work of being a new mom and staying home with my daughter, there were some days the desire to know I was a significant person, doing significant work according to the standards by which I had always measured my life, crept in at full force. My identity had to shift from finding significance in what I *did* to who I *was* in the quieter role God had given me.

What I learned through that season of motherhood was that God cared about my heart, my needs, my cries, my hurts, and my desires. He wanted me to be encouraged and always sent encouragement my way right when I needed it. And He cares for you in the very same way. Why? Because He planted the desire for significance in our hearts. In and of itself, the need and the wait for significance is not a sinful desire. It certainly can be when our sinful nature takes center stage and the focus becomes all about self, self, self! But the wonderful news is, God created us to be significant: not a shallow, temporary, earthly significance here today and gone tomorrow, but a deep, eternal significance that does not change when our circumstances do.

How do I know this? Plain and simple, the Bible tells me so.

Turn to Revelation 22:1–5. We are going to peek at the very last chapter of the Bible to see how we will spend an eternity with Christ. Fill in the blanks from verse 5:

> "And there shall no longer be any night; and they shall not have need of the light of a lamp nor the light of the sun, because the Lord God shall illumine them; and they shall _____ _____ and _____."

The word for "reign" means "to be king, to rule." It "applies to God; to Christ; to those who belong to Christ . . . to reign or have predominance."[10] Dear friends, we are told repeatedly throughout the New Testament that God's purpose for us does not end when we breathe our last breath here upon earth. In fact, our true purpose is really just beginning. We will not spend an eternity floating around on clouds with wings playing a harp—far from it! In Christ, we are created to *rule and reign* . . . forever and ever.

Just in case you are not convinced, let's look in the book of Daniel. Through Daniel's visions, God gives us an incredible glimpse of what is to come.

Read Daniel 7:13–14, 18, 27. In verses 13–14, who is given dominion, glory, and a kingdom?

For what purpose is this dominion given? (Look in verse 14.)

Who does Christ give the kingdom to in verses 18 and 27?

It almost defies human imagination, doesn't it? When the end comes and Christ returns, all dominion, power, glory, rule and authority is given to Him; and He turns around and gives it to us, His saints, allowing us to share and participate in His rule and reign.

My friend, you may feel insignificant in the here and now. As a mother, daughter, grandmother, single woman, wife, or worker, you may wonder what in the world your "significance" amounts to. But let me tell you something: Christ created you to rule and reign with Him for all eternity. Your mere 70, 80, or 90 years here on this earth is just a practice round.

"But what am I practicing?" you may wonder. "The only thing I rule these days is a toddler in diapers or a cubicle in an office. My prospects aren't very hopeful!"

Let's look a little more in depth at who actually rules and reigns with Christ.

In the Sermon on the Mount, Jesus gives His disciples an intense and revolutionary look at what life in the Kingdom is supposed to look like. Even more specifically, in the first twelve verses called "The Beatitudes," He paints a clear picture of the type of person who is "blessed." While we could do an entire study on The Beatitudes alone, I want to look at just one in particular.

Read Matthew 5:5 and copy it below:

Who is it, exactly, who inherits the earth?

Does that word surprise you? Why or why not? If so, what word were you expecting Christ to use: the mighty? the wealthy? the educated? the elite? the superstars? Write your answers below:

In your concordance, look up the definition for the Greek word "gentle" (#4240), and write it in the space below, or copy parts of the definition from the margin that stand out to you:

> *Prautes*—"an inwrought grace of the soul and the expressions of it are first and chiefly toward God. . . . That attitude of spirit in which we accept God's dealings with us as good and do not dispute or resist . . . *prautes* is a condition of mind and heart which demonstrates gentleness not in weakness but power. It is a virtue born in strength of character."[11]

Those who crucify their flesh and live first and foremost to act upon and obey the will of God, those who willingly accept the workings of God's Hands as good and right, and those who *imitate Christ* are the saints who will inherit the earth. So it seems that those who will rule and reign in eternity are those who rule and reign their earthly passions in the here and now.

On day 2, we looked in Exodus 34 at the different enemies God promised to wipe out as long as the Israelite children were faithful to observe His commandments. The enemies mentioned there were physical enemies—Canaanites, Hittites, and Jebusites, just to name a few.

One last time, turn to the book of Colossians, and read Colossians 3:1–10. Who are the enemies on the land of the believer's heart Paul lists in Colossians 3:5–8?

How does Paul tell us we are to slay these enemies, which are much deadlier than any Canaanite with a sword? See vv. 1–2 and 9–10.

To an ancient Greek, "setting one's mind" involved much, much more than thinking good thoughts. The mind encompassed one's affections, will, and moral considerations. In other words, it involved the entire person, straining toward the goal, which is the upward call of God in Christ Jesus (Philippians 3:14).

The truly significant ones in eternity are those on this earth who, in gentleness of spirit, committed their mind, will, affections, desires, passions, conscience, heart—*everything*—to loving Jesus. Period. And those who love Jesus more than self, more than life, and more than the things in this life are the ones who will rule and reign with Him forever.

So significance is simple: it's setting your heart and mind, body and strength, soul and spirit, on loving Jesus. And Paul tells us in Colossians 3:4 that "[w]hen Christ, who is our life, is revealed, then you also will be revealed with Him in glory."

Look again at the enemies of the soul listed in Colossians 3:5–10. Is there an enemy in particular that stands out to you? One that consistently keeps you from moving forward in the Kingdom of God in Christ-like behavior? If so, take a moment to write out a prayer of repentance and deliverance. Repent, first, of the sin, and then ask God in very specific ways to deliver you and to help you "take off" that sin:

Now read Colossians 3:12–17, and as a chosen, holy, beloved child of God, write out a prayer asking the Lord to help you "put on" the character of Christ as expressed in these verses. Use verses 12–17 to help you in the wording of your prayer:

As you continue to pray this same prayer in the days and weeks ahead, you will be amazed to see how God will deliver you, just as He delivered the Israelites.

Yesterday I told you we would look at the "prize" Paul mentions in Colossians 2:18, so to finish our time together today, turn in your Bible to the book of Philippians, right before Colossians.

Read Philippians 3:8–14.

In light of these verses, what do you think the goal of the Christian faith or "the prize" is that Paul mentions in verse 14?

Copy Philippians 3:10 below:

Our purpose and prize is Christ: knowing Christ, loving Christ, being found in Christ, walking with Christ, communing with Christ, and being known *by* Christ. Everything else, as Paul says, is "loss." *Christ* is our significance; *Christ* is our life; *Christ* is our hope of glory. And, once again, what we see in our wait for significance is that what we are really waiting for is Christ Himself.

In his small group study on "Self-Control and Emotions," Tim Keller includes a section of prayer showing "how to use the gospel of grace during the day when certain emotions crop up"[12] and the struggle with the enemies of anxiety, shame, pride, guilt, or lethargy begins. These prayers helped me tremendously in my struggle with significance, and I pray they will help you as well. I even placed some of them on the doors to my house and in my car so that I could see them often and be reminded of their truths.

Continuing on with Paul's instructions in Colossians 3 to "put off" the old self and be renewed instead in the image of Christ, let's finish this day and this week in an attitude of hopeful prayer. Take a few moments to read and pray through each prayer. Repent when necessary, and ask the Lord to enable you to set your affections and desires upon Him.

*When we feel **anxiety** we may think: 'If I slip up, if I make a wrong move here, I could lose everything.'*

- *But we must think, instead, 'All the things I have are really gifts of grace. They aren't here because of my performance, but by God's generosity. If He loves me enough to lose His only Son for me, surely He will continue to give me what I need. Console yourself.'*

*When we feel **pride and anger**, we may think: 'I am not getting what I deserve! People are not treating me right! Who do they think they are?'*

- *But we must think, 'All the things I have are really gifts of grace. I have <u>never</u> gotten what I deserve— and I never will! If God gave me what I deserved, I'd be dead. Humble yourself.'*

*When we feel **guilt**, we may think: 'I <u>have</u> blown it! My problems mean he's abandoned me.'*

- *But we must think, instead, 'All things I have are the results of God's grace. I never earned them to begin with so I couldn't have un-earned them. He accepted me long ago even though He knew I would do this. This was in my heart all along—I just didn't see it, but He did. He's with me now. Be confident, Self.'*

*When we feel **boredom and lethargy**, we may think: 'Sure, I'm a Christian. Sure I have good things. So what?'*

- *But we must think instead, 'All the things I have—every one—is a gift of grace. The very fact I am a Christian is a miracle. Be amazed. Be in wonder, Self.'"[13]*

Walk away today with the hope that just as the Lord placed in you the deep, deep need for significance, He also gave you the way to fill that need through taking on the nature of Christ. So as you wait to rule and reign, let Christ rule and reign in and over you—now and for all eternity. Your significance stands secure in your relationship with Him alone.

I. Genesis 1:26–31; 2:7–9, 15–25—Original Significance

 A. "The man and his wife were both _____ and they felt no _____." Genesis 2:25

 B. Significance in the Garden

 1.

 2.

 3.

 4.

II. Genesis 3:1–7—The Fall from Significance

 A. The Enemy of Significance is the Enemy of _____

 1. "_____ is a fall from your _____;

 2. _____ is a fall from your _____.

 3. The opposite of _____ is _____;

 4. The opposite of _____ is _____ or _____."[14]

 ❑ Hosea 4:6–7

 ❑ Shame—*buwush*—"to be confounded, disappointed, to keep waiting, to become pale or blush. The word often occurs in contexts of humiliation and _____ _____ _____. It is the feeling of public _____."[15]

 B. Three Ways _____ and _____ Relate

 1. "They _____—you feel them at the _____ time for the _____ reason."[16]

 2. "They are _____ of each other—you can be ashamed of something that is _____ morally wrong but that is _____."[17]

 3. "They can work _____ each other."[18]

 ❑ "Ashamed of doing something morally _____"[19]

 ❑ "Ashamed of NOT doing something morally _____"[20]

 C. Pinpointing Your Models

 ❑ The problem: The church often gets its _____ from Scripture but its _____ from the culture around it.

III. Genesis 3:8–21—The Remedy for Significance

 A. What Not to Do: (Knee-Jerk Reactions to Shame) (vv. 7–13):

 1. They made for themselves _____ _____ (v. 7).

 2. They _____ into _____ (v. 8).

 3. They _____ the _____ (vv. 10–13).

 B. God's Remedy for Shame (vv. 8–21):

 1. He _____ them (vv. 8–9).

 2. He calls them from _____ into _____ (v. 9).

 3. He _____ them and then He adequately _____ them (vv. 14–19, 21).

 ❑ Genesis 3:21 points us forward to the blood covering of the _____of _____, a covering that offers us both _____ for our sin and _____ for our shame.

 ❑ The remedy for _____ is _____, but the remedy for _____ is "_____."[21]

"Again He stoops from the throne, and girds Himself with a towel, and in all lowliness, endeavors to remove from thee and me the stain which His love dare not pass over. He never loses the print of the nail; He never forgets Calvary and the blood; He never spends one hour without stooping to do the most menial work of cleansing filthy souls. And it is because of this humility He sits on the Throne and wields the scepter over hearts and worlds."

F. B. Meyer, *Love to the Uttermost*[22]

IV. The Significant Ones

 A. The Significant Woman is the one who makes _____ her _____ _____ (Psalm 32:1–7).

 ❑ Brutal honesty _____God and acceptance _____God is psychologically the safest place to be. But if we refuse to make God our hiding place, rather than hating our _____, we end up hating _____.[23]

 1. We must get _____ and our _____ out of the holy place of our lives and put _____ _____ there.[24]

 2. We must give God the _____to determine our significance—who we are and if we are worth loving.

 B. The Significant Woman is the one who makes _____ _____ her _____ (Hebrews 12:1–3).

 ❑ The first Adam sinned in a garden but his sin was _____; the second Adam lived a sinless life but was betrayed in a garden and left _____ - _____, so you and I would never have to be (Mark 14:32–52; Revelation 22:1–4).

WEEK TWO

Waiting for a Father

The Real Thing

Waiting for a Father—this wait strikes a deep and common chord in all of us, for the need for a father is one of our most basic needs as human beings. We all come into the world wired for instant contact with two people—a mother and a father. And if the mother's role is to draw her children *in*, giving them a sense of being, identity, nurture, safety, and support, it's the father's role to send his children *out*, giving them direction, courage, strength, purpose, and place in the world around them.[25]

At one time or another, we've probably all heard the illustration about how to tell the real from the counterfeit. In order to train those who work for the United States Treasury in detecting money laundering schemes, agents-in-training never see or handle counterfeit U.S. bills. They only train with the real thing. Therefore, when counterfeit bills come across their path, they are quickly able to detect the fake from the real.[26]

Wouldn't it be great if our experience with our earthly fathers was like that? What if all dads were great dads, loving dads, and truthful dads? What if we were never allowed to experience counterfeit characteristics but only real characteristics that perfectly mirrored our Heavenly Father's character, image, and love?

This week I want to do a little training with "the real thing" so that when a counterfeit image of a father rears its ugly head in our present circumstances or in memories from our past, we can recognize it to be a fake substitute for our real Father. But don't think for a moment that this week is an excuse to begin bashing our earthly fathers—far from it. My prayer is that by learning about and loving our Heavenly Father, we will gain the strength, confidence, and grace to forgive and love our earthly fathers just as the Father forgives and loves us and calls us to do the same.

In order to do this training, I want to spend some time in the book of John. In John 13, Jesus is eating His last Passover meal with His disciples, and in just a few short hours, He will be arrested, tried, and sentenced to hang as a common criminal on a cross. So when the apostle John records Jesus' final instructions, conversation, and prayer for His disciples in John 14–17, it is here that we see a deep, unique glimpse into Jesus' heart. In their final hours before death, people often speak about what is most important to them. In just four short chapters, Jesus says the word "Father" fifty times, and

in doing so, we are able to see what, or who, was most important to Him. Jesus Himself said, "Out of the overflow of the heart, the mouth speaks" (Matthew 12:34). And while our words often reveal our hearts to be egocentric and self-centered, Jesus' words revealed His heart to be Father-centric and completely selfless.

So this week, I want us to pull up a chair and sit ourselves down in the middle of the conversation in John 14–17 and listen so quietly and closely that we don't miss a word. My prayer is that we walk away so full of the real characteristics of a good Father that we will never again be tempted to trade an image of a counterfeit father for the real thing.

 Today, I want us to do something a little different. I want us to spend our time reading all four chapters of John 14–17. Set a timer if you have to, but take at least 15 minutes to soak in Jesus' intimate words. As you read, ask to hear the heartbeat of the Son for His Heavenly Father.

To help you in the process, John 14–17 is printed out for you in the following pages. My prayer is that this will help you read Jesus' words less like a Bible study lesson and more like a conversation between intimate friends.

Read it all the way through without stopping (sometimes it helps to even read it out loud), and then go back and circle each occurrence of the word Father. From there, observe what Jesus says in the context of each circled word. Any specific observations you have, jot down in the space provided at the end of each chapter.

One last thing before you start: pray the following prayer paraphrased from Psalm 25:12–14. May the Holy Spirit, your Helper, Comforter, Companion, and Closest Friend, reveal to you the true nature of your Heavenly Father as you read.

> *Father, Your Word promises that You will instruct the woman who fears You in the way she should choose. Her soul will abide in prosperity and her descendants will inherit the land. You also tell me that Your secrets, Your place of intimate counsel, advice, and serious consultation, is for the woman who fears You. So give me a heart that fears You, loves You, and longs to know Your counsel so that I may know Your covenant and Your character as Father, Son, Spirit, Counselor, and Friend. In the Name, Power, and Authority of Jesus I ask all of these things. Amen.*

JOHN 14–17

John 14

(1) "Do not let your heart be troubled; believe in God, believe also in Me. (2) In My Father's house are many dwelling places; if it were not so, I would have told you; for I go to prepare a place for you. (3) If I go and prepare a place for you, I will come again and receive you to Myself, that where I am, there you may be also. (4) And you know the way where I am going."

(5) Thomas said to Him, "Lord, we do not know where You are going, how do we know the way?"

(6) Jesus said to him, "I am the way, and the truth, and the life; no one comes to the Father but through Me. (7) If you had known Me, you would have known My Father also; from now on you know Him, and have seen Him."

(8) Philip said to Him, "Lord, show us the Father, and it is enough for us."

(9) Jesus said to him, "Have I been so long with you, and yet you have not come to know Me, Philip? He who has seen Me has seen the Father; how can you say, 'Show us the Father'? (10) Do you not believe that I am in the Father, and the Father is in Me? The words that I say to you I do not speak on My own initiative, but the Father abiding in Me does His works. (11) Believe Me that I am in the Father and the Father is in Me; otherwise believe because of the works themselves. (12) Truly, truly, I say to you, he who believes in Me, the works that I do, he will do also; and greater works than these he will do; because I go to the Father. (13) Whatever you ask in My name, that will I do, so that the Father may be glorified in the Son. (14) If you ask Me anything in My name, I will do it. (15) If you love Me, you will keep My commandments. (16) I will ask the Father, and He will give you another Helper, that He may be with you forever; (17) that is the Spirit of truth, whom the world cannot receive, because it does not see Him or know Him, but you know Him because He abides with you and will be in you. (18) I will not leave you as orphans; I will come to you. (19) After a little while the world will no longer see Me, but you will see Me; because I live, you will live also. (20) In that day you will know that I am in My Father, and you in Me, and I in you. (21) He who has My commandments and keeps them is the one who loves Me; and he who loves Me will be loved by My Father, and I will love him and will disclose Myself to him."

(22) Judas (not Iscariot) said to Him, "Lord, what then has happened that You are going to disclose Yourself to us and not to the world?"

(23) Jesus answered and said to him, "If anyone loves Me, he will keep My word; and My Father will love him, and We will come to him and make Our abode with him. (24) He who does not love Me does not keep My words; and the word which you hear is not Mine, but the Father's who sent Me. (25) These things I have spoken to you while abiding with you. (26) But the Helper, the Holy Spirit, whom the Father will send in My name, He will teach you all things, and bring to your remembrance all that I said to you. (27) Peace I leave with you; My peace I give to you; not as the world gives do I give to you. Do not let your heart be troubled, nor let it be fearful. (28) You heard that I said to you, 'I go away, and I will come to you.' If you loved Me, you would have rejoiced because I go to the Father, for the Father is greater than I. (29) Now I have told you before it happens, so that when it happens, you may believe. (30) I will not speak much more with you, for the ruler of the world is coming, and he has nothing in Me; (31) but so that the world may know that I love the Father, I do exactly as the Father commanded Me. Get up, let us go from here."

Observations about the Father:

John 15

(1) "I am the true vine, and My Father is the vinedresser. (2) Every branch in Me that does not bear fruit, He takes away; and every branch that bears fruit, He prunes it so that it may bear more fruit. (3) You are already clean because of the word which I have spoken to you. (4) Abide in Me, and I in you. As the branch cannot bear fruit of itself unless it abides in the vine, so neither can you unless you abide in Me. (5) I am the vine, you are the branches; he who abides in Me and I in him, he bears much fruit, for

apart from Me you can do nothing. (6) If anyone does not abide in Me, he is thrown away as a branch and dries up; and they gather them, and cast them into the fire and they are burned. (7) If you abide in Me, and My words abide in you, ask whatever you wish, and it will be done for you. (8) My Father is glorified by this, that you bear much fruit, and so prove to be My disciples. (9) Just as the Father has loved Me, I have also loved you; abide in My love. (10) If you keep My commandments, you will abide in My love; just as I have kept My Father's commandments and abide in His love. (11) These things I have spoken to you so that My joy may be in you, and that your joy may be made full.

(12) This is My commandment, that you love one another, just as I have loved you. (13) Greater love has no one than this, that one lay down his life for his friends. (14) You are My friends if you do what I command you. (15) No longer do I call you slaves, for the slave does not know what his master is doing; but I have called you friends, for all things that I have heard from My Father I have made known to you. (16) You did not choose Me but I chose you, and appointed you that you would go and bear fruit, and that your fruit would remain, so that whatever you ask of the Father in My name He may give to you. (17) This I command you, that you love one another. (18) If the world hates you, you know that it has hated Me before it hated you. (19) If you were of the world, the world would love its own; but because you are not of the world, but I chose you out of the world, because of this the world hates you. (20) Remember the word that I said to you, 'A slave is not greater than his master.' If they persecuted Me, they will also persecute you; if they kept My word, they will keep yours also. (21) But all these things they will do to you for My name's sake, because they do not know the One who sent Me. (22) If I had not come and spoken to them, they would not have sin, but now they have no excuse for their sin. (23) He who hates Me hates My Father also. (24) If I had not done among them the works which no one else did, they would not have sin; but now they have both seen and hated Me and My Father as well. (25) But they have done this to fulfill the word that is written in their Law, 'They hated Me without a cause.' (26) When the Helper comes, whom I will send to you from the Father, that is the Spirit of truth who proceeds from the Father, He will testify about Me, (27) and you will testify also, because you have been with Me from the beginning."

Observations about the Father:

John 16

(1) "These things I have spoken to you so that you may be kept from stumbling. (2) They will make you outcasts from the synagogue, but an hour is coming for everyone who kills you to think that he is offering service to God. (3) These things they will do because they have not known the Father or Me. (4) But these things I have spoken to you, so that when their hour comes, you may remember that I told you of them. These things I did not say to you at the beginning, because I was with you. (5) But now I am going to Him who sent Me; and none of you asks Me, 'Where are You going?' (6) But because I have said these things to you, sorrow has filled your heart. (7) But I tell you the truth, it is to your advantage that I go away; for if I do not go away, the Helper will not come to you; but if I go, I will send Him to you. (8) And He, when He comes, will convict the world concerning sin and righteousness and judgment; (9) concerning sin, because they do not believe in Me; (10) and

concerning righteousness, because I go to the Father and you no longer see Me; (11) and concerning judgment, because the ruler of this world has been judged. (12) I have many more things to say to you, but you cannot bear them now. (13) But when He, the Spirit of truth, comes, He will guide you into all the truth; for He will not speak on His own initiative, but whatever He hears, He will speak; and He will disclose to you what is to come. (14) He will glorify Me, for He will take of Mine and will disclose it to you. (15) All things that the Father has are Mine; therefore I said that He takes of Mine and will disclose it to you. (16) A little while, and you will no longer see Me; and again a little while, and you will see Me."

(17) Some of His disciples then said to one another, "What is this thing He is telling us, 'A little while, and you will not see Me; and again a little while, and you will see Me'; and, 'because I go to the Father'?"

(18) So they were saying, "What is this that He says, 'A little while'? We do not know what He is talking about."

(19) Jesus knew that they wished to question Him, and He said to them, "Are you deliberating together about this, that I said, 'A little while, and you will not see Me, and again a little while, and you will see Me'? (20) Truly, truly, I say to you, that you will weep and lament, but the world will rejoice; you will grieve, but your grief will be turned into joy. (21) Whenever a woman is in labor she has pain, because her hour has come; but when she gives birth to the child, she no longer remembers the anguish because of the joy that a child has been born into the world. (22) Therefore you too have grief now; but I will see you again, and your heart will rejoice, and no one will take your joy away from you. (23) In that day you will not question Me about anything. Truly, truly, I say to you, if you ask the Father for anything in My name, He will give it to you. (24) Until now you have asked for nothing in My name; ask and you will receive, so that your joy may be made full. (25) These things I have spoken to you in figurative language; an hour is coming when I will no longer speak to you in figurative language, but will tell you plainly of the Father. (26) In that day you will ask in My name, and I do not say to you that I will request of the Father on your behalf; (27) for the Father Himself loves you, because you have loved Me and have believed that I came forth from the Father. (28) I came forth from the Father and have come into the world; I am leaving the world again and going to the Father."

(29) His disciples said, "Lo, now You are speaking plainly and are not using a figure of speech. (30) Now we know that You know all things, and have no need for anyone to question You; by this we believe that You came from God."

(31) Jesus answered them, "Do you now believe? (32) Behold, an hour is coming, and has already come, for you to be scattered, each to his own home, and to leave Me alone; and yet I am not alone, because the Father is with Me. (33) These things I have spoken to you, so that in Me you may have peace. In the world you have tribulation, but take courage; I have overcome the world."

Observations about the Father:

John 17

(1) Jesus spoke these things; and lifting up His eyes to heaven, He said, "Father, the hour has come; glorify Your Son, that the Son may glorify You, (2) even as You gave Him authority over all flesh, that to all whom You have given Him, He may give eternal life. (3) This is eternal life, that they may know You, the only true God, and Jesus Christ whom You have sent. (4) I glorified You on the earth, having accomplished the work which You have given Me to do. (5) Now, Father, glorify Me together with Yourself, with the glory which I had with You before the world was. (6) I have manifested Your name to the men whom You gave Me out of the world; they were Yours and You gave them to Me, and they have kept Your word. (7) Now they have come to know that everything You have given Me is from You; (8) for the words which You gave Me I have given to them; and they received them and truly understood that I came forth from You, and they believed that You sent Me. (9) I ask on their behalf; I do not ask on behalf of the world, but of those whom You have given Me; for they are Yours; (10) and all things that are Mine are Yours, and Yours are Mine; and I have been glorified in them. (11) I am no longer in the world; and yet they themselves are in the world, and I come to You Holy Father, keep them in Your name, the name which You have given Me, that they may be one even as We are. (12) While I was with them, I was keeping them in Your name which You have given Me; and I guarded them and not one of them perished but the son of perdition, so that the Scripture would be fulfilled.

(13) But now I come to You; and these things I speak in the world so that they may have My joy made full in themselves. (14) I have given them Your word; and the world has hated them, because they are not of the world, even as I am not of the world. (15) I do not ask You to take them out of the world, but to keep them from the evil one. (16) They are not of the world, even as I am not of the world. (17) Sanctify them in the truth; Your word is truth. (18) As You sent Me into the world, I also have sent them into the world. (19) For their sakes I sanctify Myself, that they themselves also may be sanctified in truth. (20) I do not ask on behalf of these alone, but for those also who believe in Me through their word; (21) that they may all be one; even as You, Father, are in Me and I in You, that they also may be in Us, so that the world may believe that You sent Me.

(22) The glory which You have given Me I have given to them, that they may be one, just as We are one; (23) I in them and You in Me, that they may be perfected in unity, so that the world may know that You sent Me, and loved them, even as You have loved Me. (24) Father, I desire that they also, whom You have given Me, be with Me where I am, so that they may see My glory which You have given Me, for You loved Me before the foundation of the world. (25) O righteous Father, although the world has not known You, yet I have known You; and these have known that You sent Me; (26) and I have made Your name known to them, and will make it known, so that the love with which You loved Me may be in them, and I in them."

Observations about the Father:

His Presence

Standing at six feet, four inches and weighing close to 250 pounds, my father-in-law is a man whose physical presence commands respect. As an offensive lineman for the Houston Oilers and San Diego Chargers in the 1960s, his deep, resonating voice and past tackling capabilities demand attention. And believe you me, when my husband and I first started dating, Mr. Baker always had my attention. I always knew where he was in a room, what I should say, what I shouldn't say, what I should do, and exactly what I shouldn't! I was more than a little fearful of this tall, assertive man!

When Jason and I were engaged, I started to think about what in the world I would call "Mr. Baker" once he officially became my father-in-law. I just couldn't seem to get his first name, "Johnny," out of my mouth—I feared I would shrivel up from disrespect on the spot. But "Johnny" it was for about a year until the first grandchild was old enough to talk and dubbed her grandfather "Papa." I, with much relief, dropped our "first name basis" familiarity and joined in with the rest of the family on calling him "Papa."

Over the years that Jason and I have been married, "Mr. Baker" turned "Johnny" turned "Papa" has become exactly that to me—"Papa." There are still times he can scare the living daylights out of me, but this "fear" is now rooted in deepest love and respect. If before I respected his physical frame and past credentials, now I respect his heart. I have found Johnny Baker to consistently be a man of honor, faithfulness, generosity, gentleness (with his 8 granddaughters!) and integrity.

In fact, when Lillian, my oldest daughter, was little, one of my favorite things to do was to pull her in her wagon over to Papa's office, which was within walking distance of our house. I never had to schedule an appointment; I just walked right in—why? Because Johnny was not my father-in-law in name only; he had become my father.

So it is with our Heavenly Father. Before Christ came, God's people only had temporary access to Him through the sacrificial system of animal offerings. Once a year, the high priest was only able to access the Holy of Holies, the place in the temple where God's Presence dwelled. Because of the nature of sin and people's unholiness in relation to God's holiness, access to God was full of rules, regulations, blood, sacrifice, holy terror, fear, and dread.

But Jesus' coming changed all of that, and His conversation with His disciples the night before He died in John 14–17 shows us exactly that. Through the life of Christ, His perfect obedience, death, and resurrection, God's people now have continual, eternal access to God the Father. The Father's love and desire for relationship with His children had been there all along; His people just couldn't see it in forms they could understand. But now, through Jesus, they could. Jesus was the embodiment of the Father's heart walking around in skin and bones. And because of Christ, not only are the people of God called to keep and demonstrate a healthy respect for the Lord, they are also to walk right in, straight past the front desk, so to speak, and call out, "Abba, Father! Daddy!" Sounds too good to be true, doesn't it? Yet if we are walking in a relationship with our Father that is anything less than personal and intimate, we are missing out on what is offered to us as daughters of the Most High God.

Turn to Hebrews 12:18–24. What have we not come to (vv. 18–21)?

What is the author of Hebrews referring to here? Keep one hand in Hebrews 12, and turn to Exodus 19:10–20 with the other. God is preparing His people, through Moses, to receive the giving of the Law.

According to Exodus 19:10–20, what preparations did the people have to make in order to be ready for the coming of the Lord to Mt. Sinai (vv. 10–15)?

What was the coming of the Lord like (vv. 16–20)?

Like the Israelites, would you have been terrified of a similar encounter with God? If so, why?

Now go back to Hebrews 12:22–24. What, now, have the people of God come to?

Why? What made the difference between the people's fear and trembling on Mount Sinai and our triumphant access to God in heaven, the Judge of all (see v. 24)?

Jesus, Jesus, Jesus. Because of Jesus, we do not have to fear death in the Father's Presence. We can boldly take our place as the "general assembly," "church of the first-born," and "spirits of righteous men made perfect." Jesus not only made the way to show us the Father's heart, He *is* the way to the Father's heart.

Think back to your observations yesterday from John 14–17. I want to begin digging into this portion of Scripture. We won't, of course, be able to cover everything, but I do want to examine a few things from Jesus' discourse with His disciples that show us the Father's heart.

With a highlighter or pen in hand, go back to your copy of John 14 (just chapter 14 today) and highlight or bracket all words and phrases that indicate we are true children of the Father.

Jot down your observations below:

1.

2.

3.

4.

5.

What does it mean to be a true son or daughter? I think John 14 gives us insightful clues. One thing that stands out to me is that the heart of a good Father wants to be with His children.

What does John 14:2–3 tell us?

John 14:23 also tells us something interesting; where do the Father and Son take up residence?

The Greek word for "abode" in verse 23 is *mone*, which means "to remain, dwell. A mansion, habitation, abode."[27] The Lord Jesus Christ has gone to prepare a mansion, a house, a place for us to dwell with Him and with the Father forever. But (are you ready for this?), until then, as His children, *we* are His mansion, for we are not only where He wants to visit but where He wants to *dwell*. Permanently. Forever. In his book *Experiencing Father's Embrace*, author Jack Frost says, "So often, well-meaning Christians pray for a *visitation* from God, but what He really wants is a *habitation* with us."[28]

Unlike so many earthly fathers, God is not a father who stands from afar, pointing his finger and criticizing our faults, or impassively showing little or no concern for or connection to His children. God is a Father who wants to dwell with us *continually*; in fact, He never wants to leave our presence. And as our Father, He desires us to know that we have a permanent place in and with Him.

As believers in Christ, what evidence do we have that the Father has taken up permanent residence in us (see John 14:16–20)?

As daughters, are we safe and secure in our dwelling place? As confirmation of our security, using concentric circles, draw a diagram of the word picture Jesus uses in John 14:20.

If you drew the circles as Jesus described, what you see is that your position, identity, and dwelling place in the Father is totally and completely secure. *Nothing* can snatch you from the Father's grasp as His daughter or penetrate the walls of protection He has built around you.

Now look at John 14:27. When we begin to become troubled or afraid, what has Jesus promised to give us?

Why is this such an important gift to a child? (Think about your own children or your own experience as a child.)

Keeping one hand in John 14, turn to Numbers 6:22–27 with the other.

While God chose to use Moses as a deliverer of His people from slavery in Egypt, He chose to use Aaron, Moses' brother, as a priest over His people. Throughout Biblical history, all priests were descendants of Aaron's line. Verses 24–26 designate what is known as the "Aaronic Blessing"; this was the blessing priests were commanded to use to bless the people of Israel as the children of God.

This blessing is so important to God's people, I want you to know it by heart. Copy verses 24–26 word-for-word in the space below:

According to verse 27, by using this blessing, what were Aaron and his descendants doing for the sons of Israel?

During the time of the temple in Jerusalem, the priests recited this blessing over the people every day. Still today, some synagogues, many in Jerusalem, recite this blessing every morning. While reading about this particular topic, I found a quote describing the manner in which the priests use the Aaronic blessing to bless the Jewish people. As you read, try to picture what the author is describing:

> When performing the Priestly Blessing, the [Priests] stretch their arms and hands forward. They hold their hands together palms-down. They split their fingers so there are five spaces: one space between the thumbs, a space between the thumb and first finger of each hand, and a space between the second and third finger of each hand.
>
> It is believed that the five spaces allude to verses in Song of Songs (2:8–9). The verses state that God 'peeks through the cracks in the wall.' In other words, God watches over and protects the Jewish people even when He is hidden.[29]

Using tangible and beautiful imagery, every morning in Jerusalem and in synagogues around the world, priests or rabbis seek to invoke something that believers in Christ often take for granted—the peace and the presence of God.

Think back for a moment to your childhood. Can you remember a time when you were terribly afraid?

As a child in a fearful situation, what did you long for most, and why?

More than anything, when children are afraid, they innately want the safe and secure presence of a parent, for nothing brings peace to a child in the midst of new, strange, or troubling situations like a loving mommy or daddy's arms. And as parents who love our children, when our children are afraid, we *want* them to be in our arms, receiving the comfort we know only we can bring.

As children of God the Father, we are no different from our own children. And as a parent, God is no different from us, only infinitely better. He *longs* to give us the comfort of His paternal, nurturing arms. And what was once a temporary blessing that had to be invoked time and time again over the people of Israel, Jesus promises once and for all in John 14:27. But how?

Go back to John 14:16–18. Who does Jesus promise is coming, and what is His role?

How long will He be with us?

As sons and daughters of God, we have been promised the very peace and presence of God—forever. For God has done what every good earthly parent longs to do: He has made a way to comfort, fill, abide in, calm, direct, and bless His children at all times.

What a good Father we have.

End today by placing your hands over your heart and speaking the blessing of Numbers 6:24–26 over yourself as a reminder that the Face of the Lord your God is lifted up upon you forever and that His peace and His presence have made their home within your heart. Then take time to pen your own prayer of response back to the Lord, thanking Him for what a good Father He is.

> *"The Lord bless you, and keep you;*
> *The Lord make His face shine on you,*
> *And be gracious to you;*
> *The Lord lift up His countenance on you,*
> *And give you peace."*
> *Numbers 6:24–26*

DAY THREE
Because of His Love

To know Joe Ince, my earthly father, is to know a patient, kind, humble man. I have many wonderful childhood memories of my father that fill me with a deep sense of gratitude and love for the father that he was and still is today. One thing that stands out to me as a consistent reminder of his love is how he disciplined his children. To my knowledge, Dad never disciplined me or my two brothers out of anger. Whoever had committed the offense was taken up to his or her room, given the opportunity to talk over and confess the wrongdoing, and then appropriate action was taken. After appropriate discipline had been administered, amidst the sniffles and tears, we were given a hug from Dad for as long as was needed.

To this day, I am thankful for such loving, faithful discipline from Joe Ince, for I know from many fathers, loving discipline was the exception, not the norm.

No matter how you were disciplined (or not disciplined)[30] as a child, today I want to look at the perfect Father's disciplinary measures, measures filled with intentional correction and life-saving lessons in obedience, consequences, and love.

Taking a highlighter or pen, go back to your copy of John 15 from Day One. Highlight or bracket all words and phrases showing how God uses discipline as a good and perfect Father.

Now look at verses 1–11 (the first paragraph). From what you highlighted or bracketed, list three of the ways that God uses discipline in the lives of His children:

1.

2.

3.

As parents, grandparents, instructive friends, aunts, and role models, I am certain that we all have differing modes, methods, and opinions about discipline. But I hope we can all agree on one thing—discipline is necessary. To be a good parent, one must discipline his or her children. Why? Proverbs 13:24 says, "He who spares his rod hates his son, but he who loves him disciplines him diligently." We discipline our children diligently not because we hate them but because we love them. If we hated them, we would either fly off the handle in rage and discipline them harshly or perhaps, even worse, not discipline them at all because we did not care what or who they turned out to be.

Let's look at Hebrews 12 again. Read verses 4–13.

According to this passage, who does the Lord discipline? Fill in the blanks from verse 6:

> "For those whom the Lord _____ He _____, and He _____ every son whom He _____."

What does God's discipline in our lives prove (see vv. 7–8)?

According to verses 10–11, why does God discipline us?

What does the Lord's discipline yield, or produce, in our lives (see v. 11)?

In John 15:16, Jesus tells His disciples He has appointed them to go and do something very specific. What is it? Fill in the blanks:

> "You did not choose Me, but I chose you, and appointed you, that you should go and bear _____, and that your _____ should remain . . ."

Let's connect the dots: Jesus tells us He has chosen and appointed us to go and bear *fruit* that will last. Hebrews 12:11 tells us that those who have been trained by God's discipline will yield the *fruit* of righteousness in their lives. No one I know, including those who have walked with the Lord for a very long time, enjoy seasons of the Lord's discipline in their lives. But let me ask you an honest question: as painful as discipline is, do you think you would ever be able to bear the fruit of righteousness and holiness, appointed by the Lord for you to bear, if it wasn't for those very same seasons of discipline?

Think about your answer for a moment, and let the reality sink in of the true purpose of the Lord's discipline in your life.

Think back on different seasons in your life. How has the Lord used seasons of discipline to yield fruit and a harvest of righteousness in you? Give at least two examples.

Is there a specific harvest of peace and righteousness you are enjoying right now because of a season of discipline in the past?

Does this change how you think and feel about God's discipline in your life? If so, explain below:

What Hebrews 12:6–8 tells us is that discipline from God is a sign to us that we are His *legitimate children*. If God simply let us go our own merry way without allowing any Spirit-led conviction, repentance, or humbling, major warning signs should start to flash in our heads. We would begin to wonder if we were His children at all.

Let's go back to John 15. In verse 2, if you were to substitute the word discipline for the word prune, what would this tell us about the nature of discipline? In other words, why does the Father find it necessary to "prune" His children?

There are two different types of discipline described in John 15:2. The first kind of discipline is in direct response to sinful disobedience or to the branches in us that "do not bear fruit." The second type of discipline is not a direct consequence of sin; rather, it exists to increase our "fruit production," much like the discipline a coach would require of an athlete in training.

In his book *Orthodoxy*, G.K. Chesterton explains that to merely approve of something or someone is not enough. Approval by itself never changed anything or anyone. To see change, beauty, glory, and growth, one must *love* something, and love requires acknowledging, pointing out, and working to change the hindrances to growth that are not only bad, but are sometimes good, yet keep someone or

something from becoming something great.[31] About the nature of love Chesterton says, "Love is not blind; that is the last thing that love is. Love is bound; and the more it is bound, the less it is blind. . . . [Love] is ready to smash the whole universe for the sake of itself."[32]

The Greeks used at least three different words for *love* in comparison to our one. The word *agape* described a supernatural, God-based love rooted in the nature and character of God Himself. *Fileo* described a friendship-based love, and *eros* described a sexual, erotic love.

> *Agape*—"love . . . meaning benevolent love. Its benevolence, however, is not shown by doing what the person loved desires but what the one who loves deems as needed by the one loved. It is God's willful direction toward man."[33]

The word for "love" used in Hebrews 12:6 and John 15:8–13 is the same word. In your concordance, look up the Greek definition for the word love (#26), and write it in the space below or copy parts of the definition from the margin that stand out to you:

God's discipline for us is rooted in nothing less than divinely-based, supernatural, *agape* love. *Agape* is the New Testament equivalent of *checed* (pronounced "hes-sed"), the Old Testament word for the covenantal nature of God's love, a love that is not swayed by the performance of His people but is rooted in the unchanging character of God Himself.

That, my friend, is good news for us! Many earthly fathers' discipline is swayed by their children's performance or by their own feelings, emotions, and mood in the moment. If dad had a bad day, most likely his children will have a bad day as well.

Not so with our Heavenly Father. He is constant, unchanging, faithful, tender, compassionate, and full of mercy and love, no matter what kind of discipline He is administering.

Are memories of your father's discipline good or bad? If you feel comfortable doing so, explain below:

How do memories of your earthly father's discipline line up with how the Lord's discipline is described in John 15 and Hebrews 12?

I want us to enter into a time of personal prayer and reflection for our fathers. There are many of us who need to spend time forgiving our earthly fathers for the way they did, or did not, discipline us. If your father was heavy-handed and disciplined in anger or was impassive and refused to take responsibility and discipline you at all, your soul bears scars that only forgiveness can heal. If you need to wait to do this section until you have the time and space to really hear from the Lord, please do so.

- Start by praying for your father, and ask the Lord to give you a heart of compassion for him. (This, by the way, does not excuse what he's done; it simply gives you a heart of understanding for why he did what he did.)

- Next, ask the Lord to bring to mind any memories or incidents of discipline that He wants to heal that were administered in anger and wrath rather than in a spirit of love. As you remember certain incidents, ask the Lord to come in and uproot from your heart any and all seeds of hurt, bitterness, wounding, anger, shame, or unforgiveness that were planted during that time. Forgive your dad for any specific action or word that needs to be forgiven. Use the space below to write out your prayer if you need to:

- Next, using specific verses from John 14 and 15, write out a prayer of blessing for your dad, even if you don't feel like it. I have written a sample prayer for you to follow if help is needed, but feel free to use the space below to write your own words of blessing. Remember that Christ does not tell us to obey and to love only when we feel like it. We are to obey and walk in faith that *as* we forgive, bless, and learn to love, the feelings will come. Bless your father using Jesus' words: if he is an unbeliever, pray that Christ would come and make His home in him, giving him peace that is eternal and joy that is full. If your father is already a believer in Christ, bless him in his continued walk with the Lord. Ask that the branches in his life that need to be pruned would be pruned, and those that need removing would be removed. Bless him with the fullness of Christ's peace, joy, and presence. If your father has passed away or if you have never met him, that's OK. You can still go through the process of forgiving and releasing your dad and blessing him as your earthly father. Regardless of how you feel, forgiving and blessing your father will release him to be the man God created him to be. And you will find as you release him, you will be released and freed as well. Take as long as you need, and use the space provided as you feel led.

Prayer of Blessing for Your Father:

Heavenly Father, the man You gave me as my earthly father is exactly that—a man. He is not perfect, and he has failed in his role as my father many times through the years. Nevertheless, You are the One who gave him to me as my father, and it is Your Word that commands me to honor him so that it will go well with me, no matter what the past may be (Exodus 20:12). I know You do not excuse my father's sin, nor turn a blind eye to the damage it has caused in my life and in the lives of others, but I also know holding on to unforgiveness will only rot my bones and keep my heart locked in a prison of unforgiveness, hate, and self-pity. So today, I choose to forgive my father and turn over the keys to the past, his mistakes and failures, to You. You love my father and are patient toward him, not wishing for him to perish but for him to come to repentance (II Peter 3:9). I ask that You would put this same love for my father in my heart. I bless my father and the role You

gave him to play in my life. I ask that You would draw my father to You with cords of lovingkindness and turn his heart toward willing surrender and obedience to You. And for all the ways my father has honored You, thank You. Thank you for putting a man in my life who was used by You to turn my heart to You, not only by the good things he did, but also by the things he did not do. Every wound in my heart is simply a space created for You to fill. So I bless my father today, and in the future, and bless, most importantly, his relationship with You, his Heavenly Father. It is in the powerful Name of Jesus I pray and ask these things, according to Your will, Amen.

If you feel so led, call your father and read the blessing to him, or send it to him in the form of a letter. But only do so at the direct prompting and in the perfect timing of the Holy Spirit. And only do so if you can bless him in genuine love without trying to inflict guilt or shame. We can trust that God's timing is always perfect—we never want to try to force someone to hear or receive something that they are not ready to hear.

- Last, ask the Lord for a heart of wisdom, understanding, and compassion to walk out this path of forgiveness and healing in the days ahead. Ask Him to speak a Fatherly Blessing of protection and peace over you as His beloved daughter. Thank Him that He has called you His daughter and appointed you to bear fruit in His Name that will last. Again, I have provided a sample prayer for you to use, but feel free to record your own prayer in the space below.

Prayer of Blessing as the Daughter of God:

Heavenly Father, before I am my earthly father's daughter, I am Your daughter. Please give me a heart of wisdom, understanding, and compassion for my earthly father so that I may be free to live as your beloved daughter rather than locked up in a debtor's prison of unforgiveness and shame over the things my earthly father has done or left undone. As Your daughter, I ask that Your protective covering of love and blessing and peace would stand guard over my heart and mind in Christ Jesus (Philippians 4:7) and that You would continue to lead me down a path of healing, forgiveness, and love on a daily basis. I ask that Your Hands and Your Word would give me guidance, wisdom, and direction in the days ahead so that I may fulfill all the purposes You have for me in my generation and become the woman You have created me to be (Acts 13:36). My job is not to worry or fret or figure the future out. Your job is to work out the plans that You have for me, plans for my good, to give me a hope and a future (Jeremiah

29:11). Give me the grace to simply rest in the unfailing love of a good God and a faithful Father. Let me hear a voice behind me saying, "This is the way, walk in it (Isaiah 30:21). No good thing do I withhold from those whose walk is blameless" (Psalm 84:11). In the Mighty Name of Jesus I Pray, Amen.

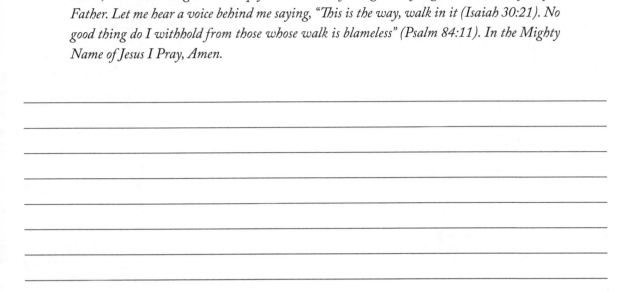

Keep this blessing in a place where you can see it and read it often. Pray its words of life over you regularly so that the truth about your relationship with your Heavenly Father and identity as His daughter is able to replace any of the lies you have believed concerning your identity as a daughter and relationship with your earthly father.

If you want or need to, please feel free to meet with a mentor, counselor, friend, or your spouse and share the blessing you wrote for your earthly father; then ask them to read over you the blessing you wrote for yourself as the daughter of God. In fact, I strongly urge you to do so. It has the potential to be a powerful time promoting healing and change in your heart and will be a marker you can go back to in the days ahead when seasons of struggle come. Agree together that God is going to heal and restore both you and your father in ways you cannot expect or even imagine.

Whew! That was intense, wasn't it? But know that your labor is not in vain; an eternal harvest of righteousness will spring forth from the way you forgive, honor, and bless your father today and in the future.

As we finish today, I want you to end with Jesus' words from John 15:15 on your heart: "No longer do I call you slaves, for the slave does not know what his master is doing; but I have called you friends, for all things that I have heard from My Father I have made known to you." The purpose of any kind of discipline from the Father is friendship with the Father. He does not want us to spend our entire Christian lives with a "master/slave" mentality. He wants us to know and be known as "friends." What a gift! Whether or not friendship and ultimate restoration with your earthly father is possible because of unalterable circumstances or the way he chooses to or not to respond to you as his daughter, friendship with your Heavenly Father *is* possible. The discipline He inflicts and allows lasts only for a moment, but friendship with Him, the ultimate goal of the pain and pruning, is eternal.

DAY FOUR
Inheritance

*I*nheritance. It's a word that does strange things to families, doesn't it? It often draws out feelings of rights, entitlement, greed, worth, birth order, and rank. It is sad to say, but issues of inheritance split families apart more often than they bring them together. Even though it's something we don't think about very often in our day and age except at funerals and on deathbeds, regardless of how often the issue of inheritance crosses our minds, in many parts of the world, and even in many families here in Houston, Texas, inheritance is a word that represents legitimacy as true sons and daughters.

In Biblical times, an inheritance spoke volumes about one's identity socially, fiscally, and emotionally. For the most part, women were not given any amount of inheritance (there is an exception outlined in Numbers 27:1–8). Inheritance in land, possessions, flocks, herds, and any other form of wealth was passed down to sons, not daughters. And if you were a son, birth order was everything. The first-born son received the lion's share of the inheritance, while what was left was divided between the rest of the brothers.

It was not until relatively recently in the pages of history that Western culture began to change in regards to how inheritance was handled and wealth and possessions were divided up equally between siblings, boys and girls.

With all of this in mind, go back to your copy of John 16 from Day One and read it again, highlighter in hand, through the eyes of its original audience. Mark the phrases that turn all of the well-known, well-established rules of inheritance upside down.

According to John 16:7–15, what is the inheritance of those who believe in Christ? Is there any mention of birth order?

Turn to Romans 8:14–16. What kind of spirit, as believers, have we been given (v. 15)?

What do our spirits continually cry out (v. 15)?

What is the Holy Spirit's job in the lives of believers (v. 16)?

Now read Romans 8:17. Paul, the author of Romans, expounds on his definition of children. According to verse 17, what is his definition, and what are the requirements involved in this definition?

Now go back to John 16 and read verses 23–27. According to verses 23–24, as children, what are we given?

And what is the guarantee for receiving?

Verses 25–27 seem rather convoluted and mysterious. But Christ says something very similar early on in His ministry to the woman at the well in John 4:21–24.

Both in John 4:21, 23 and John 16:25, Jesus states, "An hour is coming." According to these verses, what is going to happen in this "coming" hour?

- John 4:21, 23—

- John 16:25—

"An hour is coming," Jesus says, "when you will not have to go to a specific mountain, a specific city, or a specific place to worship the Father. You will worship Him directly without bulls, animal sacrifices, temple or tabernacle, or veil. And you won't worship Him out of slavery or fear but in the spirit of *sonship*! As a son or a daughter approaches his or her father, so you will approach your God. You will receive a warm welcome to intimate Father-child relationship."

As true sons and daughters of the Most High King, what greater inheritance could we ask for or desire? Everything that the Son has is ours. Everything that the Father has access to is ours. Why? And how can this possibly be? What caused the change from the last pages of the Old Testament in the book of Malachi to the first pages of Matthew, Mark, Luke and John?

Remember your reading from Day Two in Hebrews 12:18–24? Turn there once again, and look closely at verses 22–24.

The author of Hebrews lists all of the things that the people of God have come to, and in light of today's lesson, one phrase stands out in particular. What is it, and why is it so significant in light of what we have learned today about inheritance?

According to Hebrews 12, we, meaning the church, the body of Christ of whom Christ is the Head (see Eph. 1:22–23 and Col. 1:18), are all "first-born children" of the living God with first-born privileges, rights, and inheritance. All of this, *all* of this, *all of this*, is given to us because of the blood of Jesus (Hebrews 12:24). He gave up everything, all of His first-born rights and privileges, so that we could become partakers of His inheritance and His glory as we identify with Him in His death and resurrection. I Corinthians 15:20–22 tells us, "But now Christ has been raised from the dead, the first fruits of those who are asleep. For since by a man came death, by a man also came the resurrection of the dead. For as in Adam all die, so also in Christ all shall be made alive."

I shared with you all in last week's study about my battle with rejection. I clearly remember several years ago experiencing a particularly painful incident. I was in my car, crying, feeling worthless and forgotten, when an index card of Scripture on the floorboard caught my eye: "But you have come to Mount Zion and to the city of the living God . . . and to the . . . church of the first-born who are enrolled in heaven." My tears started to flow even faster as a supernatural and deep peace flooded over my head and heart. "Susannah," I heard ever so quietly in my heart, "you are not forgotten or forsaken or looked over or picked over—you are a first-born, *My* first-born, with first-born rights, privileges, and inheritance. It's not something you can ever earn or ever lose—it simply *is* because of The First-Born, Jesus Christ. So be at peace."

I can testify that one simple phrase in Scripture from Hebrews 12:23 did loads of healing in my heart. And the healing still remains; the Spirit of God often brings that verse to mind when I have need of its healing words.

I long for more of the same confidence and understanding for both you and me. But do you know what I long for most of all? For all of us to learn to walk as the first-born sons and daughters that we really are instead of the orphans we pretend to be.

Let that concept sink in for a second; as you think on that, go back and read John 14:18. Write it out word-for-word in the space below:

Although Christ's words in John 14:18 along with other passages in Scripture are very clear about our spiritual adoption, how do you act as an abandoned orphan as opposed to an adopted child with full familial rights and privileges?

How do you think your behavior affects the heart of your Father? How would it affect you if your child lived as an orphan, like he or she had no parents, no home, no protection, no food, no rights, no privileges, no future inheritance, as opposed to the loved, cared, and provided for child he or she really is?

I have news for you: the Father is no different from you or I would be as parents in this situation. In fact, whatever our response of grief or sadness would be, His is infinitely more.

What are the specific ways you need to repent of living like an orphan and in a spirit of fear and slavery as opposed to living in the spirit of adoption you have according to Romans 8:15?

One of the most revolutionary parables Jesus taught was the parable of the Prodigal Son (Luke 15:11–32). You may already be familiar with this well-known illustration of a wayward son's disobedience and a loving Father's redemptive forgiveness, but go ahead and review the details by reading Luke 15:11–32. Whether you are reading for the first time or for the hundredth time, think about how a beloved son who acts like an orphan and lands in the bottom of a pit returns home.

The father declares about this son for all to hear: "Quickly bring out the best robe and put it on him, and put a ring on his hand and sandals on his feet; and bring the fattened calf, kill it, and let us eat and be merry" (Luke 15:22–23).

Pastor and author Joseph Stowell observes that what the father offers his son is:

- ❏ A Robe—a symbol of familial embrace and authentic sonship
- ❏ A Ring—a symbol of authority with the full power to make decisions
- ❏ A Pair of Sandals—a symbol of freedom; only freemen wore shoes in biblical times; only slaves went barefoot[34]

The son essentially admits he deserves a life of punishment, slavery, and fear, and the father replies, "Nonsense! You are my son—you always have been whether you've acted like it or not! Come, live in my house, receive your inheritance, walk in your freedom, use your authority, and embrace your sonship—you belong to me!"

Which aspect of "sonship" do you need most to embrace—the robe, the ring, or the sandals? Why?

How do you plan on doing so while learning to walk in the inheritance that is, by the grace of God, rightfully yours?

If you need to, take a few extra days before proceeding on to the next lesson to really go over in your heart and mind what it means to live as a daughter and not as an orphan. This truth is too important to skip over lightly. Let it sink in and take root in your heart.[35]

Close today in prayer and then take a moment in the section below to write out the things you have received as your inheritance as a true daughter of the King (the Father's embrace, authority, and freedom), and then transfer it to an index card or a piece of paper so that you can take it with you or put it in a place where you will see it often. As you really begin to believe and live out the biblical truths about your identity in Christ, you will be radically changed from the inside out. It is time for you and for me to learn to walk in the inheritance that is truly ours as daughters of the King.

Father, thank You that in my identity as a daughter, I belong to You. I pray that the eyes of my heart would be enlightened to know the hope of Your calling, the riches of the glory of Your inheritance as Your child, and the surpassing greatness of Your power toward those who believe in Your Son, Jesus Christ (Ephesians 1:18–19). Help me to apply the riches of Your love as my Heavenly Father to my life on a moment-by-moment basis. Heal my heart so that I can walk in daily relationship with You, trusting You as my Good Father. In the Name of Jesus I ask all these things, in accordance with Your Word and Your will, Amen.

My inheritance is...

The Promise of Protection

*Y*esterday we had a taste of what it means to walk in the inheritance and identity that is ours as daughters of our Heavenly Father. Today, I want to continue delving into that identity so that we will know how to walk as we wait one day to live in the presence and in the home of our Father God.

Even with the knowledge that we are no longer orphans driven by fear but daughters with first-born rights and privileges abiding in the Father's constant, unconditional love, it is easy to become frustrated and confused when suffering and hardship cross our path.

"Doesn't a good Father always protect?" we wonder. "Doesn't a good Father always keep us out of harm's way?" And the answer, of course, is "Yes." But just because suffering, hardship, or waiting occurs doesn't mean that we have been abandoned or orphaned by our Father and must revert to living according to fear rather than His love.

Turn to your copy of John 17 from Day One and mark or highlight all words and phrases that tell us we are loved and protected by the Father.

In verse 15, when Jesus says, "I do not ask Thee to take them [my disciples] out of the world, but to keep them from the evil one," is He banishing suffering for His followers forever? What do you think He means by this?

Interestingly enough, in verse 18, Jesus asks His Father to send His followers out into the world rather than keeping them from it. Does this seem like a strange prayer request to you? Why do you think Jesus asks the Father this?

Does the Father leave His children unprotected? What does verse 17 tell us?

How could "truth" sanctify or protect us? Read Jesus' words in John 8:31–32. Record verse 32 below:

If before sending us into the world Jesus asks that we be sanctified in the truth, and if we learn from John 8:32 that the truth sets us free, how then does "freedom" act as our protection?

Beloved sisters, the enemy of our souls, known in heaven as the "accuser of the brethren" (Revelation 12:10), loves to accuse and deceive us into thinking that when hardship hits, we become the outcasts and the orphans of God. Nothing could be further from the truth. The very same chapter when Paul tells us that those who have the Spirit of God are no longer orphans but children of God, he writes one of the most beloved passages in all of Scripture:

> Who shall separate us from the love of Christ? Shall tribulation, or distress, or persecution, or famine, or nakedness, or peril, or sword?
>
> Just as it is written, 'For Thy sake we are being put to death all day long; we were considered as sheep to be slaughtered.'
>
> But in all these things we overwhelmingly conquer through Him who loved us. For I am convinced that neither death, nor life, nor angels, nor principalities, nor things present, nor things to come, nor powers, nor height, nor depth, nor any other created thing, shall be able to separate us from the love of God, which is in Christ Jesus our Lord (Romans 8:35–39).

Who can separate us from the love of Christ? Nothing. No one. Not even tribulation, hardship, famine, nakedness, or the sword. In fact, *in* our suffering we conquer, and *in* our tribulation we cry out, "Abba, Father!" And *in* our nakedness we find the shelter of Him who loved us enough to send His only Son on our behalf.

As children of God, what we need to understand is that we are protected from ultimate annihilation and death: this is what Jesus means in John 17:15 when He asks that we would be kept "from the evil one." If we have trusted in Christ as our Savior and Lord, our souls are protected from spending an

eternity in hell with the evil one, separated from God. But we still live in this world. And as Christ's followers, we are not exempt from suffering. Yet even our suffering is redemptive, for it is the very thing that draws us closest to the Father's heart. It enables us to enter in and identify with the One we love the most, Christ Himself.

What does I Peter 1:6–9 tell us about the nature of suffering as a Christian? What does it produce in us?

Suffering proves our faith to be genuine; it proves the love of the Father to be enough; and it proves that Jesus is indeed the greatest treasure of our souls. And our sufferings, according to Paul in Romans 8:18, "are not worthy to be compared with the glory that is to be revealed in us" as true sons and daughters of God.

What good father, by allowing his child to undergo a small bit of suffering for a short amount of time in exchange for receiving unimaginable glory later, would deny his child the experience of delayed gratification?

Are you believing the lie that you do not have a good Father because of a particular trial you are undergoing or because of a season of waiting? If so, what is the trial, and what is the lie you are believing?

Have you allowed your heart to grow hard or cold toward your Heavenly Father in any way because of your trial or wait? If so, how?

I remember after the birth of our first daughter, my husband and I entered into a season of sweet rest, though not physical rest! We were exhausted from 3 a.m. feedings and bouts of crying with a colicky baby. But we were at rest emotionally. For the first time in a long time, I could let my guard down because I wasn't "waiting" anymore. Although many people wait much longer, our journey to have a child took over three years and involved two miscarriages; once I was pregnant, at our twenty-week ultrasound, the doctors found a large mass on Lillian's left lung. For the next four months, we saw doctor after doctor and were monitored very closely for signs of fetal distress. Fetal surgery was

always a possibility hanging over our heads as well as surgery immediately after delivery. It wasn't until Lillian was born and home from the hospital, safe, secure, and perfectly and miraculously healthy that Jason and I could breathe a sigh of relief after months of intense prayer and waiting.

But, surprisingly enough, my heart began to harden toward the Lord and shrink back from His presence. Every time I looked at my child and my husband to enjoy the peace and quiet of my home and Lillian's nursery, I heard whispers of, "What is God going to do next? You think you're safe, you think you're secure, but you're not. Every time God comes close and wants to teach you a lesson about waiting, you are hurt in the process. What He desires is your suffering more than your good."

Every day was a battle not to distance myself from the Lord. I thought I had had enough of His refining processes! Now that my soul was "sanctified" from all that pruning, I was perfectly content to remain at rest and to enjoy a quiet life with my husband and child.

It sounds so ridiculous, doesn't it? But it wasn't until the women's conference at our church several months later that God began to break through the walls of hardness and fear I was so afraid of taking down. Our pastor's wife spoke, and at the end of her talk, sheets of paper were passed around with the words "What is Your Next Step?" printed at the top. She encouraged us to take a few moments to ask the Lord what our next step in walking alongside Him should be. So clearly and so quietly, I heard the words from Psalm 73:28 whispered to my soul: "The nearness of God is your good." Over and over again the Holy Spirit spoke those words to my heart: "The nearness of God is your good, the nearness of God is your good."

I quickly found the Scripture reference in my Bible, and for the first time in months, with true peace flooding my soul, I let the walls of hardness down and my Heavenly Father in. My "Next Step" was allowing the nearness of God to be my *good*. I wasn't sure what particular suffering lay ahead for Jason, Lillian, and me. I didn't know how long it would take to have another baby. When it came down to it, I didn't know anything about my future! But I did know, and still know today, as the Holy Spirit is faithful to remind me on a regular basis, "The nearness of God, Susannah, is your good." God is my good, no matter what lies ahead, because no matter what happens, my reward at the end of the journey is *Him*.

I want you to do a little research on your own for your "Next Step." Look in your Bibles or in your concordance, and find a specific verse in Scripture that speaks directly to the lie you are believing about the character of your Heavenly Father, for the Word of God has divine power to demolish strongholds and to tear down anything we've built up to keep the Father out (II Corinthians 10:3–5). Remember, while we live in this world, our protection against our enemy, the father of lies, is truth; and truth proceeds directly from the Word of God.

Spend as much time as you need finding your verse and your next step, and write them below:

❏ Verse—

❏ Next Step—

I want you to remember something: every time the accuser comes and lies to you, telling you that your Heavenly Father does not care, is not involved, wants your destruction and not your good, does not have an inheritance for you, loves someone else more, or whatever other lie he wants you to believe, speak and pray your verse out loud. If you need to, like you did yesterday with the parable of the Prodigal Son, take an index card and write on the top, "What is Your Next Step?" Then underneath, write out your verse. Use it as a bookmark in your Bible, place it by your bed, or put it by the kitchen sink. But allow that verse which has "divine power to demolish strongholds" (II Corinthians 10:4) to do its work of tearing down all the walls that stand between you and your Father.

The choice is yours. From this point on, you can choose to embrace the real, true goodness of your Heavenly Father as His daughter with all of the rights and privileges that relationship entails; or you can cover your ears, close your eyes, and shut Him out, choosing to live in darkness, fear, isolation, and slavery.

C.S. Lewis writes in his book *The Weight of Glory*:

> In some sense, as dark to the intellect as it is unendurable to the feelings, we can be both banished from the presence of Him who is present everywhere and erased from the knowledge of Him who knows all. We can be left utterly and absolutely *outside*— repelled, exiled, estranged, finally and unspeakably ignored. On the other hand, we can be called in, welcomed, received, acknowledged. We walk every day on the razor edge between these two incredible possibilities.[36]

Sobering, isn't it? But that is what is at stake here as we learn to distinguish between the counterfeit and the real. As His daughter, come inside, take your guard down, forgive your earthly father, and receive your Heavenly Father's peace, nearness of presence, protection, inheritance, and love. For the nearness of God, your Heavenly Father, is your good.

The Fifth Commandment—"Honor your father and your mother, that your days may be _____ in the land which the Lord your God gives you" (Exodus 20:12).

❑ The 5th commandment is the _____ between loving God and loving others:

1. To be in the right relationship with _____, you must be in the right relationship with your _____ _____ (Commandments 6–10).

2. To be in the right relationship with your _____ _____, you must be in right relationship with your _____ _____ (Commandments 1–4).

I. The Father of Lies

A. Who he is

❑ John 8:42–44

B. What he does

❑ He does not come as a dumb _____ to break our _____ but he comes as an expert _____ to break our _____.

C. How he does it

❑ Mothers: give us a sense of _____, self, being

❑ Fathers: call children _____ and _____ of their mothers and send them out into the world with their _____

II. Results of Fatherlessness: The Orphan Spirit

1. _____ - _____

2. _____

❑ Both are the Sin of _____: the spiritual _____ and _____ we experience when we begin to perceive the height to which God has raised us, and we _____ to _____.

❑ "He fears, more than anything else, the demands that are made, as a matter of course, on one who is well." Josef Pieper, *On Hope*[37]

IV. The Remedy for Fatherlessness: The Father of Truth (John 8:54–59)

❑ We see the _____ most vividly through the _____.

❑ Jesus has shown us three things:

A. The _____ of the Father

 1. The Remedy for our Over-Activism: The Hands of the Father Turn Us _____ to securely attach us to Himself.

 2. The Remedy for our Passivity: The Hands of the Father Turn Us _____ and _____ so that we can walk in obedience as the women He called us to be.

"The true center of Rembrandt's painting [*Return of the Prodigal Son*] is the hands of the father. On them all the light is concentrated; on them the eyes of the bystanders are focused; in them mercy becomes flesh; upon them forgiveness, reconciliation, and healing come together, and, through them, not only the tired son, but also the worn-out father find their rest. . . . Gradually over the years I have come to know those hands. They have held me from the hour of my conception, they welcomed me at my birth, held me close to my mother's breast, fed me, and kept me warm. They have protected me in times of danger and concealed me in times of grief. They have waved me good-bye and always welcomed me back. Those hands are God's hands."

Henri Nouwen, *The Return of the Prodigal Son: A Story of Homecoming*[38]

B. The _____ of the Father (John 10:27–30)

 ❑ We can _____ many voices talking at the same time, but we can really only _____ to _____.

 ❑ Learning to Listen Takes:

 1. _____

 2. _____ and a _____

 3. _____

 4. _____

C. The _____ of the Father (John 20:17–18)

 ❑ The Good News of the Gospel is this: We are _____ No Longer

 ❑ Three Things the Gospel Gives Us:

 1. _____ from _____ our _____

 2. _____ from _____ our _____

 3. _____: The Secure Identity as His _____.

 ❑ The Sign and Seal on our Hearts as His Daughters is His _____ (Romans 8:11–16).

WEEK THREE

Waiting for a Wedding Day

Looking for Identity

From the very first pages of Genesis to the closing chapters of Revelation, Scripture is full of imagery centered around a wedding, a wonderful feast, and a beautiful bride and groom. The nation of Israel is known throughout the Old Testament as the God of Israel's bride (Hosea 2:16, 19), and the church is known throughout the New Testament as the bride of Christ (Revelation 19:7). The Lord God calls Himself His people's "Husband" (Isaiah 54:5), and Christ is identified as the church's "Groom" (Ephesians 5:23–27).

Not all little girls grow up waiting for or wanting a wedding day; some are more interested in athletics, academics, careers, missions, or other various pursuits or interests. But when it comes to the pages of Scripture, we can be assured, no matter our backgrounds or differing stories, we were *all* created with a deep desire to wait for a wedding day with our Heavenly Groom. As the people of God, created by Him and for Him, the wait and the longing for a wedding day is built into our spiritual DNA. The problem is sometimes we become so entangled with marital longings and wedding details in the here and now, or we are so wounded or bruised from the pain of our pasts, that we have shut down to the idea of marriage altogether, and we forget we will never find complete satisfaction or healing, single or married, until the wedding day and marriage that is to come (Revelation 19:7–9).

If you are a new believer in Christ, or even if you have been a believer for a long time but have no idea what heavenly wedding day I am referring to, rest assured, we will get to that. But for now, let's start with what the longing and the wait for a wedding day encompasses and symbolizes in the human heart.

To tell the story of the longing, waiting heart, I want to look at an unlikely wedding day character; it isn't Sarah or Rebekah or Rachel. In fact, it isn't a woman at all! I want us to look at the heart of a man who spent most of his life wrestling with and waiting for worth, value, love, and companionship. Meet Jacob, supplanter and deceiver of men, yet called the Israel of God.

To understand Jacob's story from the very beginning, turn to Genesis 25 and read verses 19–28.

Describe the birth of the twins: what was life like in the womb for Jacob, how did Jacob come out of the womb, and what does the name "Jacob" mean?

- Life *in* the womb—

- Coming *out* of the womb—

<div style="float:left">

Ya'aqob—
"heel-catcher (i.e., supplanter)"[39]

</div>

- The meaning of "Jacob" (Look in your concordance for this Hebrew word, #3290, or copy the definition from the margin)—

Verse 28 is perhaps the key to unlocking Jacob's entire life. Who loved Jacob? And who loved Esau, his twin brother?

Stop right here. In just nine short verses, we are given an accurate description of Jacob's inner wrestlings and emotions. From the very beginning, even in the womb, Jacob struggled. He wrestled with everything and everyone: with his brother, with his position in life as the youngest, and with the desire for his father's love.

Can you identify with Jacob on any of the things with which he wrestled? Have you struggled with difficult relationships? With wanting a parent's love? With a favored sibling? With your identity and place in life as "less than," "lacking," "smallest," or "youngest"? If so, how?

Has your wrestling, as it did with Jacob, left a vacuum in your heart that waits and longs to be filled? If so, how have you tried to fill it?

Jacob's "vacuum," so to speak, was the lack of a father's blessing and love, and he looked everywhere and was willing to do just about anything to fill it.

Turn a couple of pages in your Bible to Genesis 27:8–29.

There are many elements of the human heart we could examine here, but I want us to look at one in particular. To give you a little background before you read, Isaac, Jacob's father, is nearing death, and he knows it is time to pass on the patriarchal blessing to his eldest son, Esau. In ancient times, this was known as the Law of Primogeniture, something we talked a little bit about in "Waiting for a Father." Rebekah eavesdrops as Isaac tells Esau to prepare himself to receive his blessing by going out to hunt, kill, and prepare wild game for his father, so Rebekah springs into manipulative action (remember, Esau is Isaac's favorite, but Jacob is hers).

Go ahead and read the outcome of events in Genesis 27:8–29. The dialogue opens with Rebekah giving instructions to Jacob.

What specific things does Jacob do to deceive his father into thinking that he is Esau?

This may seem like an obvious question, but when Isaac blesses Jacob, who does he think he is blessing?

Now, before we are too quick to jump onto Jacob for what he did, ask yourself this question: have you ever been so desperate for a blessing or for approval that you have "dressed up" as someone other than who you really are to try to get it? Maybe it was in high school, college, or maybe it's as recent as the present-day in your Bible study class, office setting, neighborhood, or group of moms at your child's school. If so, explain below:

How did it, or does it, make you feel once you received this "dressed up" affirmation or blessing? Fulfilled or empty? Satisfied or still searching? Phony and fake, or real? Explain below:

As Tim Keller explains in his sermon series The Gospel According to Jacob, deep down we all know that a "blessing" received under the guise as someone else is no blessing at all. It still leaves us searching with a vacuum-shaped hole in our hearts even bigger than before.[40]

In Jacob's case, the final outcome of the blessing was real. Isaac's words were to ring truer than either ever realized, but Jacob's heart was not satisfied. He was still empty, alone, and more desperate for approval than before. Yes, he had received a real blessing with real and powerful promises, but he had received them as "Esau," not Jacob. How do I know Jacob was still unsatisfied?

Read the words of the prophet Hosea below, written under the inspiration of the Holy Spirit centuries after the life of Jacob:

> (3) In the womb he [Jacob] took his brother by the heel,
> And in his maturity he
> contended with God.
> (4) Yes, he wrestled with the angel and prevailed;
> He wept and sought His favor.
> He found Him at Bethel,
> And there He spoke with us,
> (5) Even the Lord, the God of hosts;
> The Lord is His name.
> (6) Therefore, return to your God,
> Observe kindness and justice,
> and wait for your God continually.
>
> Hosea 12:3–6

Circle the words in the verses above that show Jacob's search and struggle for blessing and approval.

Now, in verses 4 and 5, underline whose favor Jacob was really seeking.

Finally, draw a box around the place where Jacob found favor.

In verse 6, what are the prophet Hosea's instructions to God's people as they, like Jacob, wait for blessing, favor, and approval?

Waiting for approval, favor, and for someone to come along and bless us as we really are, for who we really are, is the cry of every human heart. In fact, I believe it is at the core of every wait, particularly the wait for a wedding day.

I don't know where you are in your wait for a wedding day. I don't know if you are single and waiting for a husband or content right where God has you. Maybe you are married and wonderfully satisfied or still feel desperately alone, locked into a loveless marriage. Or maybe, like most, you are somewhere in the middle.

Although I don't know the particulars of your situation, I do know this: God sees your wait. He sees your tears, your weeping, your searching, your struggle, and your loneliness. And He says, just as He said to His people through the life of Jacob, "Wait for Me. Return to Me. Observe justice and kindness and love Me with all of your heart in your wait, and I *will be* found by you. I will show Myself to you, just as I showed Myself to Jacob."

As Genesis 27 ends and chapter 28 begins, we find Esau in a rage over his stolen blessing, plotting his brother's murder. So Jacob is sent away to search for a wife among his mother's people. The journey is so long and arduous that Jacob's mother will pass away before he ever has the opportunity to see her again. We can only assume that Jacob senses the finality in saying his good-byes, and as he leaves to search for a wife and a wedding day, his only belongings are the clothes on his back, a stolen blessing, and a history or wake of broken relationships. As Hosea says, Jacob leaves searching for God, a wife, and a blessing with many, many tears.

Where are you in your wait for a wedding day? Are you, like Jacob, searching with many, many tears? If so, why?

Wherever you are in your wait, can you take comfort from the words of Hosea? Can you commit to waiting on God in kindness and justice, looking to love the Lord and meet the needs of others, even amidst many tears? Write your heart's cry and prayer of commitment below:

Take comfort in the fact that as you seek Jesus Christ, your true Bridegroom, He *will be* found by you as you seek Him with all of your heart, just as He was found by Jacob.

Found by God

A s we pick up in the life of Jacob where we left off yesterday, look back at Hosea chapter 12.

Where does Hosea tell us Jacob found God?

Circle one: Bethel Paddan-aram Palestine Bermuda

Interestingly enough, there are two separate occasions in Genesis where it is recorded that God revealed Himself to Jacob in Bethel. Today, I want to look at the first occasion, found in Genesis 28, for it is the stopping point in Jacob's journey as he leaves his homeland to find a wife.

But before we go any further with Jacob, I want to let you know how much God cares about your wait and your journey for a wedding day no matter what stage of life you are in. I really prayed and puzzled over this week of waiting—I didn't want to give you the same old pep talk with the same old answers or ask you the same old questions. In my wildest dreams, I never thought I would use the life of Jacob to talk about waiting for a wedding day. But in answer to my prayers, it was as if, quite literally, God Himself took over my pen and let me know He was writing this week Himself. He *hears* your cries, He *knows* your heart, and His response over and over again is, "Wait, Beloved, wait. I will be found by you as Lover, Husband, Groom, and Friend, and you will not be disappointed."

With that being said, let's go back to Jacob. Turn to Genesis 28, and let's continue with him on his journey to Paddan-aram, his mother's homeland, to find a wife and to seek a blessing. Read Genesis 28:10–11.

In verse 11, when Jacob is ready to sleep, what object does he place under his head for a pillow?

Practically speaking, what do you think this tells us about Jacob at this stage in his journey?

I don't know about you, but if I was forced to depart on a long journey and sleep outside, a stone would be the last object in the world I would use as a pillow! Tim Keller notes what this tells us about Jacob is that he probably left in such a low and hurried state, he literally had nothing, not even an extra tunic to fold up and place beneath his head.[41] This also tells us that Jacob was not traveling through forests or pastures where moss or grass was readily available for use. Rather, Jacob was journeying through desert wastelands that offered only rocks for pillows and stones for bread.

In both a very literal and figurative sense, Jacob is in the wilderness. And all this time, he is on his way to search for a wife. Can you relate? Do you think that most people's search for a spouse stems from wilderness areas in their hearts and lives? Explain below:

What about in your own life? Are you searching, or did you search, for a spouse out of the vacuum of a parental blessing or from a stony wilderness area spiritually, emotionally, or physically? If so, how?

What were the effects (and may still be the effects) of your wilderness searching?

If you are in despair at this point in the lesson, please don't be! We *all* search for fulfillment out of the stony wastelands of our hearts; that's why we are all in need of a Savior! So the Lord has good news for us today, no matter where we are in the wilderness journey. He is wanting and able to redeem *all* that has been lost and to turn every wilderness area into a place of refreshment and redemption.

Continue reading in Genesis 28:12–22.

From the description given to us in verses 12–13, draw in the space below a picture of what Jacob sees in his dream (don't forget to include where the Lord is standing—and don't worry, stick figures are fine):

How does the Lord identify Himself to Jacob (verse 13)?

There are three different parts to the blessing the Lord gives Jacob. What are they?

1. (v. 13)—

2. (v. 14)—

3. (v. 15)—

In verse 17, when Jacob wakes from his dream, he knows he has been in the presence of the Lord. How does he describe the place where he laid his head? Fill in the blanks:

"How _____ is this place! This is none other than the _____ of _____, and this is the _____ of _____."

In verse 19, Jacob gives the place where he encounters God a name. What is that name?

Beyth-
El—"house of
God"[42]

Look in your concordance at what the name "Bethel" means (#1008), or copy its definition from the margin in the space below:

Before we begin putting the pieces together of Jacob's dream, turn with me to John 1:45–51. In the first chapter of John, Jesus is in the process of putting together His group of twelve disciples, and John gives his readers the details of how Jesus called the disciple Nathanael.

What can you surmise about the character of Nathanael from this passage?

As noted by Timothy Keller is his sermon series on the life of Jacob, in verse 51, Jesus is clearly making a reference to Jacob's dream in Genesis 28.[43] Look back at the diagram you drew. On what object are the angels of God ascending and descending?

Now look at John 1:51. On what are the angels of God ascending and descending? Fill in the blanks:

"on the _____ of _____."

What is Jesus saying about Himself? For further confirmation, read John 10:1–10, and write your answer below:

We, like Jacob, are at the bottom of the ladder, heads on stones, journeying through wilderness wastelands. So that we might ascend from the wilderness of our own sin, loneliness, and pain, Jesus laid down His life on His own accord so that we might ascend into the Father's presence and dwell in the very House of God. As Keller notes from this passage, just as He revealed to Jacob, then later to Nathanael, and now to us, *Jesus* is the door, *Jesus* is the gate, and *Jesus* is the ladder and our only access to heaven. No one comes to the Father but through Him (John 14:6).[44]

But perhaps the most amazing part of Jacob's dream and blessing is *who* God chooses to give it to. It wasn't Abraham or Moses or David, or any of the other Godly men throughout Biblical history who quickly come to mind. It was Jacob—swindling, deceiving, running, hurting, lost and lonely Jacob. And it was in his very place of lonely wilderness wandering that Jacob was given a glimpse into heaven and a picture of the pre-incarnate Christ and the saving work He would accomplish one day through the cross and resurrection.

Look back at the three different components of the blessing God gives Jacob in verses 13–15. During one of the most lonely, painful times of his life, Jacob is given a blessing from God, his Heavenly Father, just as he is, with no strings attached. He is given the blessing of security and inheritance in land, the most valuable of all Middle Eastern commodities. He is given the blessing of abundant fruitfulness and multiplication, long before he is ever given a wife. He is given the blessing of the assurance of the presence and protection of the Lord and a place in the family and House of God, at the precise moment in his life when he feels as if he is totally alone. Finally, he is also given a picture of complete and total salvation based on the work of Christ alone, even if he didn't understand it all.

Nothing about Jacob's circumstances or identity had changed between the time he laid his head on his stone pillow to the time he woke up. Yet the overwhelming realization of the goodness of who God was and what He had promised had changed. It was not *Jacob* who would save himself; it was God. It was not because of *Jacob* that he would receive an inheritance or a blessing; it was because of God. It would not be *Jacob's* efforts that would secure a family for himself; it would be God's. And all of a sudden, Jacob's wandering became purposeful, and his search for identity was rooted in the reality that the very person and presence of God was with him.

Dear sister, I can tell you with confidence that every part of Jacob's dream and blessing is yours through the person, promise, and provision of Jesus Christ. II Corinthians 1:19–22 (ESV) tells us,

> For the Son of God, Jesus Christ, whom we proclaimed among you . . . was not Yes and No, but in Him it is always Yes. For all the promises of God find their Yes in Him. . . . And it is God who establishes us with you in Christ, and has anointed us, and who has also put His seal on us and given us His Spirit in our hearts as a guarantee.

Can you relate to Jacob in any way? Is there a part of Jacob's blessing that you need in the midst of your wilderness wandering? Do you need extra assurance of God's presence, promises, and provision? If so, use the space below to tell the Lord exactly what you need:

Now stop right now and thank God that the very provision of which you have desperate need is yours through the person, promise, and provision of Christ. Since He has placed the Holy Spirit in your heart as a guarantee of that promise, ask that His Spirit would give you tangible reminders today and throughout the week that He is meeting your each and every need.

Look back at Jacob's response to his dream and God's presence in verse 17: "How awesome is this place!" That word for "awesome" is *yare*, a verb meaning "to fear, to respect, to reverence . . . to fear God."[45] Jacob's response to God wasn't a thought, word, resolution; it was a *verb*, an action, something he actually did to show the Lord he was listening and paying attention. Let's close today by looking at what Jacob *did* to show that although his circumstances had not changed, his understanding of who God is had.

In verse 18, Jacob takes the stone that was a pillow under his head and does two specific things with it. What does he do?

1.

2.

After building a memorial to the Lord and giving the place a name, in verses 20–22, Jacob makes a vow to the Lord. In verses 21–22, he promises the Lord three things if the Lord faithfully carries him through his journey. What are those three things?

1.

2.

3.

My junior year of college, while going through a very lonely season of life, my grandmother sent me a card with these words on the outside cover: "Loneliness: Our friend when it forces us to enjoy the fellowship of God as much as it would the fellowship of others." I do not know the person who penned those words, but I owe them a great debt. For through those words, my perspective on my season of loneliness and emptiness changed, and where I once craved the fellowship of people, I began hungering for and turning to the presence of God. Because of my lack of human fellowship, I was able to process and internalize the promises and presence of God in such a way that I am still reaping the harvest from that spiritually fruitful time.

Similarly, the stone that was a pillow representing Jacob's loneliness and emptiness in life became a pillar and a testimony to the presence and promises of God in his life. In making that stone a pillar and pouring oil on its top, Jacob was consecrating the stone and setting it apart as holy, marking it as the cornerstone and foundation of his life.[46]

There is another stone that Scripture talks about that is consecrated and set apart as holy:

> Therefore thus says the Lord God, "Behold, I am laying in Zion a stone, a tested stone, a costly cornerstone for the foundation, firmly placed. He who believes in it will not be disturbed" (Isaiah 28:16).

The stone which the builders rejected has become the chief corner stone. This is the Lord's doing; it is marvelous in our eyes (Psalm 118:22–23).

The stone throughout Scripture that we are commanded to make our foundation, our chief cornerstone, is none other than Christ Himself, the Anointed One (I Peter 2:4–6). He is the stone that many have rejected (Psalm 118:22), but for those who choose to build their lives upon Him, He is peace, security, provision, abundant blessing, and life.

My friend, the stone in your life wet with the tears from your wilderness journey in your wait for a spouse, your bitterness over an unfaithful spouse, or your pain and hurt over a spouse who does not treat you as he is called to do, can cause you to stumble over resentment, bitterness, unforgiveness, pain, and heartache. But through Christ, that same stone can become your cornerstone, the very place where the Messiah, the Anointed One, meets you with His promises, His provision, and His presence, and transforms your wilderness into a fruitful place of intimacy, peace, and expectation.

While your circumstances may not change, like Jacob, your perspective can. Instead of focusing on your loneliness, you can lift your gaze to the very House of God, knowing your place is secure within the family of God. And like Jacob, the stone that once testified to your loneliness can become a pillar and a testimony to your anointed place in God's family.

Is what you are learning about Jacob's dream stirring you? Is it evoking a response of worship and the fear of the Lord? Then, my friend, *act upon it*. Don't miss this opportunity to actively respond in thought, word, and deed to God Most High.

What is the Holy Spirit inviting you to do? Perhaps He is moving you to create a pillar or a memorial in your garden or your kitchen as a reminder of the provision and faithfulness of God. Maybe He is moving you to change your perspective on your loneliness. Rather than seeing it as a place of barrenness, He is inviting you to see it as a place of great fruitfulness in your relationship with Him. Maybe you are to memorize a certain Scripture, compose or sing a song, or instead of focusing on your loneliness, reach out to a specific ministry and begin to find your place in the House of God and minister to those who need to hear what God has done and is doing in your life. But whatever you choose to do, commit to waiting on the Lord in fear, reverence, and hope for the rest of your journey. Commemorate this season of waiting on the Lord in the space below, and write about the specific action you are going to take:

I know that today's homework was long, but I pray the Scripture you read and the promises they contain begin to transform your season of loneliness into a place of well-watered hope, provision, and joy. If you only remember one thing from today, remember this: what Jesus told Nathanael two thousand years ago, He tells you and me: "Nathanael, or _____ (fill your name in the blank), if you will come and follow Me, Jacob's dream and Jacob's blessing is yours. Just as you are. No strings attached. So no more deceit. No more guile. No more wrestling or striving or jockeying for position or pretending to be someone you are not. I am in the business of making a table for you in the very middle of the wilderness as you wait for a spouse, a family, a home, or for whatever it is that you think you need. And access to My house, My table, and My family is always . . . *yours*."

As you wait for a spouse and for a future wedding day, know that Jesus, Jacob's ladder, *is more than enough*. Are you up for the journey? Are you ready, like Nathanael, to behold "the Son of God, the King of Israel" (John 1:49)? He has so much in store for you, just as you are, and for all true Jacobs and Nathanaels as they choose to follow Him. May God bless you in your journey.

DAY THREE
Still Wrestling

Wrestling. We all wrestle, don't we? We may be tempted to think wrestling is only for guys wearing funny-looking suits and masks who square off with opponents on mats in a high school gym or in a professional ring. But don't be fooled. Wrestling occurs on a daily basis in all of us. We wrestle with our inmost desires, hopes, fears, longings, and dreams. We wrestle with others in search for our identity. And we wrestle with the questions, "Is God good?" and "Can I trust Him?"

With this in mind, turn with me to Genesis 32.

When we left Jacob yesterday, he was alone in the wilderness on his way to his mother's homeland, Paddan-aram, to look for a wife. While the natural place to pick up today would be when Jacob actually meets and finds his wife, we are going to save that passage for our lesson when we meet together. If you want to read about the amazing and unusual encounter of Jacob with Rachel, by all means, go ahead and read Genesis 29–31; it is well worth your time! But if you would prefer a summary of Jacob's marital situation, I will do my best to give it to you here. In just three short chapters, Jacob meets Laban, his mother's brother, and Laban's two daughters, Rachel and Leah. Jacob immediately falls in love with Rachel, the younger daughter, but he is tricked by Laban into marrying Leah, the oldest daughter. He eventually marries Rachel as well, but only after working for Laban as a shepherd for fourteen long years. Through his two wives, Jacob has eleven sons and one daughter. He also accumulates much wealth while tending to Laban's livestock, and after many years of living in a strange land away from immediate family, Jacob decides it's time to return home.

There's just one small problem . . . Esau. For Jacob, the journey home means having to face the twin brother he so cunningly deceived. Last time Jacob was home, Esau was nursing a murderous grudge over his stolen blessing and was reported to have said something like, "Once our father, Isaac, is dead, I can't wait to kill Jacob" (see Genesis 27:41–42). To say the least, Jacob and Esau didn't depart on exactly friendly terms.

In light of all of this background information, read Genesis 32:1–12.

How does this passage tell us Jacob is feeling about his upcoming encounter with his brother?

How does it appear that Esau is feeling?

Jacob turns to God in his distress and cries out for mercy. What does he ask God to do, and why does he ask God to do it (vv. 11–12)?

Let's stop right here for a moment. Do you think Jacob ever really overcame his fear of his brother? Do you get the feeling that after all these years of separation, although God has blessed Jacob with family and material wealth, the stench of fear, a stolen blessing, and a brother nursing a murderous grudge has lingered in his nostrils and kept him up at night, tossing and turning and . . . wrestling?

Can you relate to Jacob? Perhaps God has blessed you in more ways than you can count, and many of your desires and dreams have been fulfilled. Perhaps you are married and have children, or are single and have a great job, ministry, and friends. Perhaps you are growing, prospering, and multiplying, yet you still don't feel comfortable in your own skin because of unresolved issues in your past.

Is there an "Esau" in your life that lurks behind every corner? A person or a situation that if you were forced to confront would cause you to tremble in terror? If so, who or what is it?

My friend, we can be married, prosperous, successful, have a house full of children, and still be miserable on the inside. Marriage, for Jacob, did not take away his uneasiness or fear, just like it does not for you and me. Please don't misunderstand what I am saying. I love my husband and children more than words can say, but ultimately they do not satisfy the aches, fill the gaps, or heal the wounds from a broken past. This can only mean one thing: we must be created to be filled and healed by something or someone else.

C.S. Lewis says it this way in his book *Mere Christianity*:

> Most people, if they had really learned to look into their own hearts, would know that they do want, and want acutely, something that cannot be had in this world. There are all sorts of things in this world that offer to give it to you, but they never quite keep their promise. The longings which arise in us when we first fall in love, or first think of some foreign country, or first take up some subject that excites us, are longings which no marriage, no travel, no learning, can really satisfy.... The wife may be a good wife, and the hotels and scenery may have been excellent, and chemistry may be a very interesting job: but something has evaded us.[47]

We too, like Jacob, are waiting for something more—something more than the best marriage or most beautiful earthly wedding day celebration can provide.

Let's keep reading to find out what it is and how God answered Jacob's cries. Continue reading Genesis 32:13–23. What is Jacob's scheme to try to pacify Esau?

According to verses 22–23, where does he send his family?

Why do you think he does this?

Now read Genesis 32:24–32. Read slowly, paying attention to the detail embedded in these nine verses.

Fill in the blanks from verse 24:

"Then Jacob was left _____, and a man _____ with him until _____."

According to Jacob, who is this man he wrestled with throughout the night (v. 30)?

In Genesis 32:11, Jacob asks God to "deliver him" from the hand of Esau, so how in the world is a wrestling match an answer to this prayer? Turn to Genesis 48:15–16. At the end of his life, Jacob is giving a blessing to his son Joseph along with Joseph's two sons. In verse 16, what does Jacob tell us about the angel with whom he wrestled?

Why and how do you think redemption from evil occurred for Jacob in this wrestling match?

Now look again at Genesis 32:26. Notice that by daybreak, Jacob seems to know he is wrestling with God, for what does he tell this man? Fill in the blank:

"'I will not let you go unless you _____ me.'"

| barak—"to bend the knee, to kneel down; to bless, praise"[48] |

Look in your concordance for the Hebrew word and definition for "bless" (#1288) Jacob uses here, or copy the definition from the margin in the space below:

Now why in the world would Jacob ask for covenantal blessing from God when he has already received it (remember his dream at Bethel)? To help us answer that question, notice something else: before He blesses him, what does the "Wrestling Man" ask Jacob in verse 27?

Why would an omniscient, all-knowing God ask Jacob his name? Don't you think He already knows it? Think back to the first day of homework from this week. What does the name "Jacob" mean?

No true blessing, peace, reward, or satisfaction can ever occur in our lives until we admit exactly who we are or what we are before the Face of God. Jacob had to look at God eye-to-eye and say, "I am *ya-qob*—deceiver, heel-grabber, and supplanter," and *then* God blessed him and changed his name.

Keller makes the point in his sermon "The Fight of Your Life" that God left Jacob no room to dress up and pretend to be someone other than who he really was in order to receive a blessing, for if He had, God knew it wouldn't have been a blessing at all.[49]

And like He did with Jacob, in response to all of our prayers of "Deliver me," (v. 11), God's first answer is to always deliver us from ourselves:

1. He attacks us and forces us to let go of our idols (which in Jacob's case was identity and approval from men rather than God).

2. He wounds us with wounds so deep sometimes we wonder if we will ever be able to survive the pain.

3. He forces us to admit who we are.

4. He changes our name and gives us a new identity and secure blessing when we hold on and refuse to let go.

If you are wrestling with God in this season of life, *do not let go.* Because, as theologian Gordon Wenham points out in his commentary on Genesis, like Jacob, if you survive meeting with God, you will survive meeting with Esau. As Jacob walks away from his wrestling match, he says, "I have seen God face to face, yet my life was preserved" (v. 30). In other words, "What can man do to me?"[50]

Turn to Psalm 32:3–7. How do the truths expressed in this Psalm reflect Jacob's experience in Genesis 32?

Redemption offers no short cuts around repentance. There is no way to true blessing except on the road of total transparency.

But that is because brutal honesty before God is, psychologically speaking, the safest place to be. Satan, the enemy of our souls, wants us to keep our sin hidden in the dark as we cower in guilt, fear, and shame. But God wants us to bring our sin out into *the light*, for once we do that, the power of that sin is broken, and that is when true healing and restoration begins.

Look once again at Psalm 32:3–7. What happens to the Psalmist in verses 3–4 when he keeps his sin hidden?

In verse 5, when he chooses to acknowledge his sin before the Lord and bring everything out into the open, what does the Lord do?

In verse 7, after David's confession of sin, what does the Lord become?

Here's the surprise in all of this: when we choose to make ourselves our own hiding place, we waste away—physically and spiritually speaking. But when we choose to confess our sin and bring it out into the light before the Face of God, *He* becomes our hiding place, and He sings over us songs of deliverance. In his excellent book *Beyond Identity*, Dick Keyes writes, "By no longer hiding his sin from God (v. 5) [David] was able to find a *hiding place* in God (v. 7). When he hid his sin from God, God seemed an enemy. When he acknowledged his sin, God became the one in whom he could hide from the trouble in the world."[51]

We are a "coffee-talk" culture, and it is easy at times to talk to others about our sin but tough to get quiet enough and honest enough to confess our sin before God. What I am asking you to do today, and from here on out, is to first and foremost be totally transparent before the very face of *God*. There will be moments when He uses your transparency to bless, encourage, and strengthen a fellow traveler, and it is usually a ways down the road after your own confession, repentance, and healing has occurred, but for the most part, your search, struggle, and your transformation will be an intimate exercise with Him alone.

In his short, simple, and profound book *The Way of the Heart*, Henri Nouwen writes,

> Silence guards the inner heat of emotions. This inner heat is the life of the Holy Spirit within us. Thus, silence is the discipline by which the inner fire of God is tended and kept alive.
>
> Diadochus of Photiki offers us a very concrete image: "When the door of the steambath is continually left open, the heat inside rapidly escapes through it; likewise the soul, in its desire to say many things, dissipates its remembrance of God through the door of speech, even though everything it says may be good. . . . Timely silence, then, is precious, for it is nothing less than the mother of the wisest thoughts."[52]

Let's close today by asking a few more questions.

What is the blessing God gives Jacob after asking him his name?

What is Jacob's new name?

As the sun rises upon Jacob, now named "Israel," and day breaks, Israel walks away from his wrestling match with a limp. Why? What did God do to Jacob?

Why do you think He did this? Read Hosea 6:1–3 and write your answer below:

Jacob enters this wrestling match alone as a wretched, sinful, cowardly man, but, as Wenham points out, he emerges from the fight as the victorious, conquering, triumphant nation of Israel.[53] Through this we see that God's blessing to Jacob was twofold: on an individual level, Jacob had striven and wrestled with men his whole life, but now he had striven with God and prevailed. It was a promise to Jacob he would also prevail with Esau on the other side of the river. But the blessing also became a promise and national identity to the nation of Israel, a small, struggling nation whose ultimate triumph would be to give us the Messiah who would change and save the world. Yet Jacob received his new name and blessing as *Jacob*, total sinner that he was. And the limp he received was a perpetual reminder that he received his blessing because of *grace*, not his own works. He did nothing to earn it, therefore he could do nothing to lose it. He would never have to wrestle again, either, to maintain it. Wenham writes, "Jacob is no longer the strong victorious controller of the divine but Israel who is totally dependent on God's grace and lame."[54]

Perhaps some of you are asking (and you SHOULD be asking), "What kind of God is this who attacks us with one hand and blesses us with the other? What kind of God wrestles His own people in the dark and wounds them so they walk away with a limp?"

The answer is simple, even if it's not easy: it is the kind of God who loves us enough to save us from ourselves, our idols, and from all lesser things that do not satisfy. When we wrestle with an idol, we are left empty-handed and unsatisfied, wounded and bleeding with no blessing to show for it and no one to blame but our sinful selves. But when we wrestle with God, He knows just what to withhold, just what kind of trial to give us so that we die to ourselves, surrender to His greatness, and receive true, lasting blessing from His Hand.

Perhaps you already walk with a limp. Perhaps it is your singleness, or perhaps it is your marriage. Have you recognized it as a gift of grace, a holy wound, and the very touch of God? Have you submitted to the fact that wedding day or no wedding day, good marriage or tough marriage, there is only one Groom who satisfies for those who hold on for true, lasting blessing from Him?

Like Jacob, can you see your wrestling match as your redemption? Remember that in all of our prayers of "Deliver me," God's first answer is to always deliver us from ourselves. Stop where you are, admit who you are, receive the true name and the blessing God desires to give you, and walk confidently with your limp, knowing that you have personally encountered the only God who saves.

In order to help us do that, let's close today in prayer, using Jacob's experience as a model for our own. Is there unconfessed sin, a hidden identity, or an idol in your life hindering you from receiving true blessing from God? Take a few moments to consider and reflect. Once you are ready, write a prayer of repentance below, confessing your sin, your idol(s), and who you *really* are, not who you pretend to be, before the face of God, and then close with receiving your new identity before the only God who saves.

Lord, I have been wrestling my whole life—wrestling with myself, my family, my friends, and others in an attempt to gain an identity and a blessing apart from You. I repent, Lord, for wrestling with and making an idol(s) of worship out of:

I confess that my idols and my wrestling have never brought me lasting joy or satisfaction but only pain and heartache. Who I really am instead of who I so often pretend to be is:

Today, Lord, I release my grip from wrestling with empty idols and turn to fully embrace You. Only You have the Words of Life that will make me whole, and only You can tell me who I really am. Give me ears to hear, eyes to see, and a heart to embrace my true identity found in Jesus Christ. Today, in accordance with Your Holy Word, instead of shame, fear, guilt, wrestling, and striving, the identity and the name You have given me is:

I ask for Your help to begin to walk in the confidence of this new identity, even if it means walking with a limp. In the Name of Jesus, in accordance with Your will and Your Word, I ask all these things, Amen.

The First and the Last

Jacob, now named Israel, has taught us well. But I think there is one more lesson we can learn from his life as we wait for our wedding day, and, more specifically, for our Groom.

Hebrews 11, the "Hall of Faith" chapter in the New Testament, highlights certain events in the lives of many Old Testaments saints, and mentions Jacob in only one verse. Hebrews 11:21 reads, "By faith, Jacob, as he was dying, blessed each of the sons of Joseph, and worshiped, leaning on the top of his staff." Out of all the events that occur in Jacob's lifetime, why did the author of Hebrews choose to mention this one as the crowning achievement of Jacob's life of faith? What is so significant about the way Jacob blesses Joseph's sons?

Turn to Genesis 48 (of which we read a portion yesterday) to read about one of the last recorded events of Israel's life.

I think the question that burns in my mind is, "Did Jacob get it?" After wrestling with God face-to-face and finally receiving true, satisfying blessing, did Israel live up to his name change? As Keller points out in his sermon on this event in Jacob's life, "The Meaning of Free Grace," did he finally cease his "wrestling" and allow the God of Abraham and Isaac to be "enough?"[55]

Let's read Genesis 48:1–2, 8–19 to find out. (Keep in mind that Joseph is one of Jacob's 12 sons.)

Does this remind you of a similar scene in Genesis that occurs between Jacob and his father, Isaac? Turn back to Genesis 27:18-23 (from Day One of your homework) to refresh your memory. Record below how the events in Genesis 27 and Genesis 48 are alike:

Now describe how the events from these two chapters are different, specifically comparing and contrasting the actions of Jacob versus Isaac.

Isaac blesses his youngest son, Jacob, over his oldest son, Esau, but his actions are not intentional. What does Genesis 48:17–19 tell us is so unusual about the way Jacob intentionally blesses Manasseh and Ephraim?

Now look back at Hebrews 11. What does Hebrews 11:21 say that Jacob did as he blessed Joseph's sons and leaned on the top of his staff?

How was this an act of worship? By blessing the youngest son over the oldest, how has Jacob shown us he has stopped wrestling with God and started worshiping Him instead?

Think back to our discussion about inheritance in the homework from "Waiting for a Father." This world has a pretty clear system of showing who is first and who is last, doesn't it? Remember that in Jacob's day, the oldest son was first: first in wealth, rights, property, and blessing. Today, we don't follow the system of primogeniture in the Western World, but we can still identify those who are "first": the wealthy, the powerful, the good-looking, and the intelligent. In even more pointed terms, it's the woman with the good-looking figure, the good-looking husband, the good-looking house, the good-looking friends, the good-looking job, the good-looking kids, and the good-looking parents.

But who, like Jacob, does Jesus say is first? Turn to Mark 10:28–31 and record your answer below:

God is all about taking the man-made systems of this world and turning them upside down. He doesn't play by the same rules as we do; man looks at the outward appearance, birth order, bank accounts, family backgrounds, or status; but God looks at the heart (I Samuel 16:7).

Like Jacob, in the areas of our lives where we come in "last," we tend to fret . . . and plot . . . and plan . . . and manipulate . . . and toss . . . and turn . . . and attempt to control . . . and wrestle. But we can be absolutely confident that the things that make us "last," the things that we sometimes hate about ourselves and wish we could change, the things we cannot control and finally turn loose into the Hands of an Almighty God, give us the opportunity to be called "first" in His Kingdom.

Some of you may be familiar with Psalm 37, but let's turn and read Psalm 37:1–9 with fresh perspective and new eyes.

Whenever it seems that we are last, behind, or forgotten in an area where we want to be first, whenever we compare and contrast and compete and want blessing when it seems all we've inherited is a curse, the psalmist tells us three times in nine verses to avoid doing one thing. What is it (vv. 1, 7, and 8)?

What does the word fret mean in Hebrew (#2734)?

charah—"to burn, to be kindled; to glow with anger, to be incensed, to be zealous . . . it points to the fire or heat of the anger just after it has been ignited."[56]

Why are we called to cease from fretting? What does verse 8 tell us it leads to?

Friends, God does not take the sin of fretting lightly. In fact, He tells us not to do it because He says it leads to one thing and one thing only: evil doing. Those who fret are those who become evil, hateful, resentful, murderous people, people who listen to and abide by the lies of Satan himself. Nothing leads us further from our calling to be daughters of light and truth when we choose to fret. That's why instead of smoldering in selfish ambition, jealousy, worry, discontent, or anger, we are called to actively place our trust in the Lord.

Let me say a quick aside here. God has called me to repent more times than I would like to count through His words in James 3:14–16: "But if you have bitter jealousy and selfish ambition in your heart, do not be arrogant and so lie against the truth. This wisdom is not that which comes down from above, but is earthly, natural, demonic. For where jealousy and selfish ambition exist, there is disorder and every evil thing." When you and I harbor envy, jealousy, and selfish ambition in our hearts and look at other women (sisters in Christ, neighbors, friends, co-workers, and so on) in comparison to ourselves, and begin to fret and say, "I want what she has, and because she has it, I don't like her all that much. In fact, I'm going to build her up in my mind and create her to be something she isn't, so I can fret, and worry, and compare, and complain," God doesn't just call it "sin"; He calls it downright demonic.

Don't do it. We must resist the temptation to fret, envy, and compare, because it opens the door to demonic oppression in our lives and lets in every evil thing, just as the psalmist warns us.

So how are we going to do this? In Psalm 37:1–9, I can count at least twelve specific commands given to those who are called to faithfully wait upon the Lord instead of fret. List at least six of the twelve below:

1.

2.

3.

4.

5.

6.

In the areas of your life where you seem to be "last," are you fretting? If so, why? What lies are you believing about yourself and/or the character of God?

From the list of the six commands you listed in Psalm 37, pick just one to really focus on this week. Ask God to give you a change of heart, then repent and cease from fretting. Take time to pause and worship Him, just as Jacob did, for who He is and what He can do, and turn that one command into a prayer of commitment to Him and to trusting His ways:

Now that you have done that, I want you to look at what God promises He does for those who wait for Him with a faithful, trusting heart.

- What is the promise in verse 4?

- What is the promise in verse 5?

- What is the promise in verse 6?

- What is the promise in verse 9?

By now, you know the drill. Find an index card or a piece of paper and write out the command you chose and the promise that speaks to you the loudest, and carry that card with you wherever you go. You can put it in your purse, you can put it in your car, you can put it in your kitchen, or, if you're like me and need a moment-by-moment reminder, you can pin it to your shirt! Just be sure to put it in a place where you will be able to see and be reminded often that God is in control.

But wherever it is, when the father of lies comes to you and begins to whisper to your heart, "God is not faithful. You are last, not first; you are cursed, not blessed; you are shamed, not loved, forgotten, not remembered," speak aloud your command and promise from the Word of God, choosing to believe and submit to the truth, and Satan himself with have to flee (James 4:7–8). It is time we started abiding by the rules of Christ and His Kingdom rather than by the rulers and powers of this present darkness (Ephesians 6:12).

Our only other option is fretting . . . and manipulating . . . and plotting . . . and planning . . . and scheming . . . and wrestling . . . and evil-doing. Husband or no husband, children or no children, home or no home, do not trade your rightful inheritance as a daughter of God for a pack of demonic, hateful lies.

One final thing: when Jacob blesses Joseph and his sons in Genesis 48:15, he calls upon "[t]he God who has been my shepherd all my life to this day." Keller points out that this is the very first instance in Scripture where God is called a shepherd.[57] Isn't that beautiful? Instead of wrestling with and running from God, Jacob has finally turned to trusting Him as the Overseer and Shepherd of his soul.

Through Christ, as spiritual daughters of Abraham, Isaac, and Jacob, the same knowledge and blessing of Jacob's Shepherd-God is yours today and all of the days of your life.

 Close today with a hopeful heart as you pray the words of David, Israel's Shepherd-King, over your heart, and close by writing out your own prayer, trusting God as your faithful Shepherd, Protector, and Restorer of Peace:

The Lord is my Shepherd,
I shall not want.
He makes me lie down in green pastures;
He leads me beside quiet waters.
He restores my soul;
He guides me in paths of righteousness
For His Name's sake.
Even though I walk through the valley of
The shadow of death, I fear no evil;
For Thou art with me;
Thy rod and Thy staff, they comfort me.
Thou dost prepare a table
Before me in the presence of my enemies;
Thou hast anointed my head with oil;
My cup overflows.
Surely goodness and lovingkindness will follow
Me all the days of my life,
And I will dwell in the house of the Lord
Forever.
Amen.
Psalm 23:1–6

Satisfied

When my grandfather left my grandmother, they had been married for over twenty years. My mother and her twin brother were seniors in high school, and my aunt was a sophomore in college. My grandfather was a professed believer in Christ, an elder in his church, and a descendant of a strong Christian family, yet he decided all of that wasn't enough to withstand worldly pleasure, so he left his World War II bride for a season of seven long years.

My grandmother, who had never worked outside the home, was forced to find a job at a downtown bank and left the house at 5:30 a.m. to make sure she was there on time. Her world had turned upside down, and the only thing that kept her right side up was the time she spent on her knees. Every morning when she rose at 5 a.m., my mom remembers her kneeling beside her bed and praying for her marriage. Mom wrote her a poem that hung beside her beside table until my grandmother gave it to me on my 21st birthday:

Faith

I will have faith
However dreams are shattered,
I will have faith that righteousness can live;
I will have faith even when my heart is breaking,
To work and pray and give . . .

I will have faith
When troubled is life's ocean,
When low-blown clouds the Pilot's face shall hide;
I will have faith when my fair ship is battered;
I will await the turning of the tide . . .

I will have faith
That God is still in heaven,
I will have faith that He is by my side;
I will have faith though every star is darkened,
That He and Truth abide . . .

My grandmother, Suzanne Tracy Haden, was not a tall woman, nor a loud or brash or particularly bold woman. But when it came to faith in the character of her God, she was about as tough as they come. She was so tough, in fact, that my mom gave her the nickname the "Iron Butterfly." So tough, in fact, that when her friends, her family, and even her pastor told her to divorce my grandfather, she told them all, "No. If my husband was physically ill and had cancer, I wouldn't divorce him. And this is no different. My husband is sick—it's just that he's spiritually sick, and I will stand by his side until he is well."

And after seven arduous, knee-bent, tear-stained years, Suzanne Haden saw her husband come back to his senses, back to her side, back to the church, and ask for her forgiveness. He never left her side again, and December 21, 2007, marked 61 years of their marriage.

How did she do it? How did my grandmother withstand the pressure of all the different voices, hurts, and heartaches in and around her to stand by her husband for better or for worse, for richer or poorer, in sickness and in health? She did it simply by fixing her heart on her Heavenly Husband. Her heart was not fixed on waiting for her earthly husband to come home and rescue her from her pain; her heart was waiting for Jesus to come, every day, to heal and to carry her in her pain.

As we have seen this week through the life of Jacob, we can spend seven months, seven years, or seventy-seven years waiting for an earthly spouse to come through and change our circumstances. But we are given absolutely no guarantee of satisfaction. Our only hope is found on our knees, every day seeking the only Spouse who can truly satisfy.

This week we spent looking at the life of Jacob and learned many lessons from his wrestling and wilderness wandering. We saw that through all of his searching, at the end of his life he could look back and say, "Through all of my wandering, God was the Great Shepherd who tenderly cared for me all of my days." Today, I want to close our week by continuing to look at other characteristics of our Great God so that no matter what season we are in, or where we are in our wait for a wedding day, when hardship comes, as it did in the life of my grandmother and in the life of Jacob, we can be confident we have a Husband who never leaves or forsakes us and whose love never fails.

We have already looked at the book of Hosea twice this week, but I want to turn there once again to read from a chapter that became very significant to me my junior year of college. I spent that year of undergrad at Wheaton College, a Christian college in a suburb outside of Chicago. I loved every minute of my time there for many reasons, the primary one being that I came to know Christ in an entirely different way than before. No longer was He just an intellectual or cultural exercise; He became Lover, Healer, Intimate Confidante, and Friend. No longer did I simply "know" all of the youth group answers; I became "known," and I haven't been the same since. I still remember the time on campus when an acquaintance, a girl I didn't even know very well, shared Hosea 2:14 with me. The Lord tells the prophet Hosea in regards to His people, Israel, "Therefore, behold, I will allure her, bring her into the wilderness and speak kindly to her." That verse became a signpost for me during my year at Wheaton, and it is this verse and chapter from Hosea that I want to share with you today. I pray that you, as I did over fifteen years ago and am still learning to do, will open yourself up to the Husband who is waiting to respond to you with love, compassion, tenderness, and intimacy beyond all that you or I could ever imagine.

With this in mind, turn to Hosea 2:14–23. What are the qualities that make up a good spouse, or, specifically, a good husband?

How does God exhibit these qualities in Hosea 2:14–23?

I want to look at one quality in particular. Fill in the blanks from verse 16:

"'It will come about in that day,' declares the Lord, 'that you will call Me _____

And will no longer call Me _____.'"

To find out what the word Ishi means, turn to the very first place in Scripture it is used. Read Genesis 2:18–24. Out of all the creatures on the earth that Adam named, did he find one to be a "helper suitable for him"? Why or why not?

How did God create a "helper suitable" for Adam?

Can you imagine the very first moments when the Lord God brought woman to man? Adam was so taken by this person who was so "other," yet so much a part of him, that he named his beautiful bride on the spot, and in doing so, forever named all women.

Fill in the blanks from Genesis 2:23:

"The man said, 'This is now bone of my bones, and flesh of my flesh; She shall be called _____, because she was taken out of _____.'"

The Hebrew word for "man" here is—you guessed it—*Ishi*. So, according to the original Hebrew, when the Lord God declares in Hosea 2:16 to Israel, His bride, that they will no longer call Him *Baali* but *Ishi*, what He is saying is this: "A day is coming when you will stop seeing Me as *Baali*—a master, slave-driver, and god like all the other gods you and the people around you worship. Instead, you will see Me as *Ishi*, a word going as far back as Adam and Eve and as far back as My original intent for

marriage in the Garden of Eden. I will be your *Husband*, one who is other than you, yet completer of you, enthralled with you, delighted in you, faithful to you, and completely unlike the other gods of this world." God promises us we have a Husband in Him who *never* fails.

In Hosea 2:19, how long does the Lord say His people are betrothed to Him? A day? A year? For as long as they are faithful to Him and obedient to His commands?

According to verses 19–20, what guarantees surround our betrothal, and what characteristics does our "Betrother" possess?

 The Scriptures, both Old and New Testaments, are full of the promises of the faithful love of our Heavenly Husband. When an earthly man proposes, there is always the lurking possibility of a broken engagement, of *un*-faithfulness and *un*-righteousness on the part of our groom. Not so with our God. Not for one split second. In Him there is not the slightest hint of the pain of a broken covenant or of the deceitful nature of the human heart.

What does II Timothy 2:13 tell us about our God?

 Once the Spirit of the Living God indwells, fills, and betroths us to Himself, He cannot be unfaithful no matter how faithless we are, for He cannot be unfaithful to Himself.

 How is this possible? How can the love of God be so faithful and constant, even when His bride is often so unfaithful?

> *checed*—"the attitude of love which contains mercy . . . love, benevolence, kindness, good will, favor, benefit, grace, mercy, piety, loyalty, unfailing love, beauty"[58]

The key to God's covenantal love is found throughout the Old Testament in the word lovingkindness (Hosea 2:19). This is a word that is so important for all believers to know, so please look up the Hebrew word and definition in your concordance (#2617) or copy both from the margin in the space below:

 As mentioned earlier in our study, *checed* (pronounced "hes-sed") is the Old Testament word used to describe God's covenantal love for His people. We briefly discussed the concept of *checed* in "Waiting for a Father," but I want to look at it in greater detail today.

I still remember the day I learned what *checed* means. I was sitting in my Systematic Theology class at Wheaton, and my professor, Dr. Gary Burge, said this: "*Checed* is the kind of love that is based on the character of the Lover, not the beloved." Let that definition sink in for a moment. If you are in a place where you are free to do so, say the definition out loud.

Now write Dr. Burge's definition of checed below (can you tell I want this to be burned in your memory as it was mine?):

Checed, my dear friends, is how Suzanne Haden plowed through seven years of marriage to a faithless husband; she leaned on and loved my grandfather with the *checed* love that was rooted in the character of God Himself. This is also how my grandfather received forgiveness from the Lord and from my grandmother. God was faithful, even when my grandfather was faithless, for God could not, and would not deny Himself. He had made a covenant of *checed* love with both Charles and Suzanne Haden that could not be revoked.

You *cannot* outlive, outrun, or outdo the *checed* love of the Lord, for it is a love based on *His* character, not yours. It is a love based on *His* performance, *His* obedience, *His* death, and *His* resurrection. And not only does this free us from the fear of unfaithfulness from or rejection by the Lord, it also frees us from needing to look for any other love or lover outside of Him.

"Great," you might be saying, "that's just what I needed to hear. An intangible lover loves me with an intangible love when all I want is a man with flesh and bones who can put his arms around me."

Let's look at one more characteristic of our Heavenly Husband in Hosea 2:21. When God's people begin to call Him Ishi as opposed to the false god and slave-driver Baali, and when God betroths us to Himself with His checed, faithful love, what does He promise He will do? Fill in the blank below:

"I will _____, declares the Lord."

One of my favorite worship songs is *My Redeemer Lives* sung by Nicole C. Mullen. Every time I hear it, I turn up my volume and belt out the words for one reason in particular. In fact, it's just for one line at the very end of the song when she names all the reasons she knows why her Redeemer lives: "I SPOKE WITH HIM THIS MORNING!"

Women, we are married to and in love with a *RESPONSIVE, LIVING* God! It doesn't matter what your earthly husband is like or how your dad treated your mom or how your boyfriend treats, or treated, you—God is interested; God is responsive; God is active in our lives and *delights* in our loving Him. Even when we are faithless, He hunts us down, wanting a response from us. This is the very reason why we were created: for responsive, interactive, joyful, flesh-and-bones interaction with our *checed* Lover.

We worship *Ishi*, not *Baali*, and when we look for and love our God for who He tells us He is, we will hear our Heavenly Husband declare, just as Adam declared to Eve, "You are bone of my bone and flesh of my flesh; I am your *Ishi*, and you, my bride, are My beloved, My beautiful one, My *Ishshah*."

In your wait for a wedding day and for a groom, go now and respond to the One who gave His all to call you "His"—your Bridegroom is waiting.

Waiting for a Wedding Day

I. Blueprint for a Betrothal

A. Archetypes and Type-Scenes

1. Archetype—The _____ who does certain things in a certain way at certain times.

2. Type Scene—"an elaborate set of tacit _____ between artist and audience about the _____ of the art work . . . [It] is at all times the _____ _____ in which the complex communication of art occurs."[59]

 ❑ The type scene is what _____ communication to occur between the _____ and the _____.[60]

 ❑ The Artist's point is made both by what elements are the _____ and by what elements are _____ in the type scene.[61]

B. Fixed Elements—The Five Fixed Elements in a Biblical Betrothal Type Scene are . . .

1. The Future Bridegroom journeys to a _____ land.

 I and R: _____ J and R: _____ J and SW:_____

2. There He encounters a _____ (s) at a _____; usually the girl is _____, a _____, and _____.

 I and. R: _____ J and R: _____ J and SW:_____

3. He or she draws _____ from the _____.

 I and R: _____ J and R:_____ J and SW:_____

4. Afterward, the girl _____ _____ to bring news of the stranger's arrival.

 I and R: _____ J and R:_____ J and SW:_____

5. A _____ is concluded, usually only after the stranger has been invited to a _____.[62]

 I and R: _____ J and R:_____ J and SW:_____

C. Examples—

1. Isaac and Rebekah—Genesis 24:1–67

 ❑ Divergent Elements—

 a. Isaac is conspicuous by his _____

 b. The _____, not the man, draws water from the well.

2. Jacob and Rachel—Genesis 29:1–13

 ❑ Divergent Elements—

 a. Jacob has an _____ to overcome, wrestling the _____ from the mouth of the well.

"The type-scene is not merely a way of formally recognizing a particular kind of narrative moment; it is also a means of attaching that moment to a larger pattern of historical and theological meaning. If Isaac and Rebekah, as the first man and wife born into the covenant God has made with Abraham and his seed, provide certain paradigmatic traits for the future historical destiny of Israel, any association of later figures with the crucial junctures of that first story—the betrothal, the life-threatening trial in the wilderness, the enunciation of the blessing—will imply some connection of meaning, some further working out of the original covenant. . . . The fact of recurrence, however, is as important as the presence of innovation in the use of the type-scene; and the convention itself, the origins of which may well antecede biblical monotheism, has been made to serve an eminently monotheistic purpose: **to reproduce in narrative the recurrent rhythm of a divinely appointed destiny in Israelite history.**"

Robert Alter[63]

II. Betrothal by a Well

A. Fixed Elements—

❑ Jesus is the very _____ Bridegroom who has left His Father's House to seek His bride among the "sons of the east," just like _____, and just like _____.

❑ In asking the woman to draw water, Jesus breaks three huge cultural taboos:

 1. He talks to a _____.

 2. He ignores a 500 year _____ between Jews and Samaritans.

 3. He _____ after a Samaritan, causing personal _____.

B. Divergent Elements—

❑ The primary divergent element in this type of scene is the _____ of the _____; she is clearly not a _____, and she is clearly not _____ (vv. 16–18).

❑ The second divergent element is the nature of the _____ He offers her: He does not offer to satisfy her _____ thirst, He offers to satisfy her _____ thirst and to quench her _____ and her _____ (vv.13–14, 39).

 1. Jesus lets her know that worship isn't about being in the right _____; it's about being at the feet of the right _____ (vv. 21–26).

 2. Defilement doesn't come from the _____; defilement comes from the _____. And we don't run the risk of making Jesus _____; instead, Jesus makes us _____.

III. Our Betrothal

A. We must choose to be _____ and to drink from His _____, the _____ for our _____.

❑ As Christian author Henri Nouwen writes, "We not only _____ the Beloved, but also have to _____ the Beloved."[64]

❑ We allow the _____ Word to apply the _____ Word to our _____ (Ephesians 5:25–27).

B. We must choose to be continually _____, no matter the circumstances of our _____.

C. We must choose to make our _____ the will of God and invite others to _____ at His Table. (John 4:34–35, 39).

WEEK FOUR

Waiting for Beauty

The Beautiful One

A s long as I can remember, I have ached for the beautiful—not so much to be beautiful, but to be involved in the beautiful, wrapped up in a beautiful story, living in a beautiful place, and doing beautiful things. Perhaps you have felt that ache too.

Sometimes the ache can overcome us when we hear a piece of music, see a certain landscape, smell a particular flower, or dream of an upcoming vacation. Yet if we try to hold on to the actual feeling or thing of beauty, the feeling always vanishes and the "thing" never satisfies.

In the Prologue to her book *The Beautiful Ache* author, friend, and mentor Leigh McLeroy says this about the ache so perfectly:

> It's the pang that strikes when loss is sudden, or suddenly realized. It's the stealthy tears that fall when something stunningly grand (or nakedly simple) sets holiness on clear display. It arrives with crickets chirping on a June night, or a bright pink sunset slung low and wide across the sky, or the sound of a child's sleepy whisper. It lingers in memory-infused music and nibbles the edges of silent hope. It's evoked by a longed-for touch or a word well spoken, delivered just in time. It invades carpool lines and conference rooms with equal deftness. It is no respecter of place or time.
>
> It's the beautiful ache. It says, *There's more.*
>
> More than you've seen and much more than you've longed for. Beyond what you know and far, far past your strongest yearning. As C. S. Lewis said, "If I find in myself a desire which no experience in this world can satisfy, the most probable explanation is that I was made for another world."[65]

I couldn't agree more. As Leigh says throughout the rest of her book, the challenge is to let the ache lead us to something, or rather, to Someone else. Let's look at Scripture to find out what this longing is and exactly where it originates.

Turn with me to Psalm 27:4–6. What is the "one thing" the psalmist has asked of the Lord?

For what two reasons does he want to dwell in the house of the Lord (v. 4)?

1.

2.

In Psalm 27:4, we see King David, the psalmist, a man who Scripture tells us is a man after God's own heart (Acts 13:22), desiring one thing: to dwell in the house of the Lord. Why? To gaze upon the Lord's beauty and to meditate in His temple. Does that seem like an odd request to you? What if your husband or friend appeared on your doorstep today and said, "May I please come into your house, just for a few hours? All I want to do is gaze upon your beauty!" We would either think they were extremely odd or just plain nuts! So why is this a *good request* for David to ask of the Lord?

Look at verses 5–6. Once David gains a vision of the beauty of the Lord, what happens to him?

Fill in the blanks from verse 6:

"And now _____ will be _____ _____ above my enemies around me."

The very first thing that happens to us when we gain a vision of the beauty of the Lord is that our heads are lifted up. When we turn and lift our heads out of the muck and mire around us to see the Lord, we are given strength and grace to rise above our enemies. Now those of us who are married know that if our husbands were to spend an hour a day gazing upon our beauty, it might do a thing or two for our egos, but that's about it. Our beauty might give them satisfaction for a moment, or even for a day, but it certainly wouldn't give them the power to defeat their enemies!

But if our husbands, or anyone for that matter, were to spend an hour meditating on *God's* beauty each day, they would be transformed. Why? Because the beauty of the Lord is powerful, so powerful in fact that it gives us triumph over our enemies, strength, joy, and courage in the midst of mundane or very difficult circumstances.

With this in mind, what does God tell David to do in Psalm 27:8?

Every day of our lives we are called to gain anew a vision of the beauty of the Lord and to seek His Face. Why? Because we were created with the capacity to look at, I mean really look at, only one thing at a time, and as we daily train ourselves to look up to Him in a world full of sin, death, and suffering, this vision of the Beautiful One will lift us above our temporary, earthly circumstances and re-focus us on that which is eternal.

Look at the end of Psalm 27, and read verses 13 and 14. They are two of my favorite verses in all of Scripture. Read them slowly, really meditating on their meaning.

Now say them out loud.

What gives David the courage to go from despair to belief?

The Hebrew word for "goodness" in verse 13 comes from the root word *tov* and means "property, goods, goodness, fairness, beauty. The root concept of this noun is that of desirability for enjoyment."[66]

When we are knee-deep in murky waters while waiting on God for specific things, we will tend toward despair unless we, like David, draw our belief, courage, and hope from the goodness and the beauty of the Lord. In fact, what that word implies is that we are to take heart by downright *enjoying* the Lord in all of His beauty.

This longing for beauty is not an optional desire in our lives. *We must have it, especially if we are waiting.*

I think so often our concept of waiting on God conjures up pictures of stoic Puritans in stiff collars with grim looks on their faces. Scripture, however, tells us this image couldn't be further from the truth. When we are in the midst of our enemies, we are commanded to take great delight in all of the beauty and goodness of God's Face—in fact, we are to revel in the beauty of the Lord as we never have before!

I want you to think about yourself and your lifestyle for a moment. Are you, like most Americans, consumed with your own physical looks, figure, dress, and beauty? Do you spend an inordinate amount of time or energy trying to fit in with the culture around you making yourself look and feel "beautiful"? If so, how?

Does this desire or even obsession to be beautiful leave you feeling satisfied or dissatisfied? Empty or full? Explain below:

When you are waiting on the Lord in the midst of painful or mundane circumstances, how much of your time do you spend meditating on the beauty of the Lord in comparison to the amount of time you spend focusing on your own beauty? Be as honest as you can:

Have you found that spending an inordinate amount of time on your physical appearance has the power to defeat your enemies or pull you out of the pit of despair? If not, why do you think this is so?

If you are anything like me, you may be experiencing conviction from the Spirit of the Lord right now. Let's stop together and repent as a culture and as individuals for making too much of our physical appearance and spending too much of our precious resources of time, focus, energy, and finances on outward beauty:

> *Father, we have sinned not only as individuals but as an entire culture by making more of how we look on the outside than on the inside. We repent for our own individual sins and for the sins of our culture. Forgive us for using more time to exercise and strengthen our bodies than to exercise and strengthen our spirits. Forgive us for using so much of our emotional and mental energy worrying about the clothes that we wear, the type of figures You have given us, the appearance of our skin, hair, and everything about us that is literally fading away. Forgive us for spending so much of our financial resources on ourselves and our outer appearances instead of on the things of Your Kingdom that are truly lasting and beautiful. Forgive us, cleanse us, heal us, and give us a transformed vision of what You consider to be truly beautiful. Turn our focus away from our obsession with ourselves and all that is passing away, and turn it toward You, the eternal, Beautiful One. In Jesus' Name I pray, Amen.*

In light of our prayer above, what are specific ways you can meditate upon and enjoy the beauty of the Lord today instead of your earthly, temporary appearance?

What about this week and this month?

I want to leave you with one more quote from Leigh's book *The Beautiful Ache*. As always, she says it far better than I ever could:

> Some things leave you speechless. Seeing Michelangelo's *David* in the pure light of the Academy in Florence, Giotto's frescoes on the walls of the chapel of St. Francis in Assisi, and the aspens flaming yellow high above the tiny town that bears their name—all of these have stolen my faculty for words. But so have a single star seen from my back stoop and the long pull of a bow across the strings of a cello. . . .
>
> What evokes praise in your heart? Can you see or hear or discern in those things the hint of something vastly bigger, greater, and wilder? Would you dare to begin to honor it now, today, knowing that even incomplete hosannas are a reasonable man's best method of practice?[67]

Instead of focusing on all of the ways our own physical beauty is fading away or not what we want it to be, I want us to focus on the complete, eternal, unchanging, satisfying Beauty of the One from whom we are made.

Today pull out a chair and sit and watch a sunset. Enjoy spring flowers or an autumn afternoon. Grab a blanket and lie down in the grass, delighting in the passing of the clouds in the blue sky overhead. Or curl up in your favorite chair with your Bible in one hand and a cup of coffee in another. That, my friends, is how our hearts take courage to triumph over our physical surroundings and circumstances. And that is how we must learn to wait—gazing upon the only lasting beauty of our God, The Beautiful One.

The Garden

Yesterday we began a journey of repentance for allowing our desires for physical beauty to lead us astray from true, lasting beauty found only in the person of God, the Beautiful One. Today I want to take us back to the Garden of Eden, the place of original beauty here on earth, so that we can continue to overcome our sinful tendency to worship the beauty of ourselves, the created, instead of our Creator. We will also discover where our longing for all things beautiful originates and why this longing is within us.

But before we start, read Proverbs 4:7–9 below and make it your prayer for your time in God's Word. Today's material is heavier than normal, and we need the wisdom of God to understand what He wants to say to us:

> *The beginning of wisdom is:*
> *"Acquire wisdom; and with all your acquiring,*
> *Get understanding.*
> *Prize her, and she will exalt you;*
> *She will honor you if you embrace her.*
> *She will place on your head a garland of grace;*
> *She will present you with a crown of beauty."*

Lord, I spend much of my time acquiring things that are of little or no lasting value. Help me to put all of my energy and resources into acquiring wisdom and understanding in the ways You want me to live. Give me the assurance that as I do what You are asking me to do, embracing Your truth and Your way, a garland of grace and crown of true beauty awaits me.

In Jesus' Name I pray, Amen.

When we turn on the television or pick up the newspaper, feelings of discouragement can overwhelm us. We hear news of war and rumors of war; we read about children sold around the world into sexual slavery or slave labor; we learn of refugees dying from dehydration and starvation; we are bombarded with images of violence, hatred, killings, and shootings in our local and national schools, parks, and public places.

Often times, dark shadows of fear fall over our hearts, or, even more frightening than fear, we don't feel anything at all. Our hearts are numb, deadened by apathy from one more crime, one more heartache, and one more upheaval from the horrid effects of sin.

In the spring of 2007, Peggy Noonan, writer for *The Wall Street Journal*, wrote a thought-provoking and rather alarming article in the wake of the shooting at Virginia Tech. In describing a conversation she had with a friend about the terrible incident, she writes, "I told him I felt people were stricken because they weren't stricken. When Colombine happened, it was weird and terrible, and now there have been some incidents since, and now it's not weird anymore. And that is what's so terrible. It's the difference between 'That doesn't happen!' and 'That happens.'"[68]

She goes on to describe that in the classrooms, with the exception of a few, brave souls, nobody moved; nobody tried to stop Cho Seung-hui, the killer. Nobody did anything. And in the aftermath of the shooting, everyone from politicians to journalists to television reporters refused to really "do anything" either; no one would call the incident for what it really was—pure evil.

Noonan ends the article by saying, "The most common-sensical thing I heard said came Thursday morning in a hospital interview with a student who'd been shot and was recovering. Garrett Evans said of the man who'd shot him, 'An evil spirit was going through that boy, I could feel it.' It was one of the few things I heard the past few days that sounded completely true. Whatever else Cho was, he was also a walking infestation of evil. Too bad nobody stopped him. Too bad nobody moved."[69]

Whether or not you agree with Ms. Noonan on her opinions, I think we can all agree on one thing: "Too bad nobody moved."

Friends, may I suggest why nobody moved? As a nation and a people, we have lost a vision of what is truly beautiful. We are too consumed with our idols of physical appearance and good looks, we are too cluttered with our consumerism and materialistic mentality, and we have ceased to recognize, desire, and long for true, lasting, God-given beauty to be the norm, not the unusual. Our young people are growing up to be apathetic to the good, the true, and the beautiful because we, as the adult generation, have failed to teach, model, believe, and act on it ourselves.

The book of Proverbs warns us, "Where there is no vision, the people perish" (Proverbs 29:18, KJV), while the prophet Isaiah informs us how to regain or maintain that vision: "Lift up your eyes on high, and behold who hath created these things" (Isaiah 40:26, NIV). Oswald Chambers comments, "The people of God in Isaiah's day had starved their imagination by looking on the face of idols, and Isaiah made them look up at the heavens, that is, he made them begin to use their imagination aright. . . . Rouse yourself, take the gibe that Isaiah gave the people, and deliberately turn your imagination to God."[70] As the church of believers whose head is Jesus Christ, we must regain a vision of the beauty and the glory of the Gospel in Jesus. *That* is what rouses us to fight against evil, to move when no one is moving, and to shout "Stop!" when no one else is shouting.

How do we regain this vision? We ask for insight on God's original intent for His creation, and we ask for a vision of the beautiful that comes straight from the heart of God.

Turn with me to Genesis 1:1–25. As you read, enjoy the beauty of the narrative of the Creation account. Place yourself by God's side, and hear His Voice speak, perhaps even sing, His creation into existence.

Beginning with day three, at the end of each day of creation, God uses a word to describe His handiwork. What is it?

Keeping one hand in Genesis 1, turn to Genesis 24:15–16. In verse 16, how is Rebekah described?

The Hebrew word used for "good" in Genesis 1 and for "beautiful" in Genesis 24:16 is the same word we saw yesterday in Psalm 27: *tov*. What this tells us about the nature of beauty is twofold. The first thing is that beauty is inherently *good*. Whatever is truly beautiful will always go hand-in-hand with that which is lovely, pure, morally upright, and good. The second thing is that when God created this world, He stepped back from His masterpiece and said, "Ahh, my creation is not only good, it is beautiful. This is how it is meant to be."

Think for a second about what God was looking at when He stopped each day and said, "This is good." What do you think He saw?

My husband spent several summers in college in the Seychelle Islands off the Eastern Coast of Africa. While he was there, he learned that some people believe the Garden of Eden was in the Seychelles because of one simple fact—how *beautiful* it is. When God created the earth, each facet of His design, from the waters to the mountains to every species of living creatures, reflected a portion of His beauty and goodness.

Now read Genesis 1:26–31.

God reserves the crown jewel of creation for His last day of work. What is it?

Notice the phrase that He uses at the end of the day in verse 31. What is it, and how does it differ from what He says on the other days of creation?

What does this tell you about God's original design for all men and women?

As men and women, we are, in no uncertain terms, God's masterpiece. More than any other thing in all of creation, we reflect the goodness, beauty, and glory of God. Why is this so? Look at Genesis 1:27 and 2:7 and record your insights:

It is stunning, isn't it? Stunning to consider and think upon the fact that we are formed in God's image, breathed into by the very breath of God. I believe our original and intended glory, radiance, and beauty would stun and shock us if we were able to step back into time and behold Adam and Eve. Sadly, though, their beauty tarnished and their glory withered because of one thing—sin. Sin entered God's original design and began its dirty work of "uglying" all that God said was *tov*.

Ken Gire in his beautiful, poignant book *The Work of His Hands* describes creation and Adam and Eve's fall into sin in this way:

> When God created the man and the woman, they were the crowning achievement in a gallery that was already filled with magnificent works of art, from the pin-wheeled wonder of the galaxies to the darting iridescence of the hummingbird (Psalm 8). Of all God's creations, the man and woman were His masterpiece. They were also the only work He modeled after Himself (Genesis 1:26–27).
>
> When God placed the man and the woman in the middle of the garden of Eden, they stood as living statues, so to speak, announcing His reign over that territory. They ruled as regents, standing in the place of and serving in the spirit of God Himself. Their rule, consequently, was not dictatorial but custodial, serving as caretakers of the work of His hands (Genesis 2:15, Psalm 8:6). The mandate they received from God was not merely to rule the earth but to multiply and fill the earth (Genesis 1:28). It was through the multiplication of these images of God that the borders of His kingdom were expanded.
>
> When Adam and Eve fell from their pedestal of innocence, the image of God suffered permanent damage (Genesis 3). With each sin, the image became more defaced (Genesis 4:1-15, 23-24). After generations of such defacement, barely a vestige of the divine resemblance remained (Genesis 6:5)....
>
> Could nothing be done to repair the damage? Was there no deliverer? Was there no one who could restore the image of God on earth? Was there no hope for us?
>
> There was. It lay embedded in Eden. Hacking away at the thorns and thistles that have overgrown it, we find a fragment of hope protruding from the ground.
>
> > I will put enmity
> > Between you and the woman,
> > And between your seed and her seed;
> > He shall bruise you on the head,
> > And you shall bruise him on the heel.
> > Genesis 3:15[71]

This "fragment of hope," this "seed" who crushes the serpent on the head, is the first reference and prophecy ever recorded in Scripture concerning God becoming man. As Gire points out, even in a relatively short amount of time, by the days of Noah in Genesis 6, man had so tarnished the image of God all over the face of the earth that God wiped out all of those who were in His image with the exception of Noah and his immediate family . . . and He started over with the only righteous image left.[72]

Obviously, mankind could not destroy the effects of sin himself and make himself, or creation, beautiful once more . . . but God could. And He did, through the fragment of hope in the seed in the Garden. John 1:14 tells us that "the Word became flesh, and dwelt among us, and we beheld His glory."

God sent His Son as a second Adam (Romans 5:14) to do what the first Adam could not do—to fully love God and obey all of His commands, to perfectly rule and reign, and to beautify and restore not only physical creation, but most importantly, men and women's hearts.

But how did He do it? Did Christ come in pomp and beauty and majesty? Turn to Isaiah 53:1–5. In your own words, paraphrase how Isaiah describes Christ:

As a far, far cry from the original glory and beauty of Adam, Christ shrouded His glory and took in, so to speak, all the ugliness of the world so that we could behold, once again, the beauty of God.

Turn with me one last place, John 18:1–5. From the information we are given in verse 1, where did Christ enter with His disciples the night He was betrayed?

While Adam ultimately disobeyed God in a garden, Christ obeyed God and was betrayed by man in a garden. In fact, the whole world turned against Christ in a garden—the religious people, the pagan people, and even His friends, the disciples, fled and left Him alone. In his comments on Mark 14:48–52, Tim Keller writes in his book *King's Cross* about this scene in a garden:

> Peter and the other disciples, who had spent years by his [Jesus'] side, desert him at the first real test of their fortitude. One young man is so intent on saving his skin that when Judas's crowd grabs hold of his garment, he is willing to shed it and run away naked down the street. . . . By recounting this young man's naked flight from the garden, Mark may be reminding us of another garden. In the Garden of Eden, too, there were people who were given a test, and they failed. They were exposed as naked and fled in shame. Centuries later, another garden and another test, and everybody fails in one way or another. They're either waving swords around or fleeing in naked shame.[73]

Christ was left, in every sense of the word, alone in a garden. And in the garden, He began to taste the cup of the wrath of God. Why? Why was Christ so willing to suffer such deep shame, suffering, sorrow, torture, and death?

The familiar words of John 3:16 should ring true in a whole new way to our ears. Fill in the blanks below:

"For God so ____ _____ _____ that He gave His only begotten Son, that whosoever should believe in Him should not perish but have eternal life."

The Beautiful One who fashioned and made such a glorious and majestic world LOVED His creation so much so that He was willing to undergo ultimate hideousness and ugliness to beautify it once again.

Does that thought stagger you? Does it bless you? Does it humble you? Not only should it do all of those things on a continual basis, but it should also boldly move you into action, an idea we are going to discuss at length over the next few days.

 Let's close today by looking upon the Beautiful One and asking Him to restore our vision of what is truly beautiful and to realign our hearts with His heart and His original, intended purpose for His creation:

Lord, forgive us for spending so much time consumed with what is false that we have forgotten or never really considered or experienced what is true. Give us a vision of what is truly beautiful so that we will move when no one else moves, shout when no one else shouts, and love when no one else loves. Move us out of ourselves and into what is truly beautiful so that the beauty of Your Image and Name is restored over all the earth. In Jesus' Name we pray, Amen.

Beauty from the Outside

esterday we looked at how Jesus Christ, the second Adam, came in fleshly form to redeem earth from her ugly, sinful state and to make her beautiful again. In fact, we saw that He felt so strongly about removing the curse of death that He gave His life as the ransom for His creation.

And this leads us to our next question: if Christ was willing to suffer so greatly for the work of His hands, as His followers, shouldn't we be willing to do the same? To put it another way, if Christ was willing to lay it all on the line and even die for the sake of the Beautiful, shouldn't we, in imitation of Him, follow in His steps?

It's a sobering question, for inherently we know that the answer to that question is bound up in our suffering, just as it was for Christ. But it is a question we must not avoid if we are His true disciples.

Turn to Hebrews 13:12–14.

According to verse 12, where did Christ suffer?

What does verse 13 say we are to do as imitators of Christ? In other words, where are we to meet Him?

And, finally, according to verse 14, what is the reason we are to do this?

Why would the author of Hebrews tell us to "go outside the camp"? And what is "the camp" anyway? Turn to Numbers 2:1–34 (Numbers is the fourth book in the Old Testament). Briefly scan these verses and pay special attention to verses 2–3.

In light of Numbers 2, to what "camp" is the author of Hebrews referring? Who are the "campers" and what kind of camp is this—a summer camp or a boot camp? (Look at the language in verse 3 for clues.)

And, finally, what are the sons of Israel to camp around (see v. 2)?

After God freed His people from slavery to the Egyptians through events known as the "Passover" and the "Exodus," the Israelites wandered in the desert for forty years before ever reaching their final destination, the Promised Land. The books of Exodus, Leviticus, Numbers, and Deuteronomy all describe the rules of "camp life"—how the Israelites were to function as a people on the move, and more importantly, how a sinful people were to approach a holy God.

Numbers 2 describes exactly how the Israelites were supposed to camp each time God commanded them to stop and pitch their tents. Imagine with me for a moment the layout of the camp given to us in Numbers 2—and keep in mind, this is no rinky-dinky camp with a few small cabins, oversized fans, and bunk beds. This camp sheltered 603,550 men to be exact. (That's not including the women, children, donkeys, chickens, roosters, sheep, and cows!) In the middle of the camp was the "tent of meeting," also known as the sanctuary or tabernacle, where God met with His people. On each side of the tabernacle, Numbers 2 tells us that three specifically named tribes were to camp, with the tribe of Levi camped in the center.

Now keep your imagination going for just a minute more. Let's just say there were approximately one and a half million people (that includes women and children) in the camp. Since Port-a-Potties© and indoor plumbing were not around in approximately 1400 B.C., without getting too graphic, that is quite a bit of "waste" to have to manage. But, as always, our God thought of everything—even waste management.

Turn to Deuteronomy 23:12–14. (I promise there is a "beautiful" point in this—bear with me!)

Where were the Israelites to go when they needed to eliminate their waste? Fill in the exact words from verse 12 below:

"You shall also have a place _____ _____ _____ and go out there."

Think back to Hebrews 13:13. Where are we to go to meet Christ? Fill in the blanks from Hebrews 13:13:

"Hence, let us go out to Him, ___ _____ _____, bearing His reproach."

In addition to concern over hygiene and lowering the risk of disease, why do you think God commanded the Israelites to take their excrement outside the camp? (See Deuteronomy 23:14.)

According to Exodus 40:34–38, when Moses finished construction of the tabernacle by following the instructions God had given him, "the cloud covered the tent of meeting, and the glory of the Lord filled the tabernacle. And Moses was not able to enter the tent of meeting because the cloud had settled on it, and the glory of the Lord filled the tabernacle" (Exodus 40:34–35). For as long as the Israelites camped in the desert, the Lord's Presence, in the form of a cloud by day and a pillar of fire by night, camped with them. And wherever God moved, the Israelites moved. His Presence was there the entire time, plain for all to see (Exodus 40:38). But because of that, because God's glory literally resided in the very center of camp, *nothing* unclean was ever to reside inside the camp, for it was a direct offense to a holy God.

But here's the ironic thing: Hebrews 13 tells us that Jesus Christ, God in the flesh, stepped foot outside the camp onto unclean soil, a place where a holy God should never have had to tread. Outside the camp was not only where the excrement was taken, but it was where the lepers and the outcasts were sent as well. It was where both the literal and symbolic "refuse" of the earth dwelled. But that, my friends, is not only where Jesus stood but where He still stands today.

Ladies, we are about to unlock the biggest beauty secret ever kept under wraps. If you want to be beautiful, I mean really ravishing, the kind of beautiful where people literally stop and stare, I have four words for you: Go Outside the Camp.

As followers of Christ, we are called to get knee-deep, so to speak, not in spa treatments or pedicures or workouts or shopping sprees, but in the refuse, the dirty, the poor, and in the outcasts of the earth. If our Hero, Savior, and Friend spent His life making that which was ugly inherently beautiful, shouldn't we? And just as Christ works to give His people beauty for ashes, a spirit of praise instead of a spirit of despair, and the oil of gladness instead of mourning (Isaiah 61:3), shouldn't we?

The apostle Paul, quoting from Isaiah 52:7, calls a specific part of the body "beautiful" or "lovely." What is it?

What makes them beautiful?

The camp of the sons of Israel was not a summer camp, an arts and crafts camp, a fun activities camp, or even a sports camp—it was a spiritual boot camp! The tribes were called "armies," and they were to camp under their "standards," for God's people were *always* to be prepared to fight God's battles.

As followers of Christ in the 21st century, you and I are not any different. We are to sleep with the sword of the Spirit, which is the Word of God, in our hands; the helmet of salvation on our heads; and the belt of truth strapped to our waists (Ephesians 6:13–17). And we are to walk around with the shoes of the Gospel of peace on our feet, always ready to share the beautiful news of the Beautiful One who lived and died to make us beautiful once again (Ephesians 6:15).

Stop for a moment and think and pray. What fears or excuses keep you from living "outside the camp" with Christ?

Has God stirred in your heart recently to go "outside the camp" in any specific way and to get your hands dirty, so to speak, in serving Him? If so, how?

How are you going to begin today to shod your feet with the Gospel of peace, ever ready to spread the news of the Beautiful One everywhere you go?

Let's close today by spending the next few minutes committing your heart, your hands, and your feet to following your Savior wherever He leads, remembering that you do it seeking the beautiful city that is to come (Hebrews 13:14).

- Heart—

- Hands—

- Feet—

A Beautiful Place

Beautifying the earth with our hands, heart, and feet is a huge task—a task requiring a focused gaze on our Savior who has gone outside the camp before us. But rest assured that there is nothing else on which you can spend your life that is more rewarding or satisfying.

It is such a paradox that while we live on this earth, the place where we most often find the Beautiful One is not with the rich or the famous or the healthy or the whole—it is outside the camp with the dirty, the impoverished, the needy, the sick, the outcasts and the misfits. And to gain a vision of the beautiful, that is where we, as Christ's followers, should go as well.

I have a childhood friend whom I grew up with in Houston and eventually roomed with my senior year of college. My friend has always lived one of the simplest lifestyles I have ever observed. Clothes, hairstyles, jewelry, homes, and a wealthy lifestyle have never been attractive to her. If she had wanted any of the above, she could have had it. She was raised in a family who loves the Lord and is well off by anyone's standards. She could have chosen to live a comfortable life, in a comfortable neighborhood, married to a comfortable man, raising comfortable kids. But instead of living in comfortable security, Julie chose to minister to the world's poorest of the poor. She lived several years of her life in a Third World country reaching out and ministering to street kids. I have never known Julie to be concerned about her appearance—her clothing, jewelry, and hairstyle is always simple, and I think I've seen her wear make-up once at her sister's wedding. Yet Julie is one of the most beautiful women I know; in fact, just thinking of her causes a tightening in my chest and a lump in my throat. Her beauty overwhelms a room, a thought, a church, and even the dressiest of dinners. Why? Because she has adorned herself with the riches of Christ. She took His concerns, His cause, His Gospel, and His heart outside the camp to the forgotten, dirty, abused, ragged . . . and beautiful . . . street kids of Indonesia. My life is more beautiful by simply knowing Julie. And if I feel that way, I cannot imagine how Jesus feels.

Today, I want us, just like Julie, to gain a vision of the beautiful and to meditate on how the Lord is specifically calling you to His mission of making all nations, all peoples, and all things beautiful once again. John Milton, the great English poet, intellect, politician, scholar, and Christian penned these words:

For though I do not know what else God may have decreed for me, this certainly is true: he has instilled into me, if into anyone, a vehement love of the beautiful. Not so diligently is Ceres, according to the Fables, said to have sought her daughter Proserpina,[74] as I seek for this idea of the beautiful, as if for some glorious image, throughout all the shapes and forms of things ("for many are the shapes of things divine"); day and night I search and follow its lead eagerly as if by certain clear traces.[75]

If you have never thought about the beautiful, or your part in making the earth beautiful, it's time to start by following "its lead eagerly as if by certain clear traces." The journey begins by learning to see yourself for who you really are in Christ and walking in the confidence He gives to take authority over sin and its ugly effects by spreading the message of the Gospel in our homes, communities, and throughout the world.

Habakkuk, a very short book in the Bible, packs a powerful message in just three chapters. Turn to Habakkuk 1 (toward the very end of the Old Testament), and read verses 1–11. The first 4 verses are Habakkuk's questions to the Lord, and verses 5–11 are the Lord's reply back to Habakkuk.

What are Habakkuk's questions, and why does he seem to be so troubled?

Can you relate to Habakkuk's questioning? What acts of violence and injustice stir your heart? What effects of sin and unrighteousness in your family, city, nation, and around the world move you to pray, petition, and cry out to God?

In verses 5–11, what is the Lord's answer to Habakkuk?

Scary answer, huh? Habakkuk probably looked around and saw all of the godlessness and faithlessness in and around his culture; he probably heard the hoofbeats of approaching war, slaughter, and violence and thought, "All God needs to do is let the righteous be victorious and rule the day." Instead, God had a different plan. He said, "I am going to raise up a fierce, proud, and hated people to absolutely devour you." It almost seems as if God was saying, "I am going to fight sin with more sin, injustice with more injustice, wickedness with greater wickedness." And God's answer leaves Habakkuk scratching his head, wondering, "Where is the triumph of the holy, righteous, beautiful God and His people?"

So he questions the Lord again. Read Habakkuk 1:12–2:1 and summarize his second round of questioning in one or two sentences:

In Habakkuk 2:1, what does Habakkuk do to wait for the Lord's reply to his questions?

Now get ready to read the Lord's incredible answer—an answer that blew the doors off the concept of achieving salvation through good works long before the book of Romans ever came along. Read Habakkuk 2:2–4.

In verse 4, the Lord tells Habakkuk how the righteous shall live. Fill in the blank below:

"But the righteous will live by his _____."

In verse 3, God gives Habakkuk assurance about the vision He is giving him. What does He say concerning the vision?

To sum up God's reply, He basically says, "Habakkuk, the vision I've given you is real. Wickedness and perversion abound on the earth. Sin and suffering look like they have the upper hand. But the guilty *will* be held accountable for their sin (1:11b); the wicked *will* be brought to justice; the Lord your God, the Holy One, *is* in control (1:12). But it is not yet time. You are going to have to live by faith, trusting that all of My words are faithful and true and will stand the test of time."

To look around and see the seeming triumph of the ugliness of sin and evil all around was as heartbreaking in Habakkuk's day as it is in ours. But God tells us just as surely as He told Habakkuk: "You must *wait* for the vision and justice I will bring. This day, you must choose to live by faith."

So does that mean we just sit on our hands and think good, "believing" thoughts about God's ultimate goodness, sovereignty, and justice? Turn to James 2:14–17 and record below what he has to say about that:

When we behold a vision of the good, faithful, compassionate, and beautiful God, it changes us, just as it changed Habakkuk, and it propels us up and out of ourselves into faithful, accountable action.

 Think about the injustices that stir your heart the most. Prayerfully consider how God is propelling you into faith-filled action.

- In Your Home:

- In Your City:

- In Your Nation:

- In Your World:

James 1:27 has strong and direct words about what a heart truly devoted and surrendered to Christ looks like. According to James, what is "pure and undefiled religion"?

What God says throughout His Word is that He hates injustice. He loves the poor, the orphan, the widow, the child laborer, the prostitute, the downtrodden, the slave, the lonely, the outcast, the brokenhearted, and those who have no rights, no voice, and no name in this world. They are all intimately known and loved by Him.

As Christ's friends and followers, we are called to live by faith and not by sight, to gain a vision of the beautiful—of who God is and what He does—and to preach it with our words, hands, feet, and hearts to a dying, broken world. The next time you have a few spare moments to read, pick up a newspaper instead of a *People* magazine or the latest entertaining novel. Read through the section of international events, and pick a country, a widow, a child, or a community for which to pray. As you watch the news, don't just say, "Bless their hearts," or "Isn't that tragic?" *Cry out* to God on their behalf! If you are a stay-at-home mom, stop allowing home to feel like a prison. Use your time at home wisely, and consecrate your time to gain a vision of the beautiful, to pray out loud while you are doing the dishes, to teach your children about the nations, to take one day a week or a month to serve the poor . . . *with* your children. If you are single or married without children, stop seeing your "freedom" as a prison—use your time to gain a vision for the beautiful and then take those feet and *go*. Go where women with young children cannot. Go to the utmost parts of the world, your nation, or your inner-city and preach the good news of Christ.

As women, our God-given responsibility and privilege is to be life-givers; so what in the world are you waiting for? Get out there, whatever stage of life you are in, and give *Life*, Beautiful Life, through praying, serving, and going. In this instance, the wait is over. The time for action, in faith, is now.

 Let's close by reading Habakkuk 3:17–19, Habakkuk's faith-filled stance toward His sovereign, good God.

Use the lines below to turn this passage of Scripture into your closing prayer today:

Though the fig tree should not blossom
And there be no fruit on the vines,
Though the yield of the olive should fail
And the fields produce no food,
Though the flock should be cut off from the fold
And there be no cattle in the stalls,
Yet I will exult in the Lord,
I will rejoice in the God of my salvation.
The Lord God is my strength,
And He has made my feet like hinds' feet,
And makes me walk on my high places.

Habakkuk 3:17–19

DAY FIVE
Renewed

*Y*esterday, we closed with Habakkuk's prayer of faith and praise: "Though the fig tree should not blossom and there be no fruit on the vines, though the yield of the olive should fail and the fields produce no food, though the flock should be cut off from the fold and there be no cattle in the stalls, yet I will exult in the Lord, I will rejoice in the God of my salvation" (Habakkuk 3:17–18).

We, like Habakkuk, must choose to keep our eyes on the Beautiful One no matter what devastation we see going on around us. But I want to let you in on something—it will not always be so. The vines in our lives shall not always be unfruitful; the fields in our homes shall not always fail to produce a harvest; the yield of the olives we have planted shall not always leave us empty-handed. We shall not always live under the effects of a sin-torn, ugly world.

After He's been mutilated, mocked, and beaten, on the way to the cross Jesus says something very interesting. Turn to Luke 23:26–31. What does Jesus turn to say to the female mourners who were following Him?

Does this seem like a strange thing for Jesus to say, especially in light of the physical condition He is in? It certainly does to me! What "days" do you think Jesus was referring to (v. 29)?

Most certainly Jesus was referring to the destruction of Jerusalem by the Romans in 70 A.D., a tragic and terrible day for the Jews. They were not to enter their homeland again as an actual Jewish state until 1948 after the horrific event of the Holocaust. But Jesus was also referring to another "day."

Turn to Revelation, the book where we are going to spend most of our time today, and read Revelation 19:11–16. Jesus came to earth for the first time as a helpless, lowly baby born to poor Galilean peasants, and as a suffering, bleeding servant on His way to Calvary. But according to Revelation 19, how is He coming to earth the second time?

In light of Revelation 19, what do you think Jesus was telling the mourners who were following Him in Luke 23?

Our God is a God of Justice, Justice with a capital "J." He lets no sin go unexamined or unpunished. All will be laid bare before His eyes on the final day of judgment (Daniel 7:9–10; Revelation 20:11–15)—how terrifying! But, praise God, how thrilling! One day, we will all be made new and all of the wrongs of the earth will be made right.

Something else significant happens when Jesus returns. Turn to Revelation 21 and read verses 1–5. What happens to the heavens and the earth according to the vision that John, the author of Revelation, sees?

> *kainos*—"qualitatively new as contrasted with . . . numerically new or the last one numerically; to dedicate, consecrate into a qualitatively new use"[76]

In your concordance, look up the Greek word and definition for new (#2537) in verse 1, or copy both from the margin in the space below:

Since *kairos* means "qualitatively new" as opposed to "quantitatively new,"[77] this means that when Christ returns, He is not only going to bring justice with the sword of His mouth, instead of simply destroying everything and starting over, He is going to *renew* the heavens and the earth, making everything *tov* or "good" as it was originally created to be (see Genesis 1 and 2 from Day Two of this week). In other words, He is going to make all things beautiful *in their time* (Ecclesiastes 3:11).

According to Revelation 21:3, what is the chief characteristic of the new heaven and earth?

Do you remember the layout of the camp of the Israelites from Day Three earlier in the week? What was at the very center?

What was commanded to be outside the camp?

Revelation 21 takes us back to the very beginning. What made the Garden of Eden and the camp of the Israelites beautiful was the very presence of God. Nothing unclean was ever allowed to dwell in either.

Read Revelation 21:8, 23–27. Is anything unclean allowed to enter the new heaven and the new earth? If not, where does all that is "unclean" go?

In addition to the heavens and the earth being made beautiful once more, something or someone else is made beautiful again as well. I want you to read something I pray will bless you today. According to I Corinthians 15:40–44, 50–58, who, my friends, will be changed?

To the best of your ability, and according to what you've read in I Corinthians 15 and Revelation 21, describe what we will look like:

Ladies, this puts the absolutely worst hair day, post-pregnancy weight, stretch marks, or varicose veins in perspective—to say it plainly, who cares! *We will be changed.* These earthly bodies, along with the heavens and the earth, are passing away, and one day all of creation, including you and me, will be renewed. Engrave these Scriptures on your heart; bind them on your arm; write them on your forehead— do whatever it takes to remember that our earthly bodies are passing away, for we are not home yet.

In his sermon *The Weight of Glory*, C.S. Lewis says it beautifully. He writes,

> For if we take the imagery of Scripture seriously, if we believe that God will one day *give* us the Morning Star and cause us to *put on* the splendour of the sun, then we may surmise that both the ancient myths and the modern poetry, so false as history, may be very near the truth as prophecy. At present we are on the outside of the world, the wrong side of the door. We discern the freshness and purity of the morning, but they do not make us fresh and pure. We cannot mingle with the splendours we see. But all the leaves of the New Testament are rustling with the rumour that it will not always be so. Some day, God willing, we shall get *in*.[78]

In I Corinthians 15:58, what does Paul tell us to do in light of all that is coming? In other words, how are we to keep our eyes fixed on the beauty and the Beautiful One that are to come?

As we talked about earlier this week, you can be confident of the fact that the time you spend outside the camp investing in the work of the Lord is not in vain. Reward beyond your wildest imagination is coming. "So don't sweat the small stuff," as my husband likes to say. Spend your life and your time with the big picture in mind, with eternity in view. You will never regret the ways and the time you invest in making the outcasts of the earth beautiful; but I can say with certainty that you will very much regret the time you spend frivolously on that which is perishing.

Think back to some of our questions from Day Two and make an honest evaluation of the time God has given you and the ways in which you spend it. Are there ways you are spending your time frivolously, focusing on things which are perishing and simply do not matter?

How can you begin to "redeem" your time and focus instead on the things that are truly beautiful and that truly matter?

If you have children who are still at home, think about their schedules for a moment. What are ways in which they spend their time frivolously?

As their parent, what are ways you can help them "redeem the time" (Ephesians 5:16) and learn to focus on things that are eternal and will last?

What is something you need to do today to remind yourself and your children that your work for the Lord is not in vain?

To me, the best, most anticipatory part about the reward and the beauty that is coming is the Beautiful One Himself. Revelation 22:3–4 says, "There will no longer be any curse; and the throne of God and of the Lamb will be in it, and His bond-servants will serve Him; they will see His face, and His name will be on their foreheads." Never shall He leave us; never shall He forsake us (Deuteronomy 31:6); we will be with our God as His people forever.

To look a little further at this last point, turn with me to one more place in Scripture. The first wedding we see in Scripture in the line of God's chosen people is Isaac and Rebekah's. Rebekah agrees to marry Isaac without ever laying eyes on him; in other words, she's walking by faith and not by sight in a major way!

Turn to Genesis 24:61–67 and read about the first time Rebekah sees her groom.

In verses 63 and 64, the author of Genesis purposely uses the same phrase for what both Isaac and Rebekah do with their eyes. What is it?

According to verse 67, how does Isaac, Abraham and Sarah's long-awaited son of promise, feel about his bride?

The phrase "lifted up" in verses 63 and 64 bears the connotation of being totally taken up with one another.[79] And in ancient Hebrew culture, the eye always represented the fountain and wellspring of life. Scripture clearly portrays the patriarchs of the Jewish faith, Abraham, Isaac, and Jacob, as pictures, or small tastes, if you will, of the coming Christ. With that in mind, I believe in Genesis 24

God is painting a picture for us of the wedding of Jesus Christ, the Son of Promise, and His bride, the church, that is to come. When we behold one another, when we see Him face to face, as Rebekah "lifted up" her eyes and saw Isaac, we will be taken up with Christ and utterly swept away. And even more magnificent than that, Christ will be utterly taken with us as well.

Not only will we love passionately and completely, but we will be passionately and completely loved in return, for the word for "love" in verse 67 denotes an ardency and vehemence in feeling as well as a tender affection.

Ladies, if there are days, weeks, months, or even years when we do not feel beautiful, do not despair or be dismayed. Beauty is coming; it is coming in ways we cannot fathom or imagine. Our "Isaac" is not only waiting, standing out in the fields looking for our coming, He has the most beautiful "tent," the renewed heavens and earth, where He will take us with Him . . . Home . . . forever. Our job until then is to gain a vision of the beautiful and work tirelessly with beautiful hands, beautiful feet, and beautiful hearts, while waiting expectantly for His return.

Turn back to Day Four, and look at your response to how God is propelling you into faith-filled action in your home, city, nation, or world. Pick one of your responses to focus on in prayer and in action during this particular season of your life, and close today and this week with a commitment to go outside the camp to work for and love that which is truly beautiful, no matter what sin or ugliness around you remains. The Beautiful One is not only already there, but He is waiting for you, His beautiful bride, to join Him.

Lord, I commit to faith-filled action to work for beauty in Your world and with Your people through taking this specific step:

Give me a heart that loves Your beauty and hands that commit to working for the Beautiful One today and in the days ahead. In the Name of Jesus I ask all these things, Amen.

Waiting for Beauty

I. Setting Our Eyes—A Vision of the Beautiful

❑ We were created to _____ many beautiful _____ but to _____ only the _____ _____.

❑ I John 2:15–17—The _____ of the Flesh, the _____ of the Eyes, and the Boastful _____ of Life

A. 1st Thing that Must Happen: Gazing Upon the Beautiful One

❑ Psalm 27:1–8

1. v. 1—He _____ with the _____

2. vv. 2–3—We see where David's _____, yet he is _____.

3. v. 4—David's confidence rests on _____ _____: beholding the _____ of the _____.

4. vv. 5–6a—The Beauty of the Lord _____ his _____, so he can see what is _____, _____, and _____.

5. v. 6b—David has _____ in the_____ of his _____.

6. v. 8—The Key: "When Thou didst say, 'Seek My face,' my _____ said to Thee, 'Thy face, O Lord, I shall seek.'"

❑ We must learn to _____ our _____ so that we can _____.

❑ A Sanctified Imagination is not seeing what is _____; it is seeing what is _____.

❑ Ephesians 1:18–23

B. 2nd Thing That Must Happen: Unclogging Our Vision

❑ The Enemy of _____

1. Fantasy breeds _____, but _____ with _____ brings _____.

2. Remedy: Fix your _____ on _____.

❑ The Enemies of _____ and _____

1. We want what we do _____ have and we _____ what we do.

2. Remedy: _____ your _____.

3. Remedy: stop seeing God's "No" as _____ or _____, and see it instead as _____.

 • Isaiah 55:1–3, 10–13

II. The Power of the Beautiful

A. Gazing upon the Beautiful One empowers us to _____ beautiful people.

- Irony: the greatest revelation of the Beauty of the Lord is the _____ of _____.

B. Gazing upon the Beautiful One empowers us to _____ and _____ for beauty.

- Psalm 27:13–14

WEEK FIVE

Waiting for Fruitfulness

DAY ONE
Barrenness

Barrenness. Childlessness. Unfruitfulness. Those words have broken my heart and brought forth tears faster than any other wait I have known in my own life and in the lives of my family and close friends. And it seems everywhere I go, I hear about and see deep grief and longing over issues of infertility and childlessness.

Because of the tender nature of the subject matter we are addressing, this week has the potential to be a tough week. But there is good reason for our emotional tenderness. Proverbs 30:15–16 says, "The leech has two daughters, 'Give,' 'Give.' There are three things that will not be satisfied, four that will not say, 'Enough': Sheol and the *barren womb*, earth that is never satisfied with water, and fire that never says, 'Enough'" (emphasis mine).

As women, we were created to be fruitful, for God designed our hearts and our bodies to function in this way. And when our wombs are not satisfied, there is a constant ache deep within us likened to parched, cracked, dry land that never has enough water and always thirsts for more. Solomon also likens the womb to a leech that is never satisfied and cries out, "Give! Give! Give me a child! I want to produce life, carry life, feel life, and *love* life from within me! Give!"

So why in the world would a good God create a desire like that in the women He loves only to leave it crying out, unsatisfied, and unfulfilled? Why does the wait for fruitfulness exist whether one is single and desiring to be married and have children, or married, and for whatever reason, cannot have children?

I cannot, in my limited understanding, promise all of the answers this week, but I can promise the comfort and presence of the One whose heart, throughout the pages of Scripture and throughout the four corners of the globe, is *for* the barren woman, physically, emotionally, and spiritually.

BARRENNESS 139

Since this week addresses a sensitive subject for many of us, let's start our study with a prayer from Isaiah 49:15–16, and ask the Lord to give us His guidance and wisdom in navigating these potentially painful waters:

> *"Can a woman forget her nursing child,*
> *And have no compassion on the son of her womb?*
> *Even these may forget, but I will not forget you.*
> *Behold, I have inscribed you on the palms of My hands;*
> *Your walls are continually before Me."*
> *Isaiah 49:15–16*

> *Father, as a nursing mother cannot forget her child, so You cannot forget us. As You look*
> *upon our pain and longings, Your compassion rises to meet us in our need. Our "walls," our*
> *broken down, defenseless places, are continuously before You. So come and rebuild us; come*
> *and bring healing to our barren wombs and broken hearts. Thank You that in Christ we are*
> *not forgotten or broken but always remembered and made whole.*
> *In Jesus' Name we pray,*
> *Amen.*

With that prayer from Isaiah 49 planted in our hearts and minds, let's begin our study this week by reading the account of an incredibly significant barren woman who could stand here today and relate to our pain. Turn to Genesis 16:1–8, 15–16, and read about Sarah, Abraham's wife, referred to in Genesis 16 as "Sarai" before God changed her name.

Barrenness has the power to make us bitter, resentful creatures. From the account in Genesis 16, how has barrenness made Sarai bitter?

Barrenness also has the power to talk us into taking control of our situation (i.e., our fertility, life, marriage, ministry, and so on) into our own hands. How does Sarai take her barrenness into her own hands?

Before you check out and say, "You know, I really can't relate to this whole barrenness thing; I've never had any issues with infertility," or, "I am single and content and am in no rush to marry and have children." Or before you make a quick judgment in your heart and think, "Ancient cultures were so barbaric. I can't believe a culture would base a woman's entire worth on her ability to conceive," let's stop right there and re-think our definition of barrenness.

In the Old Testament, the word for barrenness is *aqar* and is defined as "the state of not being fertile, not being able to become pregnant."[80] Sounds simple enough. But there are certainly other ways of experiencing barrenness without experiencing infertility. As Tim Keller states in his sermon, "Real Joy and the Laughing Woman," every culture, group, or sub-culture has a standard by which they measure the worth, fertility, or fruitfulness of one another. In other words, every group has a standard by which they say, "If you are not _____ (attractive, intelligent, athletic, "spiritual," fill in the blank), you are barren."[81]

Think about your nation for a moment. What are the ways your nation tells you as women: "If you are not _____, you are barren." Write your answer(s) below:

Now let's go to a more focused level. Think about the specific geographical region in which you live, your city, town, or even your particular neighborhood, school, church, or work place, representing your social circle of friends. Maybe your "neighborhood" includes the street on which you live or the group of parents at the school where your children attend or even your Bible study class at church. In what ways does your city, neighborhood, and social circle tell you, "If you are not _____, you are barren." Write your answer(s) below:

And, finally, on an even more focused level, in what ways does your family now or in the home you grew up in tell you, "As a woman, if you are not _____, you are barren." Write your answer(s) below:

Are you starting to get the picture? Are you starting to feel Sarai's pain? Sarai wasn't just desperate to have a child; Sarai was desperate to have an *identity*. And her physical barrenness caused spiritual barrenness in her soul. Rather than waiting on the Lord in rest and trust, she became controlling, resentful, and bitter to the core.

Can you relate to Sarai? Are there ways, like Sarai, your barrenness has caused you to become bitter and resentful, creating barrenness in your soul? If so, how?

And, like Sarai, has your bitterness driven you to chuck the whole "waiting on God" thing and take your situation in life into your own hands? If so, what is it you are doing right now to manipulate and control, or what have you done in the past?

What was the end result of Sarai's manipulation (see Genesis 16:4–6, 15–16)?

What about you? What happened (or is happening now) when you stopped waiting on the Lord and took matters into your own hands?

My friends, the "Ishmaels" in our lives are never fun reminders of the destruction we wrought with our own hands. Barrenness can make us bitter creatures, seething with remorse, regret, anger, and hate for ourselves and those around us; or, as we are going to see this week, it can make us even more fruitful than the woman who has ten children or the wife with the ideal home and husband or the friend with the perfect looks, intellect, or career.

One last thing: the narrator in Genesis 16:1 tells us where Hagar, Sarai's maid, was from. Where was it?

Throughout the Old Testament, Egypt always represented a place of bondage, slavery, and direct rebellion against God. Egypt was also the place where the people of God continually ran when they refused to rely on God for strength and help.

Unlike Sarai in Genesis 16, refuse to run to Egypt in the midst of your barrenness. Turn instead to Yahweh, your covenant God, who alone can enter into your barrenness, any time, any culture, any way, and transform it from a wilderness of bitterness into a spring of joy.

End today's study with a prayer of repentance and a renewed commitment to turn from Egypt and your Ishmaels to a place of contentment and peace in waiting on the Lord and all of the fruitfulness He promises to bring.

Visited

I want you to stop and imagine with me for a moment the misery of Sarai's barrenness at the end of Genesis 16 and the beginning of chapter 17. The last two verses of Genesis 16 read, "So Hagar [Sarai's maid servant] bore Abram a son; and Abram called the name of his son, whom Hagar bore, Ishmael. And Abram was eighty-six years old when Hagar bore Ishmael to him" (Genesis 16:15–16).

With Sarai's loneliness, pain, and hurt in mind, read Genesis 17:1–2.

How old is Abram when the Lord appears to him?

So, using Abram's age as your "calculator," how many years have passed between Genesis 16:16 and Genesis 17:1?

Think with me for one second: Sarai left everything, *everything*, behind in the land of Ur, her homeland from where Abram had received God's call back in Genesis 12. For years she had followed Abram on what probably seemed like a fool's errand. Without a home to call a nest, she had lived in tent after tent until the desert dirt stuck between her toes and the grit ground between her now ancient teeth. Not only was *she* barren, but she lived in a barren, desolate place, a place that probably reminded her of the thirstiness and emptiness in her womb on a daily basis. Thirteen years had passed since Hagar bore Abram a son, confirming the fact that it was no longer "Abram and Sarai, the barren ones," but "Sarai, the barren *one*," for Ishmael was living proof, plain for all to see, "that Abraham still had the ability to sire a son in the years immediately following the promises. Sarai was the holdup."[82] Can you imagine? Can you imagine the weight of the shame and isolating, embarrassing pain?

I can so relate to those feelings of shame and thinking, "There's something wrong with *me*." After two miscarriages, it was obvious that my husband Jason was not the barren one; I was. There was something inherently wrong with my body, not with his. And although Jason, or anyone for that matter, never said a word that had even a hint of guilt or accusation embedded within it, I still wrestled with feelings of shame and inadequacy over my body's inability to function the way it was intended to.

In thinking back to our homework yesterday and the area of barrenness you personally struggle with, can you relate to Sarai's feelings of shame and inadequacy when it seems that all eyes are focused upon you?

After thirteen years of wilderness waiting, God spoke again to Abram. Continue reading Genesis 17:3–8, 15–22.

God comes to Abram and does several significant things, the first being that He reinforces His covenant with Abram, the second being that He changes his name.

What is the covenant that God confirms with Abram (vv. 4–8)?

- v. 4—

- v. 5—

- v. 6—

- v. 7—

- v. 8—

Abraham— "father of a multitude"[83]

What does God change Abram's name to, and what does your concordance tell you it means (#85)?

Something else significant happens in verses 15 and 16. What does God tell Abraham about his wife? (Be as specific as possible.)

- v. 15—

- v. 16—

Look in your concordance to find out what the name "Sarah" means (#8282):

What is Abraham's reaction to God's message about his wife (v. 17)?

After thirteen years of watching his wife suffer pain and humiliation as "the barren one," when God holds out hope and promise for Sarah, her husband falls on his face and laughs! Either the thought of his elderly wife with a huge belly was more than he could handle, or Abraham couldn't conjure up even one iota of hope for his barren wife, believing that "Sarai's barrenness was more powerful than God's promises."[85]

But God. God works even in the midst of our unbelief and laughter. So was God true to His word? Turn to Genesis 21:1–2 to find out.

Fill in the blanks below:

"Then the Lord _____ _____ of _____ as He had said, and the _____ did for Sarah as He had _____." (Genesis 21:1)

Let's look at the first two blanks you filled in. The word used in Hebrew for that phrase is paqad (#6485). Look it up in your concordance or in the margin and write the definition below:

Now look at Genesis 21:2. Exactly when did Sarah conceive and bear a son? Fill in the blanks once more:

"So Sarah conceived and bore a son to Abraham in his old age, at the _____ _____ of which God had spoken to him."

Isn't that beautiful? As the Hebrew tells us in verse 1, God didn't just glance at Sarah or remember her on His way out the door. Oh, no. He *visited* Sarah; He cared for Sarah; He looked after Sarah, and all at the appointed time (v. 2). Sarah's feelings of forgotteness, shame, inadequacy, and anguish through all of her barren years never left God's memory for one moment. He was simply waiting for the *appointed* time, the *best* time, the time when it would be clear to a watching world for hundreds and even thousands of years long after Sarah was gone, that the explanation for her child, her "fruitfulness," came from no one else but God.

Look at the third blank you filled in from Genesis 21:1. Who did God visit?

What significance is there in the fact that God gave Sarah a son and not Sarai?

Keeping your place in Genesis 21, turn to John 12:23-25. Here, Jesus is speaking about His upcoming death, but He is also speaking of a spiritual law or principle He wants His followers to remember and obey. What is it (v. 24)?

How do you think this principle applied to Sarah?

How do you think this principle applies to the area of your life where you feel most barren today?

Jesus confirms this spiritual law of death preceding life to His disciples on the night before He dies. We looked extensively at this passage in "Waiting for a Father," but let's turn again to John 15:1-2. What happens to every branch that does not bear fruit, and what happens to every branch that does bear fruit?

- Does Not—

- Does—

Sarah—not Sarai—bore fruit at the appointed time. In other words, *changed* Sarah bore a son, not perfect Sarah, or meddlesome Sarah, or young, beautiful, fertile Sarah, but pruned Sarah, old Sarah, visited Sarah, remembered Sarah. And the same principle is true for us if we are her spiritual daughters.

Chuck Colson, well-known Christian author, speaker, intellect, and founder of the ministry to prison inmates called *Prison Fellowship*, spent time in jail as a convicted felon for his involvement with the Watergate scandal under President Nixon. In his book *Loving God*, Colson reflects on one

particularly significant Easter morning. As he sat on a platform waiting for his turn to take the podium and preach to inmates in a prison he was visiting, he comments,

> My mind began to drift back in time . . . to scholarships and honors earned, cases argued and won, great decisions made from lofty government offices. My life had been the perfect success story, the great American dream fulfilled. But all at once I realized that it was *not* my success God had used to enable me to help those in this prison, or in hundreds of others just like it. My life of success was not what made this morning so glorious—all my achievements meant nothing in God's economy. No, the real legacy of my life was my biggest failure—that I was an ex-convict. My greatest humiliation—being sent to prison—was the beginning of God's greatest use of my life; He chose the one experience in which I could not glory for *His* glory.[87]

The more fruitful we want to become, the more we must die to our own names, titles, power, influence, significance, accolades, positions, and honors. In other words, the more we must die to ourselves. It's as simple as that, and, much of the time, it's as painful as that. God waits to use our barrenness and our *un*-fruitfulness until no one gets the glory but Himself for changed lives, changed names, changed hearts, and sometimes even changed circumstances.

Just a couple of other points about the life of Sarah before we end today's study—look back at the last two blanks you filled in from Genesis 21:1. Who did for Sarah just as He had promised?

Look back at Genesis 18:11. What does it tell you about Sarah?

As we touched on earlier, the "appointed time" was not only the time, but the only time, when all fruit-bearing success could be attributed to God. Beth Moore says it well in her Bible Study on the book of Genesis, *The Patriarchs*:

> To God, faith is often the point—God does nothing cheaply. Perhaps the divine nature of a promise fulfilled guarantees its expense. We may receive a hundred unexpected things from God with delightful ease while the fulfillment of some of the things we believe He promised us proves virtually impossible. You see, the impossibility is what makes the fulfillment of the promise fall under the *God category*. God makes promises man simply can't keep.[88]

And until that promised time came, there was nothing Sarai—or Sarah—in her barren state could do . . . except wait . . . and believe God, actively binding her heart to His.

Begin to ask yourself the following questions: Are there any branches God wants to prune in my life? Are there any barren branches He needs to completely remove? What are they, and why am I standing in the way?

Tomorrow we are going to spend time praying through the barren branches in our lives, giving God permission to clear them out of the way. But until then, hold onto hope that life will once again sprout in dry places. For our God is a Promise-Keeping God. Just ask Sarah, the fruitful one.

DAY THREE
Praying for Healing

Today I want to take time to process some of what we talked about yesterday and the day before. Waiting for fruitfulness, whether it is a child, a job, a calling, or a promise fulfilled can be one of the most painful waits God ever asks us to endure. If at all possible, do your homework today at a time when you can really be still. Turn off your phone, turn off the computer, television, and all other distractions, and ask the Lord for a focused heart as you look at the places that hurt the most while you learn to wait upon Him.

Are you in a place of barrenness, waiting for specific fruit? If so, there is space below to process your emotions before the face of God. Take as much time as you need, and be very clear and specific with the Lord. He wants to know your heart (Psalm 139:23):

Are you frustrated with the Lord in any way on this portion of your journey with Him? Again, be honest. Use this time to pour out your heart to Him:

Think back to our lesson yesterday. Are there any branches in your life God is in the process of pruning? Are there any barren branches He needs to completely remove? If so, what are they? Turn this response into a time of honest confession and repentance:

I Peter 3:3–6 tells us: "(3) And let not your adornment be merely external—braiding the hair, and wearing gold jewelry, or putting on dresses; (4) but let it be the hidden person of the heart, with the imperishable quality of a gentle and quiet spirit, which is precious in the sight of God. (5) For in this way in former times the holy women also, who hoped in God, used to adorn themselves, being submissive to their own husbands. (6) Thus Sarah obeyed Abraham, calling him lord, and you have become her children if you do what is right without being frightened by any fear."

According to this passage, who are Sarah's daughters? (Submissiveness to your husband is part of the answer, but not the whole answer! This passage applies to single women too! Pay close attention to verse 4.)

Using your answer above and I Peter 3:3–6, ask the Lord for a gentle, quiet, submissive, responsive spirit as you wait upon Him as Sarah did—not perfectly, but faithfully, hoping and believing life will always sprout from your barrenness:

Now ask the Lord for the grace you need to release any areas of waiting or barrenness to Him, to let go of any and all manipulation or control, and to trust He will fulfill His Word to you at the appointed time. (Often during times of prayer when I need to release something into the Lord's Hands, it is helpful if my body "prays" too. I will kneel or get into a posture of humility and turn my palms to the ground, signifying I am turning things over, or placing specific things, into God's Hands. Please feel the freedom to do the same—know this prayer time is sacred time just between you and the Lord.)

After spending as much time as you need "releasing" things to the Lord, now spend as much time as you need "receiving" from the Lord. If you feel comfortable doing so, stay in the same posture of humility, and turn your hands so that your palms are facing upward. Now ask the Lord for the grace you need to receive His Presence, His Peace, and His Powerful, All-Sufficient Promises during this time of waiting on Him. If you need help getting started, turn Hebrews 4:15–16 into a prayer:

> *"Lord, because Christ can sympathize with my weaknesses, empathize with my pain, and feel my grief, because He has been tempted in all things, yet was without sin, I therefore draw near to your throne to receive mercy and find grace in my time of need. I lift my hands and my heart to Jesus, knowing and believing He is all that I need as I wait."*

If expressing your barrenness is too painful to put into words, either written or spoken, know that it's OK. Many of us have been right where you are. There were times during my miscarriages that the only thing I could do was lie on my back on the floor with my Bible against my chest and just cry. Even then, or, I should say, especially then, the Lord was with me. Take comfort in the knowledge that the Spirit Himself helps you in your weakness. He intercedes for you with groanings too deep for words in accordance with the very will of God (Romans 8:26–27).

Finally, read Jeremiah 17:5–8, 13–14 and turn it into a prayer asking for comfort and healing in your season of need:

> *(5) Thus says the Lord,*
> *"Cursed is the man who trusts in mankind and makes flesh his strength,*
> *And whose heart turns away from the Lord.*
> *(6) For he will be like a bush in the desert and will not see when prosperity comes,*
> *But will live in stony wastes in the wilderness,*
> *A land of salt without inhabitant.*
> *(7) Blessed is the man who trusts in the Lord and whose trust is the Lord.*
> *(8) For he will be like a tree planted by the water,*
> *That extends its roots by a stream*
> *And will not fear when the heat comes;*
> *But its leaves will be green,*
> *And it will not be anxious in a year of drought nor cease to yield fruit. . . ."*
> *(13) O Lord, the hope of Israel,*
> *All who forsake Thee will be put to shame.*
> *Those who turn away on earth will be written down,*
> *Because they have forsaken the fountain of living water, even the Lord.*
> *(14) Heal me, O Lord, and I will be healed;*
> *Save me and I will be saved, for Thou art my praise.*

Ask the Lord for the courage and the obedience during this time not to trust in man or to make places or people your strength. For not only will you be barren in a physical sense, but your heart will become a barren desert wasteland as well (vv. 5–6).

Ask the Lord during this season of barrenness to make you like a tree whose roots go deep down into streams of living water and who does not fear when seasons of heat or drought come. Ask Him for the ability to bear fruit in Christ through patient trust and rest when physically speaking, it seems impossible (vv. 7–8).

Ask the Lord for the grace never to forsake your Fountain of Living Water, even in the seasons of severest drought. And for the times that you have forsaken Him, repent and ask Him to come and refresh you once again and to heal every broken and bruised place, so that you would not be put to shame, and so that your wounds would not continually lead you astray. Tell the Lord that more than a child, spouse, calling, or job, He is your salvation and He is your praise (vv. 13–14).

Finally, ask for the ability, no matter the cost to self, to bear fruit, fruit that will last and grow at His appointed time in His appointed way (John 15:16). You can ask and pray all of this in confidence, knowing that bearing eternal, lasting fruit is God's perfect will for your life.

Thank you for letting me accompany you on this journey of processing, repenting, releasing, receiving, asking, and healing. I pray that you have met, very intimately, with God.

Go forth today knowing that according to I Peter 3:3–6, Sarah's daughters are the women who, even in the midst of the driest, most difficult times of barrenness, each morning, each moment, each situation, and each day, adorn themselves with the imperishable beauty of a spirit that gently and quietly submits to God, no matter the cost to self, no matter the extent of the barrenness, and no matter the length of the wait.

May you and I have the courage, step-by-step, day-by-day, to be imperishably, eternally beautiful to our Heavenly Father as we faithfully, submissively, responsively, quietly, and prayerfully . . . wait. The appointed time is coming. Until then, as we make Him our very Fount of Living Water, we wait. And as we do so, we can be confident that we shall not end our journey without bearing much, much fruit.

DAY FOUR

Fruit and Fellowship

*A*gain, thank you for being willing to enter into a journey of prayer and healing yesterday. I pray that God continues to minister to your soul, healing and comforting you in deep and specific ways throughout the remainder of this study.

We have already spent the last three days talking about fruitfulness, but today I want to look specifically at the concept of fruit. Even though we are waiting to produce "fruit," that word can sound rather archaic or outdated to our post-modern ears.

According to Scripture, what exactly does "fruit" mean? And does it solely pertain to having children? And if a woman never has children, either because of singleness or infertility, does this mean she is destined to remain "fruit-less" her whole life?

According to God's Word, the answer, emphatically, is "No!" Our longings for fruitfulness go beyond holding the fruit of our womb in our arms: they are rooted in eternal longings given to us by the very heart of the Father. Turn with me once again to John 15.

Think back to the context of John 15 from "Waiting for a Father." The night before His crucifixion, Jesus had an intimate conversation with His closest friends, and in John 14–17, we are privy to Jesus' final instructions to the eleven disciples who followed Him (Judas was already gone by this point in the narrative).

Just as we did in "Waiting for a Father," let's pay special attention to our Lord's final words to the disciples He loved, for, in many ways, they are also His final instructions to us. This time as you read, focus on Jesus' references to "fruit" and "fruitfulness" in addition to what you've already seen about the Father.

Read John 15:5–9, 12–17.

If you could sum up in one sentence what Jesus is saying to His disciples in these verses, what would it be?

If we obey His command to abide in Him, what will be the natural outcome of our abiding (see v. 11)?

When Jesus talks about "fruit," what is He referring to in this context? To support your answer, read Galatians 5:22–23, and then give a definition of "fruit" below:

The word for "fruit" in the Greek, *karpos*, has several different meanings, but in his *WordStudy Dictionary* of the New Testament, Spiros Zodhiates says it this way: "In the New Testament, the redeemed human life is presented as a field with God being the owner, in expectation of fruit to be rendered and shared with Him. In I Corinthians 3:9, Paul reminds his readers that they are God's husbandry (. . . field, farm). . . . Christians, individually and collectively, are expected to produce good results, 'fruit unto God' (Rom. 7:4).[89]

Think with me for one moment: picture in your mind a beautiful field. Perhaps you saw it on a road trip as you glanced out of the window of your car, perhaps it is a piece of property you or your family owns, or maybe it is even somewhere you have seen only in a picture.

Now, go one step further and imagine the owner of that field coming out to survey his or her land. I think of my father-in-law who owns property near Brenham, Texas. On any given Saturday morning, you can find him in his open-air jeep driving slowly across the fields of his property, checking on grass growth, cattle movement, ruts in the ground, and fences that need to be mended. He knows every patch of earth, every blade of grass, and every gorgeous sunrise and sunset view on that property. My father-in-law loves his land—and he works his land to get the maximum profit, harvest, beauty, and enjoyment from it.

That, my friends, on a very limited scale, is how God views our hearts. Back and forth He goes, on any given day, walking the length, breadth, height, and depth of our hearts searching . . . for what? For beauty, enjoyment, harvest, heavenly profit and . . . fruit.

Please write John 15:16 below:

You and I as believers in Christ have been chosen and appointed to bear fruit. What kind of fruit? Fruit of the womb? Fruit from a tree?

Fill in the blank below:

"Fruit that will _____."

If you are a mother of one child or of many children, you are blessed. Scripture tells us that the fruit of the womb is a great reward (Psalm 127:3). But children or no children, you are called, dear sister, to bear fruit, fruit that will last. Fruit that is eternal and goes beyond flesh and blood. Fruit that is ultimately and completely satisfying. So if in your wait to bear physical fruit from your womb you become discouraged or even feel purposeless or hopeless, inscribe John 15:16 upon your heart. Do not be discouraged; do not be dismayed. The Lord has appointed you to bear fruit—specific, eternal works for His Name that are just as impactful and lasting as physical fruit.

Resist the temptation to become consumed with or abnormally focused upon your inability to bear children. Instead, turn your eyes off your circumstances, and rather than looking inward, look upward and outward to the God who created you to bear fruit sweeter and richer and fuller than you could ever dream. We waste so much potentially satisfying, fruit-bearing time with the Lord because we are so focused on what we want but do not have. Focus instead on the Fruit-Bearer Himself, and you will be amazed at the harvest He brings forth from your life.

What is the criterion for the woman who wishes to bear much fruit? (It is woven all throughout John 15 but is stated most clearly in verses 5 and 9).

Even though we have been chosen as Christ's friends to bear fruit, our focus is not to be on the fruit itself. As soon as we do that, we become burned-out, stressed-out, performance-oriented, driven women. So how do we keep our focus on abiding *in* Christ rather than producing fruit *for* Christ?

Turn to Revelation 3:20. Jesus is speaking here; what does He tell us He is doing?

What happens when someone hears His Voice and opens the door?

Who is Revelation 3:20 written to? Read Revelation 3:14 to find out and fill in the blanks below:

"And to the angel of the _____ of _____ write."

In Revelation 3:20, Christ is not knocking on the door of the hearts of unbelievers; it is believers He is seeking entrance to! What He so clearly communicates here is that His main desire for His church is not for her to work *for* Him; it is for her to dine *with* Him, to fellowship and sup in intimate communion with Him on a regular basis.

But what this verse also implies is that Christ knocks and knocks and knocks and calls and calls and calls *but only for a time*. My brother Taylor recently taught a sermon on this passage, and he reminded the congregation that when a person stands knocking on a door, he does not knock forever. If the person inside does not answer, the knocker will eventually go away. Christ is no different. The awful implication in Revelation 3:20 is that He will not knock forever. There are moments of barrenness, suffering, or pain when we can hear and feel the "knock" of Christ on the door of our hearts. We know that our pain is meant to draw us *in* to further intimacy with Christ, not to push us further away.

And the message to us as believers is when we hear and sense the "knock" of Christ, especially in our barrenness, we are to stop whatever we are doing, overcome whatever we are "feeling," and let Him in. He will not knock forever, and if we do not turn from our busyness or look up from our inward focus to open the door, our particular chance at intimate communion because of our barrenness will be lost forever. Our salvation is never at risk of being lost, but intimate communion with the Savior is.

Through your barrenness, have you felt the Savior knock and call to you in a way you have never sensed or felt before? If so, explain below:

If so, have you let Him in? Have you taken time to sit with Him, sup with Him, eat with Him, drink with Him, and commune with Him in the very midst of your barren state? If you have, explain below. If you haven't, think about why not, and explain below:

Remember the quote from Leigh McLeroy's book *The Beautiful Ache* from Day One in "Waiting for Beauty"? She writes about many of the things that cause an "ache" in us, the things that call out to us to stop and let Divinity in. I believe that the "aches" we so sharply feel are also the "knocks" of Christ as He stands and pounds on the door of our hearts, seeking entrance in. With that in mind, consider this quote from the same book:

> So what if the next time it [the ache] came you opened your heart just a little wider and allowed it even further in? What if you offered the ache a standing invitation to visit whenever it liked, to drop in anytime it was "in the neighborhood"? What if you denied the urge to fill the crevice or crater-like space it makes with activity or noise or food or drink—and simply sat with it awhile?[90]

When we wait to bear fruit, when we struggle with unfulfilled hopes, unfulfilled dreams, and unmet expectations and want *more*, when the ache to labor and bear something that will outlast us seems so great it might rip open our souls, let Christ in. Fruit is waiting—eternal, real, appointed fruit that comes in all shapes and sizes. But we must learn to recognize that ache when it comes knocking as nothing less than the knock of the Lord Jesus Christ Himself.

How are you going to let Christ in today, this moment?

How are you going to let Him inside in future moments? In other words, what are you going to do so that you will recognize and heed the knock?

Close today in a time of prayer, asking the Lord that you might bear full, rich, satisfying fruit while fellowshipping with the One your heart was created for—He's waiting:

"Sing, O Barren Woman!"

Thank you for going the distance with me this week and, most importantly, with the Lord on this journey of waiting for fruitfulness. Perhaps no other waters are more frightening, turbulent, and painful to tread than the waters of barrenness, but you have braved them well and entered into the waters of restoration and healing for your soul. From here on out, may your relationship with the Lord only continue to grow more intimate and trusting as you open your heart to Him in the midst of your barrenness, allowing His fruit to take root and grow.

Today, I want us to take one last look at fruitfulness in one of my favorite chapters in Scripture—Isaiah 54. This chapter is so full of promises to the barren woman, we will only begin to skim its surface today. So go ahead and read all seventeen verses of Isaiah 54, and let your soul savor each one.

Who is the one who is to be shouting for joy (no cheating by looking at today's title!), and why is she shouting (v. 1)?

Before we continue any further, I want to give some context about the identity of the barren woman here in Isaiah 54. While at a literal level she is exactly who Isaiah says she is—a barren woman, at another level, she represents the nation of Israel as a whole. Despite God's faithfulness to Israel, Israel continually rejected the Lord and went the way of surrounding nations by worshiping other gods. Isaiah spent much of his prophetic career denouncing Israel's unfaithfulness and prophesying about the punishment and destruction that was headed her way. But he also spent much of his time announcing the comfort and restoration of Israel through the coming of a King and Suffering Servant who would forgive all of their sin and make a people holy and ready for Himself. Through this Servant's suffering, Israel's barrenness and sinfulness would be transformed into beauty, fruitfulness, and great joy.

Yet while these promises held true for the barren woman on a literal level and the nation of Israel on a national level, they also hold true today for the people of God and the church of Christ on a global level. Christ came as the Suffering Servant and through the cross dealt with the consequences of our sin and spiritual barrenness. But He will come again one day as a conquering, victorious King to put away the effects of physical, emotional, and spiritual barrenness and rule over a righteous, fruitful Kingdom where barrenness will be banished forevermore. Until that day, we eagerly wait in the here and now, trusting in the promises of God to turn our barrenness into joy and to fully heal us, if not in the present, then when He comes again one day.

Today, we are going to look at how God uses His care and concern for the plight of the barren woman on a literal and physical level to point us to what He has done for us, His church, to a greater degree on a spiritual level.

As you answer this next question, keep in mind the context of the barren woman in Ancient Middle Eastern cultures (and still in many cultures today). The barren woman's plight was absolutely hopeless. She was single either because her parents could not afford a dowry or because of some physical defect that made her undesirable. She had no way of earning an income, no job skills or job market, and no hope for the future. When her parents died, she became truly penniless and destitute because women, for the most part, did not receive an inheritance.

Or, the barren woman was married and not able to conceive. This meant she had no value, identity, or place in her culture, society, or even in her own home. Many infertile, married women were treated harshly by their husbands because of their infertility.

Or, like Ruth in the Old Testament, the barren woman was a widow with no children, or a woman whose husband had abandoned her, and she was destined to live her days like the single woman, penniless and destitute.

To sum up her situation, the barren woman was a desolate, destitute, lonely woman with no hope or purpose in sight for her present or her future.

And do not think that the plight of the barren woman died out with Sarah and Abraham. The information I shared with you about barren women came not from the pages of any scholarly commentary or book, but from my time spent abroad a few years ago and from my visits with friends and missionaries.

If you were a barren woman in an ancient culture or in certain parts of the world today, what would be the state of your soul? How do you think you would struggle physically, emotionally, mentally, and spiritually? Really try to put yourself in the barren woman's place, and record your thoughts about her struggle below:

- Physically—

- Emotionally—

- Mentally—

- Spiritually—

With the extent of her plight in mind, what are the extraordinary promises God makes to the barren woman in verses 2–4?

How do these promises provide for the barren woman's physical needs, remembering that she has no dowry, no inheritance, and no financial security for the future?

How do these promises provide for the barren woman's emotional needs?

One word, in particular, in verse 4 is a powerful one. Look up the definition for "shame" (#954) in the margin or in your concordance. Write below the words or phrases from the definition that stand out to you the most:

> *Buwsh*—"confounded . . . disappointed, to keep waiting, to become pale or to blush. The word often occurs in contexts of humiliation or shattered human emotions . . . public disgrace . . . the confusion, embarrassment, or dismay when things do not turn out as expected. . . . The opposite meaning is trusting God."[91]

Did you catch the phrase "shattered human emotions" and "dismay when things do not turn out as expected"? That pretty much sums up infertility and barrenness, doesn't it? But God alone can put our shattered pieces back together. Isaiah 54 tells us, "Do not be dismayed! Do not fear! Actually, throw a party! Rejoice!" Why? Verse 5 spells it out for us.

Who is the barren woman's husband, and what is His Name?

When does verse 6 say the Lord calls His bride? Is it when she is whole, made new, emotionally stable, and put back together?

Can't you feel the tenderness of God's Spirit here toward those who are hurting? No matter what our politically correct culture tells us, we need to remember one thing: *the Lord loves women*, especially the broken, barren, hurting, and shattered ones. His heart is to love, honor, provide for, protect, and call them His own.

How does Isaiah 54 tell us God ministers to the whole woman? In other words, how does He rebuild her shattered human emotions? List at least six ways He does this:

1.

2.

3.

4.

5.

6.

My friends, God's promises to the barren woman did not end in Isaiah's day and age; they are for you, today, this moment, here and now. Although I cannot even begin to scratch the surface of what they mean, it's something like this: "God, in His great beauty, richness, holiness, and majesty, was looking for a bride, and His eyes rested on the shattered, bruised, broken, beaten, abandoned, and forsaken woman—the barren woman. She had no beauty to attract Him, dowry to offer Him, or children and legacy to leave Him. But that did not matter. For all He wanted to offer her was Himself."

Verses 7 and 8 describe God's emotions toward the woman He has called His own. What are they?

How? How can God offer us everlasting lovingkindness and great compassion when the shame and sin we have wallowed in up until now is the exact opposite of trusting Him?

For all the times I've read and re-read Isaiah 54, I have never noticed until today that the chapter preceding Isaiah 54 is . . . Isaiah 53. Sounds like common sense, doesn't it? (But no one has ever accused me of having too much common sense!) But it's the *words* in Isaiah 53 that struck me in a new way.

Please read Isaiah 53:4–5, 10–12.

Who bore the shame of the barren woman?

That, my friends, is why we, the un-fruitful, un-satisfied, un-glorified barren women, are called "comforted," "wife," "friend," and "beloved." And that is why the prophet Isaiah has the boldness and even audacity to proclaim, "The one who has absolutely nothing, nothing in the present and no hope for the future, has absolutely everything through the Suffering Son."

Isaiah 9:6 tells us, "For a child will be born to us, *a son* will be given to us; and the government will rest on His shoulders; and His name will be called Wonderful Counselor, Mighty God, Eternal Father, Prince of Peace (emphasis mine)."

Did you catch that? We have been given a *Son*. That is why the shattered woman can sing. That is why the barren woman can rejoice! Christ is the fruit *all* of our hearts have been waiting for, no matter how many physical descendants we do or do not have. He is the Son for the grieving woman, the lonely woman, the single woman, the married woman, the barren woman, the rejected woman, the widowed woman—every woman. Our job in the midst of our barren state is to respond to His lavish love.

How has the Lord reached out to you with His love over the past few weeks, month, or even year? Think back to yesterday; have you been responding to His call to come and be His bride, even in the midst of your barrenness?

Are you ready to "enlarge the place of your tent . . . and spread abroad to the right and to the left" so that "your descendants will possess the nations" and "resettle the desolate cities" (Isaiah 54:2–3)? If you remember one thing today, remember this: through Christ, *God has spiritual descendants for you to bear* that will spread His kingdom and family all over the face of the earth, beginning with your spiritual seed.

Stop focusing on your barrenness and look instead to the Son! He is yours for the taking, and His kingdom and inheritance is your rightful inheritance. But you must begin by responding to the voice of your Husband, looking up from your shattered pieces and allowing Him to put you back together again.

How is God equipping you to birth spiritual descendants all over the face of the earth? Perhaps it's taking the same step you committed to taking last week in "Waiting for Beauty," or perhaps it's

something different. Most likely, the very same things, people, and places you long to beautify through the Spirit of the Lord are the very same places where your spiritual descendants dwell. Maybe it's meeting once a week with a neighbor, co-worker, or friend to pray for a particular nation. Maybe it's going to a specific nation to do God's kingdom work. Or perhaps it's implementing family devotional and prayer time for the nations before or after a meal. Perhaps it's fostering or adopting a child from your city or another nation. Or perhaps it's driving across town once a week or once a month to befriend a child in the inner city or to visit and befriend prisoners in the closest prison to where you live.

Think back to the step you committed to taking in "Waiting for Beauty"; is the Lord stirring you to add anything to that step? Or simply affirming your desire to continue walking in the same direction? How is He stirring your heart today in the season you are in? Take a moment to write out your response to the Lord, and then ask Him to use you to multiply His descendants all over the face of the earth:

I don't know who your spiritual descendants are, but I can promise you one thing: God does. He is waiting to multiply your descendants and your seed in more ways and into greater numbers than you can imagine. And one day, He is not going to buy the excuse, "But Lord, I was barren. I didn't have enough money or time or a husband or fertility or resources." He will look at us and say, "My child, my daughter, my wife, my bride, you had *Me*."

So . . . what are you waiting for?

I. The Pain of Barrenness

❑ The opposite of fruitfulness is _____.

❑ Is. 54:1—*Aqar* (the Hebrew root word for "barren")—"to _____ up (especially by the _____); specifically to _____; figuratively to _____ - _____ down, _____ up"[92]

❑ Is. 54:4—Primary Emotion Associated with Barrenness: _____

Buwsh—"to be ashamed; to be _____, to be _____, to keep _____ . . . This is a root meaning to 'to become pale' or 'to blush.' When failure of sin occurs, there is a disconcerting feeling, a flushing of the face . . . The word often occurs in contexts of humiliation and _____ _____ _____. It is the feeling of _____ _____. *Buwsh* is the confusion, embarrassment, or dismay when things do not turn out _____ _____. The idea of shame at the hands of an utter defeat pervades the mood. Disillusionment and a _____ _____ follow. The opposite meaning is _____ _____."[93]

Every culture (and sub-culture) has a standard by which they say, "If you are not _____, you are barren."

II. The Promise of Fruit

❑ **The Emphasis:** The emphasis throughout the Old Testament is on _____ fruit and _____ children; but the emphasis throughout the New Testament is on _____ fruit and _____ children.

❑ **The Promise:** "You did not choose Me, but I chose you, and _____ you, that you should go and bear _____, and that your _____ should _____, that whatever you ask of the Father in My Name, He may give to you." John 15:16

❑ **The Definition:**

- **Physical Fruit:** the product of the union between one _____ and one _____.

- **Spiritual Fruit:** the product of the union between the _____ of _____ and the _____ of _____ displayed through the _____ of the Spirit (I Cor. 12; Rom. 12) and the _____ of the Spirit (Galatians 5:19–24) in our lives.

- **The Challenge:** Sometimes, the beginnings of that fruit look like _____, and we must learn to trust that we serve a _____ _____.

III. The Illusion of Barrenness and The Choice of Fruitfulness

❑ Eve chose temporary _____ for eternal _____ (Genesis 2:8–10, 16–17; 3:1–6).

❑ Christ chose temporary _____ for eternal _____ (Matthew 4:1–11).

IV. Battling Barrenness

❑ **Eve—What *Not* to Do:**

(1) Entered into _____ with Satan

(2) _____ the Word of God

(3) Used the Word of God as a _____

❑ **Christ—What To Do:**

(1) Stayed _____ of Dialogue with Satan

(2) _____ and _____ the Word of God

(3) Used the Word of God as a _____

V. Eternal Fruit

❑ **In the midst of our seemingly barren circumstances, we have two choices:**

(1) **Jeremiah 17:5–6**—"Thus says the Lord, '_____ is the man who trusts in _____ and makes _____ his strength, and whose heart turns _____ from the Lord. For he will be like a _____ in the _____ and will not see when prosperity comes, but will live in _____ _____ in the wilderness, a land of salt without inhabitant.'"

(2) **Jeremiah 17:7–8**—"'_____ is the man who trusts in the _____ and whose trust _____ the Lord. For he will be like a _____ planted by the _____, that extends its _____ by a _____ and will not fear when the heat comes; But its leaves will be green, and it will not be _____ in a year of drought or cease to yield _____.'"

❑ **Revelation 22:1–3**—To point others to the Tree of Life _____ we must eat of the Tree of Life _____

• **I Peter 2:24**—"And He Himself bore our sins in His body on the _____, that we might die to sin and live to righteousness; for by His wounds you were _____."

Xulon—"_____, timber or _____"[94]

• **Galatians 3:13–14**—His _____ of Greatest Barrenness Became Our _____ of Greatest Fruitfulness.

VI. The Sound of Barrenness

❑ Barrenness Always Sounds Like a _____

• **Rev. 3:20**—"Behold, I stand at the door and _____; if anyone hears My voice and opens the door, I will come in to him, and will dine with him, and he with Me."

WEEK SIX

Waiting For Healing

Our Broken Bones

*E*motional, physical, and spiritual healing is something for which we all long. We ache, cry, and pound our fists for it, often on the very chest of God. I received a call this week about my uncle. Several weeks ago, he had by-pass surgery, and ever since the surgery, his heart has not done well. This week his health began to fail rapidly, and his heart had to be shocked back into rhythm more times than I can remember.

When I received the call that he was not doing well and the doctors had given him a 10% chance to live, my tears began to flow. I called a good friend, and as I got on my knees, we prayed over the phone for God to heal wounds on all different levels. We prayed for physical healing for my uncle, emotional healing for my aunt, and spiritual healing for my entire family.

Waiting for healing is like that. Usually it's never just about healing in the physical realm. When we or someone we love is hurting, when cancer strikes or a bone breaks or disease raises its ugly head, we cry out for healing—first on a physical level, and then, as God peels back the layers, on emotional and spiritual levels too. It is as if the broken bone points to our broken hearts, showing us how the real issues are about relationships with people—family, marriage, siblings, friends, and ultimately God.

So what do we do when disease strikes? Where do we go when wounds are exposed? What happens when everything within us aches for healing—for ourselves or for someone we love?

Before we turn to Scripture, I want you to think for a moment about healing. Are you waiting for physical, emotional, or spiritual healing in any area of your life? (Just think about yourself for a moment; we will get to others in a second.) To help you process, think about your need for physical, emotional, and spiritual healing from any of the following seasons of life that apply to you:

❑ Childhood (Birth–5 years old):

❑ Elementary School (6 years–11 years old):

❑ Junior High (12 years–14 years old):

❑ High School (15 years–18 years old):

❑ College (19 years–22 years old):

❑ Out of School (22 years–30 years of age):

❑ Ages 31–40 years old:

❑ Ages 41–50 years old:

❑ Ages 51 – 60 years old:

❑ Ages 61-70 years old:

❑ Ages 70 years and older:

🌱 Are you waiting for healing for members of your immediate family? If so, who are they, and what kind of healing are you waiting for?

🌱 Think about members of your extended family. What kind of healing are you waiting for with them?

🌱 Last, I want you to think about your network of relationships outside of family. Are there any friends, neighbors, co-workers, or acquaintances for whom you wait for healing?

Friends, I don't want to allow each of the above things to surface just to bring up pain. I want us to experience true healing this week and to close this chapter being *confident* of the fact that each particular ache and wound in our bodies, souls, and spirits that cries out for healing in ourselves, our family members, and friends is allowed by the Lord to occur for a reason—to bring glory to His Name and to draw us even closer to Him.

During this week of study, I do not claim to have all of the answers for suffering in this world. Nor do I claim to be able to answer all of our questions or silence all of our *why*'s. But I do long to provide one thing: hope. I pray that at the end of this week, each of us will be able to look over our list of aches and say, "I have hope that the Sovereign Hand of God is working and ultimate healing is coming. I do not know if it will be in this life or the next, but I am confident that 'He who began a good work in me, my family, and my friends will carry it out to completion until the day of Christ Jesus' (Philippians 1:6)."

With this in mind, let's turn to one of Scripture's most beloved and well-known Psalms, Psalm 51, written by King David. David, a "man after God's own heart," was still a man in need of healing (Acts 13:22). After having an affair with a woman named Bathsheba and then covering up his sin by arranging her husband's murder, David was held accountable and given grave consequences for his sin by the Lord through the prophet Nathan.

Whether we are in need of physical healing, healing for sin we have committed, or healing from sin that has been committed against us, I think we can learn a few things about the nature of healing through David.

Read Psalm 51:5–9. Try to read it within the context of someone who is crying out for healing.

Over the next few days, I want to examine, piece-by-piece, each principle of healing David gives us in these verses. Let's start with verse 5. What does David mean when he says, "I was brought forth in iniquity, and in sin my mother conceived me"? Do you think he is trying to lay the blame for his sinful actions of adultery and murder on someone else?

To help us understand David's cry in Psalm 51:5, turn to Romans 5:12. What does Paul tell us spread to all men, and why did it spread?

Who is the "one man" through whom sin entered the world? To confirm your answer, read Genesis 3:17–19.

According to Genesis 3:17–19, what was the curse God placed on Adam and on the earth?

- Adam—

- The earth—

As we look around us and see evidences of the curse or the consequences of Adam's sin and ours worked out on a daily basis, and we cry out for healing, it is easy to think that perhaps God likes it this way, or at the very least, doesn't care. Otherwise, He would do something about it, right? He could call an "interference" and save the day like Superman; He could throw Satan into the fiery furnace ahead of schedule; or He could totally reverse the effects of the curse and cause those who suffer to suffer no longer.

What God has done, as only He can do, is exactly that—He has reversed the effects of the curse and tells those of us who suffer and belong to Him that a day is coming when they will suffer no longer. But in the meantime, during the interim, we have to wait for healing.

If you are ever tempted to wonder if God cares or wanted it this way or somehow takes sadistic pleasure in the suffering of men, read Romans 8:20–23:

> (20) For the creation was subjected to futility, not of its own will, but because of Him who subjected it, in hope (21) that the creation itself also will be set free from its slavery to corruption into the freedom of the glory of the children of God. (22) For we know that the whole creation groans and suffers the pains of childbirth together until now. (23) And not only this, but also we ourselves, having the first fruits of the Spirit, even we ourselves groan within ourselves, waiting eagerly for our adoption as sons, the redemption of our body.

Look closely at verses 20–21; why did God subject creation to futility?

As you consider the different things for which you are waiting for healing, according to Romans 8, do you have permission from God, so to speak, to wait in hope? If so, why?

Adam and Eve sinned of their own accord, but what Romans 8 tells us is that for true freedom from sin to occur, consequences for sin had to occur. God had to subject creation and the sons of men to futility, or a curse, in order for us to truly be set free. How? We are going to look at that over the next few days. But He does not like it anymore than we do. In "Waiting for Beauty," we looked at God's heart after each day of creation: "He saw that it was good," the word for "good" meaning "right, good, and beautiful." There were no broken bones and no broken hearts, only beautiful goodness. Everything was as it should have been. *We* were the ones who came in, broke the created order of things, and introduced a need for healing and a Healer.

But let's close with this: David's first step toward healing in Psalm 51 was to honestly admit his sinful, broken condition and the condition of the world around him. He wasn't trying to lay the blame on someone else; he was simply saying, "The moment I was born, I was born with a sinful, broken heart on a sinful, broken planet. And like Adam and every man and woman who has come after him, I am in need of a Healer." I remember one of my professors at Wheaton, Dr. Gary Burge, saying this, "Living in this world is like trying to ride a broken bike. It just doesn't work, and at some point, you and I are going to fall off while trying to ride." When we fall, when wounding comes or when disease strikes, we shouldn't be all that surprised, for the bike we are riding, after all, is broken.

But, according to Romans 8, we are to live in hope, waiting eagerly for the redemption of our bodies and the redemption of the earth. Until then, like creation and like David, we groan and we wait for healing.

How can you look at your condition and the condition around you more honestly and realistically, coming to terms that you live in a fallen world?

On the other hand, do you have the courage to hope, to live every day in the belief that healing and your Healer are coming? Read Psalm 27:13–14 and turn it into your closing prayer for today, committing to hope and believing in the goodness of the Lord in the land of the living, even when you are riding a broken bike in a fallen world:

> *"I would have despaired unless I had believed*
> *I would see the goodness of the Lord in the land of the living.*
> *Wait for the Lord; be strong, and let your heart take courage;*
> *Yes, wait for the Lord."*

DAY TWO
In the Inmost Place

*A*s we saw yesterday, while we wait for healing, the first thing we do is to recognize the true state of our condition. Not only are we ourselves broken, sinful, and in need of healing, but so is the planet on which we live. David lays out this truth in Psalm 51:5 and builds on it in verse six.

Turn to Psalm 51:5–6 and copy verse 6 below. It will be the foundation of our study today:

What is it that God desires in our innermost being?

How do you think it relates to our progress in healing? In other words, why is it an important step?

Friends, David knew, and you and I know, that until we come to a place of total honesty and transparency before God, we will never experience healing; for we were made to be whole, transparent people who walk righteously before the face of God.

Turn back to Genesis 3 where we read yesterday, and read verses 6–13.

After directly disobeying God and eating from the tree of knowledge of good and evil, what did Adam and Eve do that showed they were ashamed?

When God found them, what was He doing (v. 8)?

What implication can we draw from this verse? Why do you think He was "walking in the garden"?

When God created man and woman, it was because He desired intimate fellowship with them. Can you imagine God visiting His Garden each and every day to walk and talk with Adam and Eve? Probably every day prior to their act of disobedience, Adam and Eve loved that sound. But this day, they hid from it. For the first time since Creation, man and woman did not want to be totally transparent before the face of their God. Look at the exchange that occurs between Adam and Eve and God.

In verses 11 and 13, what are the questions God asks, and why do you think He asks them?

After Adam and Eve's confession, and after God implements the consequences of their sin, He does something unique. Read Genesis 3:21. What does God do before sending Adam and Eve out of the Garden?

Turn to Psalm 32:3–7. You read these verses in "Waiting for a Wedding Day," but I want to look at them again today within the context of healing. Remember, in verses 3–4, what happens when the Psalmist is silent about his sin before the Lord?

What happens when he repents, acknowledges, and confesses the true state of his heart in verse 5?

In verse 7, the psalmist calls God a specific name. What is it? And what, specifically, does God do?

We have covered this principle before, but it bears repeating: in both Genesis 3 and Psalm 32, we see that when we cover our sin and try to hide our wounds from God, we make *ourselves* our hiding place, and we waste away, both physically and spiritually. But, as Dick Keyes points out in *Beyond Identity*, when we confess our sin and are truthful, honest, and transparent before God, walking alongside Him as we were created to do, *God* becomes our Hiding Place.[95] It is then that we are surrounded with His songs of deliverance. In other words, that is when the process of healing is able to begin.

Let's take a moment to think about places in our hearts the Lord wants to heal:

- Whenever you are in need of healing, either because of your sin or someone else's, what is your tendency? Do you desire to fellowship freely and honestly before God, or do you want to run and hide and avoid transparency?

- How like Adam and Eve and the psalmist in Psalm 32, have you tried to "cover" your sin? Perhaps, like Adam and Eve, you've even tried to make coverings for yourself. What were they, and did they work?

- How has (or did) your dishonesty before the Lord affected you physically, emotionally, and spiritually?

- Is there anything you need to openly process, pray through, or repent of before the Lord concerning certain wounds or sin that you bear? Take time right now to take off your "coverings" and be honest before the Lord. Pour out your heart to Him:

Now listen to the Lord's "songs of deliverance." Here are just a few:

"But for you who fear My Name the sun of righteousness will rise with healing in its wings; and you will go forth and skip about like calves from the stall" (Malachi 4:2).

"The Lord is close to the brokenhearted, and saves those who are crushed in spirit. Many are the afflictions of the righteous; but the Lord delivers him out of them all. He keeps all his bones; not one of them is broken" (Psalm 34:18–20).

"Humble yourselves, therefore, under the mighty hand of God, that He may exalt you at the proper time, casting all your anxiety upon Him, because He cares for you" (I Peter 5:6–7).

"Do not be wise in your own eyes; Fear the Lord and turn away from evil. It will be healing to your body, and refreshment to your bones" (Proverbs 3:7–8).

"For the Lord will not reject forever, for if He causes grief, then He will have compassion according to His abundant lovingkindness. For He does not afflict willingly, or grieve the sons of men" (Lamentations 3:31–33).

The Lord does not promise deliverance *out* of our circumstances, but He does promise us deliverance *to* Himself. For all of our waiting goes back to one primary purpose: to know Him. So waiting for healing becomes much more than waiting for a broken bone or a broken heart to set; it becomes an intimate journey of knowing and being known by our great God.

And as we walk and talk with the Lord in total transparency, honesty, and love, the promise in the second half of Psalm 51:6 becomes ours. Fill in the blank below:

"And in the hidden part Thou wilt make me know _____." Psalm 51:6b

Here, wisdom means "knowledge, experience, intelligence, insight, judgment . . . military strategy, diplomacy, shrewdness, prudence, and practical spirituality."[96] Out of his own experiences and wait for healing, David tells us, "If you will walk transparently with God, talking, confessing, fellowshipping, pouring out your heart to, and trusting Him, not only will He cover you and sing songs of deliverance over you, He will give you *wisdom*—step-by-step, day-by-day knowledge of how to ride this broken bike in a broken world until all things are made new."

Let's close today by thanking the Lord for His delight over our truth and transparency before Him (Psalm 51:6) and by asking Him for the wisdom we need for the situations we are in because of the fallen world in which we live.

What specific situation do you need wisdom for today and in this season of your life?

Let's turn your answer above into prayer:

> _Lord, thank You for inviting me into the safe, secure place of total transparency before You. Help me to receive the covering of Your forgiveness, acceptance, and love in the inmost places where I have need of healing. As I listen to Your songs of deliverance sung over me, may I hear in them the wisdom I need for the decisions, situations, and relationships I am in on a day-to-day basis. Teach me what I need to know so that I may walk with a whole and healed heart before You._
>
> _In Jesus' Name I pray, Amen._

Now it's time, my dear sisters, to let the healing begin.

The House of Healing

One rainy Saturday morning when Lillian was about eighteen months old, Jason took us to an indoor mall to entertain his two stir-crazy women. After eating waffle fries and chicken nuggets and riding the indoor carousel, we wandered down the length of two football fields to look for shoes. I pushed the stroller and Jason carried Lillian. (Murphy's Law: If you have your stroller, your child refuses to ride in it. If you leave your stroller in the car, make no mistake about it, you will need it.)

As we wandered slowly from one end of the mall to the next, I noticed something—every store we passed beckoned us to come in through a carefully constructed façade. In fact, every store front bore little resemblance to a store and a great deal of resemblance to a house. And each "house" beckoned the passer-by to come in. One, which bore resemblance to a Grecian temple, said, "Come in here, and come out looking like a Greek goddess." Another, which bore resemblance to an old manor in the French countryside said, "Come in here, and you will find all the rest, quiet, and relaxation you need." A sleek, modern, steel rimmed storefront said, "Come into my house, and you'll come out with all the technological tools you need to conquer the 21st century." Perhaps my favorite not-so-subtle storefront, with its night-club music blaring, lights pulsing, and banner hanging out front, declared, "Come into my house, and you will find all the sexiness you will ever need to make you feel like you are perpetually twenty-one."

To be honest, I was shocked. I had never stopped to consider that each store we step into is offering much more than clothes, food, lotion, or gadgets. It offers "healing"—a haven from the world outside, a place to come in and find the perfect potion to drink to numb our wounds, heal our aches, and take away our pain. And we buy the message, we drink the potion, we run to our "houses of healing" before ever stopping to consider what in the world we are doing.

As women, it's so easy to go from house to house to look for healing. We stop at every spa, restaurant, diet, workout class, gym, beauty treatment, doctor, store, trip, or friend that offers us a moment's respite from the wounds we carry. The clothing or the friendship or the workout might heal our hurt for a moment, but it never satisfies for long. We are left more raw, chaotic, confused, and wounded than before, for whatever we choose to "consume" in our house of healing puts a band-aid on the ache, but there always comes a moment when the band-aid is ripped off, and we are left standing

outside the door of our safe house with our wound still oozing—until or before we find another band-aid at another front door.

Am I hitting a nerve here? It sure hits one in me. But until we are willing to look honestly (remember yesterday?) at our houses of healing, we will never find the wisdom we need to walk out the door of our inadequate dwellings and knock on the front door of the only House of Healing where the Healer Himself dwells.

Before looking at the next principle of healing in Psalm 51, I want us to talk a bit more about total honesty before the face of God.

Turn to Romans 1:18–21.

Why is the wrath of God being revealed against mankind? (Look at the latter part of verse 18.)

Looking at all that God has revealed about Himself through "what has been made," how do men and women suppress the truth about Him?

Now read verses 22–25.

According to Paul in Romans 1, we are bent creatures. Rather than standing up straight and worshiping God as we were created to do, we bend over and worship and serve the created rather than the Creator.

Think about it this way: the "houses of healing" that we like to visit are too small to contain our worship. Rather than allowing us to stand up straight, these houses force us to bend over to get through the door. Some of us live our entire lives in this bent position, moving from house to house, person to person, and idol to idol, looking for healing and satisfaction but getting nothing in return but a bent back, a darkened heart, and a crippled soul.

What does Romans 1:24 tell us happens to those who worship with "bent backs" for too long?

What houses of healing have you been visiting in order to dull the aches and pains in your own life?

What do you think makes this particular house(s) so appealing to you? How does it numb or cover the wounds you are trying to keep from the searching eyes of the Lord?

If you and I are ever going to be totally healed, we must have the courage, bent backs and all, to exit the idolatrous houses of healing and enter the house of the Lord. What it takes, as we discovered yesterday, is both brutal honesty and total transparency in the presence of the Lord.

If you are ready to exit your "house" and enter the house of the Lord, write a prayer of repentance and confession below, and ask the Lord for the courage to begin standing up straight in His House. You can use Psalm 32:1–7 as a guide if you need help getting started:

When we finally leave our houses and our idols and turn to the one true God , something marvelous happens.

What does Psalm 23:6 tell us? Fill in the blanks below:

"Surely _____ and _____ will _____ me all the days of my life, and I will dwell in the _____ of the _____ forever."

Look up the word for "follow" in your Hebrew concordance (#7291) or in the margin and write the definition below:

> *radaph*—"run after, chase, put to flight, follow, hunt, persecute, pursue."[97]

The Hebrew word for "follow" doesn't imply a leisurely stroll—quite the opposite. We are literally hunted down by the great God of the universe who will do just about anything to bring His children back into His presence.

Our "attackers," our "enemies," our sicknesses, illnesses, diseases, and wounds are not good things in and of themselves; but they are used, every single one of them, by the goodness and lovingkindness of God to pursue us, chase us down, and even *persecute* us if necessary to get us out of our houses of death and into the life-giving presence of the very house of the Lord.

So turn around and take a good look at your "persecutors." Are they really who you think they are? Or are those things that cause you so much pain pursuing and pushing you into the very arms of God?

Does this knowledge help you view your aches and pains differently? If so, how?

The Lord does not ask us to minimize our pain; He simply asks us to be honest about it, turn from our idols and soul-numbing remedies, and turn to Himself, the only true Healer instead.

Turn to Isaiah 30:18, one of my favorite verses in all of Scripture. What does Isaiah tell us God waits to do?

We spend most of our lives thinking that we are the ones waiting on God, when I believe that He is really the One waiting on us—waiting on us to wake up, take note of the ineffective bandages on our wounds and aches in our bent backs, and stand up straight to enter into the house of the Lord. Turn around to see goodness and mercy chasing you down, and don't wait any longer to let them press you into God's Arms of healing, for your Healer waits for you.

Our Passover Lamb

Welcome to the House of Healing—the *true* House of Healing where the One and Only Healer resides. Thank you for taking the time yesterday to make an honest evaluation of the houses in which you most often live. Having temporary bandages pulled off hidden wounds can be one of life's most painful experiences. But here is the good news: we don't have to do the pulling. What God requires of us is transparency and a heart that seeks to be fully His. When we enter that place of transparency and humility, desiring wholeness in Him, *He* does the ripping along with the healing. Our job is simply to surrender.

Let me say a further word about bandage ripping. The last thing I desire to happen through this study is for us to become a bunch of incapacitated introspectives! The best illustration that comes to mind for this principle comes from a college professor of mine named Dr. Carla Waterman. After times of intense lecture and ministry she would tell her class, "If you planted a garden in your backyard, and every day you pulled up the plants by their roots to check the status of their growth, it would kill the plants! Leave the plants alone, and let God do the growing. Just keep your gaze focused and directed upon Him."

As we talk about issues of waiting for healing, the temptation is to become very introspective and start picking at wounds only God has the power to heal. The purpose of this study is not to pick at wounds but to provide a platform for the Father, Son, and Holy Spirit, the best Counselor I know, to come in and do the healing as we faithfully surrender to Him.

With that before us, let's begin today's study with David's prayer from Psalm 139:23–24. As you pray these verses, ask God to do the searching in you throughout the remainder of this study and to lead you along His paths, His way, and in His time:

> *"Search me, O God, and*
> *Know my heart;*
> *Try me and know my anxious thoughts;*
> *And see if there is any hurtful way in me,*
> *And lead me in the*
> *Everlasting way."*
> *Amen.*

In addition to truth and transparency, today and tomorrow we are going to look at two more ways David gives us in Psalm 51 to dwell in the House of Healing.

Today our focus is Psalm 51:7. What does David say will give him a purified, cleansed heart?

Can you think of any other place in Scripture where hyssop is mentioned? If so, where, and what is its purpose?

> *masqop*—
> "the top of a door
> . . . the crosspiece
> at the top of a
> door."[98]

When David used the word hyssop, all Jewish people immediately thought of the events in Exodus 12:21–28. Read the passage, and then in the space below, draw exactly what Moses commanded the Israelites to do with the blood and the hyssop. (If you don't know what a lintel is, it's #4947 in your Old Testament concordance.)

Where were the Israelites to get the blood for the hyssop? Just so we don't miss this important detail, fill in the blanks from Exodus 12:21:

"Go and take for yourselves lambs according to your families, and _____ the _____ _____."

According to verse 23, what was the purpose of the blood? Be as specific as you can in your answer:

How long were the children of Israel to observe this event (v. 24)?

When children asked their parents, "Mommy and Daddy, why do we celebrate Passover?" (In other words, "Why are we slaying a lamb?"), what was to be their response?

Again, just so we don't miss an important detail, fill in the blanks from verse 27:

"You shall say, 'It is a Passover sacrifice to the LORD who passed over the _____ of the sons of Israel in Egypt when He smote the Egyptians, but spared our _____.'"

Let's begin to put some pieces together and connect events in the Old Testament to the New Testament. With one hand still in Exodus 12, turn with the other hand to John 19:28–30.

Why does verse 28 tell us that Jesus, on the cross, says, "I am thirsty"?

What Scripture do you think Jesus was referring to?

How did the Roman guards (men, who, by the way, had probably never celebrated Passover and certainly had never read Exodus 12) quench Jesus' thirst?

After receiving His drink, what happens to Jesus? What does He say, and what does He do?

Go back and re-read Exodus 12:23. In light of this Scripture, when Jesus says, "It is finished," what do you think He is talking about? What is finished?

Now look again at the drawing you made of the hyssop, blood, and doorposts from Exodus 12:22, and then consider the finished of Christ on the cross. When Jesus says, "It is finished," what He means is this: "If the blood of the Lamb has been applied to the doorframe of the house of your heart through the saving work of Jesus Christ on the cross, then when God the Father looks down upon you, you will not be destroyed by His wrath over sin or His anger. Your penalty for your sin has been paid, and your debt has been cancelled. You are whole, you are healed, and you are eternally *safe*, as long as you are under the covering of My blood, the blood of the Passover Lamb."

Look back at Exodus 12:27 and the response of parents to their children: "He has spared our homes. Our *houses* are *safe* because God has *passed us over* because of the blood of the lamb."

As New Testament believers standing on this side of the cross, our response to our children should be the same when they ask us, "Mommy and Daddy, why is the cross so important to you?" or "Why do we celebrate Easter?" We say, "We have entered God's House of Healing, and we are safe because of the blood of the Lamb. Our home, our hearts, and our lives have been spared, for God has passed us over because He saw on the door of our hearts the blood of His sinless Lamb."

Your healing and my healing is finished and complete because of the cross. This does not mean that we will never suffer from sickness, illness, disease, or harm. But it does mean that we are safe from something much more frightening than that—the One who can destroy both body and soul. Jesus tells His disciples, "And do not fear those who kill the body, but are unable to kill the soul; but rather fear Him who is able to destroy both soul and body in hell" (Matthew 10:28).

Finish reading about the Passover in Exodus 12:29–32. What happens to the homes of the Egyptians?

When Pharaoh calls Moses and Aaron in the dead of night to tell them to take their exodus, what does he tell them to go and do in verse 31?

The houses of the Egyptians teach us a powerful lesson. Yesterday we talked about all of the houses of healing in which we like to dwell. There is absolutely no difference between our "Americanized" or culturally specific houses of healing and the idolatrous houses of the Egyptians. In Exodus 7–12 when God inflicted ten plagues on the people of Egypt, His purpose in doing so was to judge the gods of Egypt. The Egyptians worshiped the gods of the Nile, the frogs, the sun, the moon, the cattle, the stars, and the pharaoh, just to name a few. In every plague God sent against the Egyptians, what He was saying was, "I AM God, and your frogs, sun, and pharaoh are not. The only potion you will drink in their houses is the potion of death. But in My house, salvation, life, and healing are found as you enter by the blood of the Lamb."

Pretty strong, isn't it? And once the Lord delivers the Israelites out of the hands of the Egyptian gods and brings them into His House, their response is to worship and to *stay under the protection of the house of the Lord.*

Sounds like our response too, doesn't it? Earlier we talked about how it is God's job to do the searching and revealing of our sin and needed areas of growth, and how our job is to simply surrender as He reveals them. As we surrender through repentance and obedience to the commands of God in the house of God, our job is to stay there and to live a life of worship, no matter the circumstances that occur, for as long as we stay under the finished work of Christ on the cross and blood of the Lamb, our hearts are safe.

If you do not know Jesus Christ as Lord, your step, right here and now, is to accept the gift of salvation God offers to you through the blood of His Son. If you are led to, pray a prayer of salvation and repentance and give your heart to Christ, believing in the power of His blood to save you, don't waste another minute. Get out of the house of the gods of this world and enter the house of the Lord by the blood of the Lamb.

You can pray right where you are:

> *Lord, I am sinner through and through and in desperate need of grace. Forgive me for worshiping the gods of this world; forgive me for trying to be my own savior and the lord of my own life. I bow my knees and my heart before You, the only true God who has the power to save. Please cleanse my soul with the blood of Jesus, the sinless Lamb of God, and wash me free from guilt and shame from my sin and disobedience. Come into my heart, Lord Jesus, and make it your home, both now and forevermore. In Jesus' Name I pray, Amen.*

If you prayed that prayer for the first time, please let your small group leader or someone you trust who walks with the Lord know. We want to rejoice with you in your decision and help you become involved with a local church and group of believers who can help you in your lifelong journey of walking with God as His child.

If you are already a believer, ask the Lord to show you if you are living a life of true worship and dwelling safely and securely in His house. In no way do I believe we can lose our salvation once we have trusted in Christ, but oh, do I believe that we can wander away from home and take up temporary residence somewhere else!

My friends, as uncomfortable as it might make us, until we are home in the arms of the Father, our dwelling place on this earth is at the foot of the cross. That's why Jesus says, "If anyone wishes to come after Me, let him deny himself, and take up his *cross daily* and follow Me" (Luke 9:23, emphasis mine). The cross is our daily dwelling place, our safe house, and our "home" away from home, for it is here where we find daily healing for our *hearts*, something much harder to heal than the most difficult of circumstances.

🌱 Let's get ready to enter into a time of personal reflection and prayer to finish our time together today. As a follower of Christ, what do you need to learn to do to remain at the foot of the cross in the house of Lord? Is there anyone you need to forgive? Any anger you need to release? Any shame you need to ask the Lord to lift? Any guilt you need to ask Him to forgive? Any burden you need to ask Him to bear? Each of these things will keep us wandering from house to house away from the security of the house of the Lord:

Last, as we wait for healing for ourselves and for those people we love, we must understand that there is a profound difference between walking *alongside* a spouse, child, friend, or parent in the daily act of picking up our cross and following Jesus or trying to *shoulder* the cross ourselves for the people we love. We are to walk alongside one another, absolutely, but we are not to try to be one another's Savior. As women, wives, mothers, and friends, what we often disguise as "nurturing," "mothering," or "just wanting his or her best," is nothing less than trying to take Jesus' place in one another's lives and saying to Christ, "I don't believe you can handle this. Step out of the way." Don't do it. Resist the temptation to carry the cross for those you love. Jesus is more than able to do the job, and in the end, your interference and pride only leads to deeper bondage for the other person as opposed to the healing you so desperately want to see.

🌱 Is there anyone in your life you need to leave, so to speak, at the foot of cross? If so, spend time in prayer and do that now, repenting of your sin of pride, and confessing to the Lord that He is more than able to complete the work of healing He has begun in someone else's life:

C.S. Lewis sums up a beautiful truth in Scripture when he writes that "our longing to be reunited with something in the universe from which we now feel cut off, to be on the inside of some door which we have always seen from the outside, is no mere neurotic fancy, but the truest index of our real situation. And to be at last summoned inside would be both glory and honour beyond all our merits and also the healing of that old ache. . . . Meanwhile the cross comes before the crown and tomorrow is a Monday morning."[99] While the work of Christ on the cross is finished, we still have to live through many "Monday mornings," waiting for our ultimate healing to occur when we see the Lord face to face.

 Until that day comes, let's make Psalm 118:26–28 our prayer:

"Blessed is the one who comes in the name of the Lord;
We have blessed you from the house of the Lord.
The Lord is God, and He has given us light;
Bind the festival sacrifice with
Cords to the horns of the altar.
Thou art my God, and I give thanks to Thee;
Thou art my God, I extol Thee."

Close today by asking the Lord to bind your heart as a living sacrifice to Him through cords of His love, displayed most beautifully through the cross of His Son. Ask for a heart of continual worship and thanks, even in the most difficult of circumstances, for your Healer, your God, and your Passover Lamb.

Broken Rejoicing

There is one more principle David gives us in Psalm 51 that enables us to enter and remain in the House of Healing, forsaking all other houses of this world. At first, this principle seems contradictory to healing; but without it, healing is not just hard, it is impossible.

To begin our last day of study in "Waiting for Healing," read Psalm 51:8.

After receiving purification and cleansing at the foot of the cross by our Passover Lamb, the next principle of healing David gives us involves brokenness. Look closely at what he says in the second half of the verse. How did David get his "broken bones"?

Bummer—that's definitely the first word that comes to my mind! Like me, you may be thinking, "I thought the Lord was interested in my healing, not my destruction!" Let's dig a little further to find out exactly what David is saying here.

One commentator says this, "At the present time David's very bones are still shaken, and as it were crushed, with the sense of sin. . . . Into what rejoicing will this smitten condition be changed, when he only realizes within his soul the comforting and joyous assuring utterance of the God who is once more gracious to him!"[100]

God is not a masochist; He does not delight in our crushing or in our pain. But He does use our pain to help us feel the weight of our sin and the damage it has caused us and others so that we might long for the weight of grace instead. In other words, God will allow us to feel the weight of our hurt so that we might move into a place of surrender, recognition of grace, and total dependency upon Him. He allows it because He knows if He doesn't, we will *always* be the walking wounded, no matter how desperately we want to be healed.

The irony in Psalm 51:8 is that David rejoices. He rejoices in the fact that through his brokenness, he has grown to love his God more than before his pain and the consequences of his sin of adultery and murder, and even more than in his prior seasons of obedience.

My friend, resist the temptation to become bitter over broken bones. Resist the temptation to become bogged down in self-pity or in anything but the overwhelming nature of your Savior's love. Some of our broken bones are consequences from our sin (like David's), but some of our broken bones have nothing to do with sin we have committed; they are simply consequences of living in a fallen word. But God uses our brokenness to draw us closer to Himself on a level of intimate communion we have never before experienced. Christian author and intellect C.S. Lewis married late in life and lost his wife after only a few years to cancer. Reflecting on the nature of pain and suffering, he wrote, "We are bidden to 'put on Christ,' to become like God. That is, whether we like it or not, God intends to give us what we need, not what we think we want. Once more, we are embarrassed by the intolerable compliment, by too much love, not too little."[101]

No doubt, pain is God's "megaphone to rouse a deaf world,"[102] but are we listening? Are we hearing God's call through the pain, allowing it to bring us closer to Him?

Look back to Day One to the areas of healing for which you are waiting. Which of those areas are "broken bones" right now?

Are your broken bones "rejoicing"? If not, what is keeping them from doing so?

If you are having a hard time rejoicing while undergoing pain and brokenness, I want to look at one more principle embedded in the command to take up our cross and follow Christ. Sometimes I think we are tempted to leave the cross standing on the hill in Golgotha, relegating its pain, triumph, and victory to 2000 years ago. But although the *work* of the cross was accomplished once and for all, the *power* of the cross reaches across the centuries and is ours for today.

The call to "take up our cross" and follow Christ *is* all about death to self and obeying the voice of the Lord, but sometimes we think of that call only in negative terms such as "I *can't* do this, or I *can't* do that," and the cross becomes something that leaves a sour taste in our mouths and a hollow pit in our stomachs.

But the call of the cross is also about what we *can* do. We *can* take all of our hurts and sorrows and aches and pains, and deposit them at the foot of the cross. We *can*, each and every day, cling to the cross and there find repentance and rest from the burden of sin. We *can* bring our broken bones, broken relationships, and broken hearts and find shelter and healing underneath its mighty outstretched wings. We can precisely because Christ was fully crushed under the wrath of God and weight of our sin so

that no matter how broken or crushing our circumstances, we would never have to be. But so often, we don't. We shoulder the burden ourselves, and we carry around the weight of our sickness, disease, and sin along with everyone else's. We let our wounds cause bitterness, resentment, pain, and unforgiveness when all the while Christ cries out, "Come to me, and I will give you *rest*" (see Matthew 11:28).

Does this help you in understanding the principle of "broken rejoicing"? If so, how can the cross help you to "rejoice" even in the midst of your suffering and your wait for healing?

If it helps, find a cross that fits easily into the palm of your hand. Take it down off your wall if necessary, and put it in a place that is easily accessible when you pray and spend time with the Lord. If the pain of a burden or a wound is too much to bear, hold that cross and picture all of your pain, hurt, and consequences of your sin, sickness, or disease, going into the cross of Christ. That's what the "enlightened eyes of our hearts" (Ephesians 1:18) are for—not to see the unreal but to see the unseen. And the unseen reality is that the power of the cross is for you and for me; it is for our families, our friends, our co-workers, and even for our enemies today, right now in this moment, and in the future whenever we call upon the Name of the Lord.

What is so vital about picking up our cross and following Christ on a *daily* basis? Wouldn't yearly, monthly, or even weekly suffice?

It's simple—the cross is a daily reminder that resurrection is coming, that healing for brokenness is waiting in the shadows of the stage, waiting to make its surprise entrance.

Turn to Lamentations 3.

After my broken engagement, this is the chapter of Scripture that ministered to me the most, so much so that I printed out these verses and placed them on my bedside table and read them most mornings and evenings.

Quickly read through verses 1–18. How deep is the author's suffering and grief? In the space below, write a few of the phrases of grief that stand out to you the most:

Can you relate to any of them? If so, how?

Now take your time and read verses 19–33. What does the author "remember" that gives him hope?

I think that verses 25 and 26 are so apt and profound for those who wait. What do they say?

Read verses 31–33 once more. How does this tie into what David tells us in Psalm 51:8? Does God delight in the suffering of men?

What specific reasons does Lamentations 3 give for our broken bones to "rejoice"?

When we choose, as the author of Lamentations did, to wait for the Lord, and to recognize it as *good* to wait for Him (especially for those who are in their youth—did you catch that, young women?), we will ultimately rejoice. Why? Because the Lord's lovingkindness never ceases; His compassions never fail; *great* is His faithfulness.

And every time we choose to remain at the foot of the cross, we are met with the reality of the resurrection. The skies tell of it each morning as light heralds the dawn and splits open the darkness. Each and every morning, our God has creation play out the drama of the darkened tomb and the breaking light of resurrection so that we will *remember*: resurrection is coming. Healing is on its way. We don't know if it will be in this life or if we will only see it in the next, but *it is coming* for all those who believe in the healing, resurrecting power of our God, no matter how deep the pain of our brokenness.

To close our week on "Waiting for Healing," read Revelation 7:16–17. What is the Lamb in the center of the throne called in verse 17?

And what does He do for His people?

Those who "have washed their robes and made them white in the blood of the Lamb" (Rev. 7:14) are led to the springs of the water of *life*, and all of their tears are wiped away . . . every single one of them.

The tears we shed during our wait for healing often seem endless and unbearable. But a day is coming when our bones will no longer need breaking. God will dwell in our midst, just as He did in the Garden, and we will dwell in His house forever—a house without tears, suffering, or pain that is perpetually covered by the blood of the Lamb.

There are days I feel as though I can't wait to get there. How about you? I know the days are long; I know the nights are dark. But wait, beloved, wait. Our healing and our Healer are coming to lead us to eternal, everlasting life. Resurrection is coming.

Using Revelation 7:16–17 as a guide, close with a prayer of commitment to stay in the shadow of the cross—today, this week, this month, this year, for as long as it takes—as you wait for healing. Thank Him for the brokenness that keeps you close to His heart and grateful for grace until you can dwell in His house forever.

"They shall hunger no more, neither thirst anymore;
neither shall the sun beat down on them, nor any heat;
for the Lamb in the center of the throne shall be their shepherd,
and shall guide them to springs of the water of life;
and God shall wipe every tear from their eyes."

I. The Purpose of the Wait for Healing

❑ We must remember in our wait for healing that the promises of God are both for _____ and _____ _____.

- Luke 4:17–21

- Psalm 103:1–5

 ▪ "When we ask, we get forgiveness now (1 John 1:8–9), but we may not get suffering removed now (2 Corinthians 12:8–9; 2 Samuel 12:13–23). That is because while sin always blocks our relationship with God, suffering can deepen it."[103]

❑ What we see consistently throughout scripture and in the lives of believers is that when God allows brokenness to remain in our _____ or in our _____, it always displays space created to be _____, _____, and _____ by the _____ of God.

- John 9:1–3

❑ If God allows your thorn, brokenness, weakness, or difficulty to remain, His _____ will be sufficient for you, and His _____ will be _____ in you (2 Corinthians 12:7–10).

- "perfected" (v. 9)–*teleo*–"to complete anything, not merely to end it, but to bring it to _____ or its _____ goal, to _____ it _____."[104]

- There are works God has created you to complete, glory He has created you to display, fruit He has created you to bear that _____ be completed unless your weakness _____.

- "power" (v. 9)–*dunamis*–"being _____, _____. . . . It may even mean to will."[105]

- In the places where you are the most _____, the _____ of God rushes in. It is His capability _____ you to do _____ you what you could _____ do by yourself.

II. The Posture of the Soul as We Wait

❑ We see the necessary posture of the soul in its wait for healing in the cry of Christ when He prays, "Father, if You are willing, remove this cup from Me; yet not _____ will, but _____ be done" (Luke 22:42).

- The strongest stance of the soul in its wait for healing is the stance of _____.

❑ That which enables our continual surrender is _____.

- The definition of hope: "Now faith is the _____ of things _____ for, the conviction of things _____ _____" (Hebrews 11:1).

 ▪ "hope"–*elpis*–"hope, desire of some good with _____ of _____ it."[106]

- "To hope" is to be _____ and _____ that the object of your faith really will save you.

- In the Old Testament, the word most often used for "hope" is *tiqvah*, which comes from the root word qavah, which means "to _____."[107]

 - True waiting for the Lord is _____, or being utterly and thoroughly _____, that the God you cannot see _____ _____ come through on His promises, not the God who is unreal, but the God who is _____.

 - This is why the scriptures are so closely connected with our hope and with our waiting. We _____ rightly hope or wait for the Lord unless we are _____ our souls together to God's Word through _____.

III. The Enemies of the Soul as We Wait

❑ For centuries, the church understood the virtue of hope to be rooted in the understanding that as long as we are living here on this earth, we are _____ _____ the _____.

- This understanding or state of being was called *status viatoris*, "the '_____ or state of being _____ the _____.'"[108]

- The antonym, or opposite state of being, was called *status comprehensoris*, the condition or state of having "_____" or "_____."[109]

- You either believe yourself to be a *viator*, one who is on the way, with the virtue of _____ as your companion, or you believe yourself to be a *comprehensor*, one who has _____, with the sins of _____ and _____ as your companions.

 - Despair is the "perverse anticipation of the _____ of hope."[110]

 - Pride is the "perverse anticipation of the _____ of hope."[111]

 - The longer you _____ _____ in your despair or _____ a _____ in your pride, the more you begin to "fear . . . the demands that are made . . .on one who is well" and on those who _____ that they are _____.[112]

IV. The One Who is Blessed in the Wait

❑ "How _____ is the man whose strength is in You, in whose _____ are the _____ to Zion!" (Psalm 84:5)

❑ "O Lord of hosts, how _____ is the man who _____ in You!" (Psalm 84:12)

- "trust" – *batach* – "to attach oneself, to trust, confide in, _____ _____, be confident, _____; to be _____. . . . The word expresses the sense of well-being which results from knowing that the 'rug won't be pulled out from under you.'"[113]

- How blessed is the one who ultimately trusts and remains confident and secure that by _____ with _____, you are ultimately _____ —not safe _____ trouble, but safe _____ trouble until He brings you safely _____ (Psalm 91:15).

PRAYERS FOR HEALING:

Exiting the Houses of Slavery and Entering the Healing House of the Lord —

Exiting the House of REBELLION—Lord, Your Word says, "Woe to the rebellious children,' declares the Lord, 'Who execute a plan, but not Mine, and make an alliance, but not of my Spirit, in order to add sin to sin" (Isaiah 30:1). We acknowledge that we have foolishly dwelt in the house of rebellion, walking in many other ways and worshiping many other gods, other than You alone. Forgive us for despising You, the One, True God and for despising the perfect counsel of Your Word, given to us by Your Spirit. Forgive us for rebelling against You and making plans apart from You, plans that put the gods and the spirit of this world as first in our hearts, rather than You. We confess rebellious hearts that have rebelled against You and Your Word and worshipped idols of our own making, and we humbly ask for Your forgiveness.

- *Entering God's House of OBEDIENCE*—Lord, Your Word says that "if you consent and obey, you will eat the best of the land" (Isaiah 1:19). "Submit therefore to God. Resist the devil and he will flee from you" (James 4:7). "For you were continually straying like sheep, but now you have returned to the Shepherd and Guardian of your souls" (1 Peter 2:25). As we exit the house of rebellion, give us the grace to dwell in Your House of obedience, under the authority of a Good and Perfect Father. Give us humility enough to acknowledge that the food at Your table is better than any other food in the world, and give us the obedience to stay at Your table, under Your roof, regardless of how tempting it is to follow the ways and the gods of the world around us. We declare that obedience to You, Lord, brings great blessing, both in this life, and in the life to come. "For You, Lord God, are a sun and a shield. You give both grace and glory, and no good thing do You withhold from those whose walk is blameless. Blessed is the one who trusts in You" (Psalm 84:11–12).

Exiting the House of PRIDE—Lord, Your Word says that "pride goes before destruction, and a haughty spirit before stumbling" (Proverbs 16:18). We acknowledge that we have foolishly dwelt in the house of pride, eating at her table and walking in her ways. Forgive us for exalting our thoughts and ways above Your ways. Forgive us for thinking more highly of ourselves than we ought, and forgive us for not thinking enough of ourselves, measuring ourselves and continually falling short of the standards of the world around us. We confess a proud heart that has exalted its own ways above Yours, and we humbly ask for Your forgiveness.

- *Entering God's House of HUMILITY*—Lord, Your Word says that "a day in Your courts is better than a thousand elsewhere. I would rather be a doorkeeper in the house of my God, than dwell in the tents in the wicked" (Psalm 84:10). As we exit the house of pride, give us the grace to enter into Your House through the door of humility. Give us a right estimation of who we are before You, the high and holy God. We are lowly enough to be a breath of air, a handful of grass, here today and gone tomorrow. Yet we are high enough to be the crowning jewel of Your creation, knit together by Your perfect, eternal hands. Give us the grace to live in the shadow of the Almighty and humble enough to stay under the authority of Your hand. "Therefore humble yourself under the mighty hand of God, that He may exalt you at the proper time" (1 Peter 5:6).

Exiting the House of FEAR—Lord, Your Word says, "Do not fear those who kill the body but are unable to kill the soul; but rather fear Him who is able to destroy both soul and body in hell" (Matthew 10:28). We acknowledge that we have foolishly dwelt in the house of fear and feared many things other than You. We have listened to the lies of Satan, our enemy, the father of lies, who poisons our hearts with doubts about the goodness of who You are and the power of Your goodness to save. We repent for fearing the evil one and lashing out in his ways of control, anger, doubt, and fear. We confess a fearful heart, a heart that has not trusted that Your perfect love casts out all fear (I John 4:18), and we humbly ask for Your forgiveness.

- *Entering God's House of PEACE*—Lord, Jesus Himself said to His disciples the night before He died, "Peace I leave with you; My peace I give to you; not as the world gives do I give to you. Do not let your heart be troubled, nor let it be fearful" (John 14:27). As we exit the house of fear, we ask that we may enter and live in Your house of peace. We know that You do not give peace as the world gives, a peace based on right circumstances and perfect performance. Rather, Your peace is given regardless of circumstances and despite performance. Your peace comes from Your Spirit within us, and it is Your Spirit who delivers us from all of our fears and testifies to us that we are the very children of God. Give us the grace to stay under the power of Your peace and to keep in step with Your Spirit and Your perfect love, no matter what is happening within us or around us. "I sought the Lord and He answered me, and delivered me from all my fears" (Psalm 34:4).

Exiting the House of SLOTH AND DESPAIR—Lord, Your Word says, "Remember my affliction and my wandering, the wormwood and bitterness. Surely my soul remembers and is bowed down within me. This I recall to mind, therefore I have hope. The Lord's lovingkindnesses indeed never cease, for His compassions never fail. They are new every morning; great is Thy faithfulness" (Lamentations 3:19–23). We acknowledge that we have foolishly dwelt for too long in the house of spiritual sloth and despair and refused to look up and out to the God of all hope. We acknowledge that we have listened to the lies of the enemy and allowed our souls to be pressed down while refusing to look up and out to You. Instead of looking to You, we have made our past and present circumstances our gods by allowing them to dictate who we are and who we are able to become. We repent for refusing to rise to become the people You have called us to be and confess hearts full of sloth and spiritual laziness that refuse to rise to meet the demands that are placed on those who are well. We repent, and humbly confess our sin before You, our high and holy God.

- *Entering God's House of HOPE*—Lord, Your Word says, "'The Lord is my portion,' says my soul, 'therefore I have hope in Him.' The Lord is good to those who wait for Him, to the person who seeks Him. It is good that he waits silently for the salvation of the Lord" (Lamentations 3:24–26). "Now may the God of hope fill you with all joy and peace in believing, so that you will abound in hope by the power of the Holy Spirit" (Romans 15:13). As we exit the house of sloth and despair, fill us with all joy and peace as we dwell, by the power of your Holy Spirit, in Your House of Hope. Give us ears to hear Your Voice calling us up and out of ourselves, our sin, our sloth, and our despair; and give us the courage and the hope to rise to become the women You have called us to be. Give us the grace to look past our circumstances and to refuse to be defined by our anyone or anything other than You. You are the God we adore, the One we praise, the faithful God who never changes. We rejoice in the promise and the power of the hope we always find in Your Presence; great is Your faithfulness.

Exiting the House of ENVY—Lord, Your Word says, "But if you have bitter jealousy and selfish ambition in your heart, do not be arrogant and so lie against the truth. This wisdom is not that which comes down from above, but is earthly, natural, demonic. For where jealousy and selfish ambition exist, there is disorder and every evil thing" (James 3:14–16). We have foolishly dwelt in the house of envy and acknowledge that envy is akin to the sin of murder, for it kills life in others and in ourselves, and even has the power to rot our bones (Proverbs 14:30). We have participated in this sin by dwelling in envy's house, and we repent for despising who You made us to be and the gifts You have chosen to give us. We repent for coveting in others that which You have not chosen to give us and wanting what has not been ours to take. Because of our envious hearts, we have opened the door to selfish ambition, disorder in our own personal lives and relationships, and every evil thing, even demonic darkness. We repent and humbly ask for Your deliverance and forgiveness.

- *Entering God's House of CONTENTMENT*—Lord, Your Word says, "Not that I speak from want; for I have learned to be content in whatever circumstances I am. I know how to get along with humble means, and I also know how to live in prosperity; in any and every circumstance I have learned the secret of being filled and going hungry, both of having abundance and suffering need. I can do all things through Him who strengthens me" (Philippians 4:11–13). As we exit the house of envy, we ask that we may learn how to live and richly dwell in Your house of contentment. In any and every circumstance we are in, give us the strength to say, "My God will supply all our needs according to His riches in glory in Christ Jesus"; therefore, we can do all things through Christ who gives us strength (Philippians 4:13, 19). Give us strength to be rich in contentment. Rich in the trust of a God whose mercies never fail. Rich in the confidence that whatever we have been given from Your Hand is exactly what we need. And rich with the knowledge that the promises of our God never fail. "Surely I have composed and quieted my soul; Like a weaned child rests against his mother, my soul is like a weaned child within me. O Israel, hope in the Lord, from this time forth and forever" (Psalm 131:2–3).

Exiting the House of UNFORGIVENESS—Lord, Your Word says, "Therefore you have no excuse, everyone of you who passes judgment, for in that which you judge another, you condemn yourself; for you who judge practice the same things" (Romans 2:1). "But if you do not forgive others, then your Father will not forgive your transgressions" (Matthew 6:15). We acknowledge that we have foolishly dwelt in the house of unforgiveness, holding onto our grudges like treasures until they rot our souls. Forgive us for refusing to extend the grace we ourselves have received, and forgive us for locking others up in a debtor's prison while You have declared us to be free in the grace of the Lord Jesus Christ. We repent for the sin of unforgiveness, and we humbly ask You to forgive us as we learn to forgive those who have sinned against us.

- *Entering God's House of GRACE*—Lord, Your Word says, "And when they came to the place called The Skull, there they crucified Him and the criminals, one on the right and the other on the left. But Jesus was saying, 'Father, forgive them; for they do not know what they are doing'" (Luke 23:33–34). As we exit the house of unforgiveness, let us follow Your example and walk straight into Your house of grace. Those who we need to forgive, Lord, help us to forgive. Help us to unlock the door to our prisons extending forgiveness, releasing others from any debt they might owe us, just as we ourselves have been released. Help us to choose mercy, Lord, even when we do not feel merciful, so that the healing power of forgiveness can flow not only in others' lives, but in our lives as well.

Exiting the House of SHAME—Lord, Your Word says, "When the woman saw that the tree was good for food, and that it was a delight to the eyes, and that the tree was desirable to make one wise, she took from its fruit and ate; and she gave also to her husband with her, and he ate. Then the eyes of both of them were opened, and they knew that they were naked; and they sewed fig leaves together and made themselves loin coverings. And they heard the sound of the Lord God walking in the garden in the cool of the day, and the man and his wife hid themselves from the presence of the Lord God among the trees of the garden" (Genesis 3:6–8). We acknowledge that we have foolishly dwelt in the house of shame, refusing relationship, acceptance, and love from You. Forgive us for trading the glory for which You created us for a life of hidden darkness lived apart from You. Forgive us for refusing to believe that the cross of Christ not only heals us from the guilt of our sin but also from our shame. We confess hearts that have strayed far off from You, hidden in the dark embarrassment of our shame, rather than freely coming into the light of relationship and truth; and we humbly ask for Your forgiveness.

- *Entering God's House of GLORY*—Lord, Your Word says, "Fear not, for you will not be put to shame; and do not feel humiliated, for you will not be disgraced; but you will forget the shame of your youth, and the reproach of your widowhood you will remember no more" (Isaiah 54:4). "Therefore since we have so great a cloud of witnesses surrounding us, let us also lay aside every encumbrance, and the sin which so easily entangles us, and let us run with endurance the race that is set before us, fixing our eyes on Jesus, the author and perfecter of faith, who for the joy set before Him endured the cross, despising the shame, and has sat down at the right hand of the throne of God" (Hebrews 12:1–2). As we exit the dark house of shame, we ask that we would learn to live in Your house, full of light, life, grace, and glory. Instead of looking to our shameful pasts to define us and hold us down in pain, regret, and insignificance, we look to Jesus, the Author and Perfecter of our faith, who holds out to us the hope of glory as we fully rest in our identity in and relationship with Him. We believe Your Word to be true that says, "They looked to Him and were radiant, and their faces will never be ashamed" (Psalm 34:5). Make us a people who love to live in the light—the light of Your presence, the light of truth, the light of the hope of glory for our past, present, and future. We declare that wherever You are is where we want to be. Surely goodness and mercy will follow us for all of our days, and we will dwell in the House of the Lord forever (Psalm 23:6).

WEEK SEVEN

Waiting for Friendships

Fulfilling Friendship

*E*very little girl grows up wanting to have a best friend. Not just any old friend, but a friend for secrets and sleepovers. A friend who sits by you in the classroom and plays your games on the playground. A friend who laughs when she should and knows when she shouldn't. A friend who takes turns and shares your tears.

But best friends are hard to find. And they are even harder to keep. Many of us bear wounds from the war of friendship that run deep. Sometimes it seems as if we will never heal or find in a friend what we are looking for. Some of us have a tight circle of friends that stands by us through thick and thin. But I would bet that many of us spend life on the outside of a circle of friendships wanting *in* as opposed to standing on the inside looking out.

In my own search and wait for friendship, I have learned that women can sometimes draw out the very worst in one another. In our attempts to gain companionship, we can attempt to control one another through a variety of means, including co-dependency, manipulation, withdrawal and judgment. We can destroy one another through our words and withhold love and affection.

But Christ never designed friendship to be this way. In all of our searches for a "best friend," for love, security, place, value, and importance, He desires us to search, first and foremost, for friendship and fulfillment with Himself. And once we are satisfied with Him, full of the deep love that will not let us go, we are equipped and ready to begin to freely love and serve the women around us. We find ourselves free to *be* a friend, rather than to *have* one.

Before looking at what the Word of God has to say about friendship, I want us to begin today, and each day of our homework this week, with the following prayer:

> *Father God, we know that You are not only the model for all fellowship, but You are the very center of all relationships and friendships. Heal the wounds that past friendships have inflicted, and free us to be the friends that you have called us to be. In learning to love others, let us first learn to love You. And in doing so, let our lives be so filled up with You that all other friendships are not our hope, our lifeline, or our identity, but simply the overflow of a heart satisfied with friendship with You. In Jesus' Name we pray, Amen.*

Now I want us to take a moment to think honestly about the nature of our own friendships and characteristics as a friend.

How do you normally enter into relationships (or end relationships) with other women? Is it in co-dependency, independence and isolation, manipulation, control, or a mixture of all of the above? (Sometimes I can be a little of everything all at the same time!) Remember: no one else is going to see your answers here, so really try to be honest. The Lord wants to do some work in us this week as we admit our flaws and our fears and begin to lay our friendships at His feet:

Why do you think you respond the way you do in relationships with other women? Is it from of a fear of being left out, a desperate need for attention, or because of a need to feel important or secure? Is it because of a jealous, ambitious spirit that desires to compete? Spend as much time before the Lord as you need here—and remember, this isn't about you picking apart your soul and your relationships. This is about asking the Lord to come in and reveal to you, in His mercy and grace, the specific things in your heart that stand as hindrances to right relationship with Him and with others:

Before you start getting too down on yourself, or feeling really awful about your friendships, remember one thing: there isn't one woman on the face of the earth who does not share in your struggles. A wise woman told me years ago when I was wallowing in shame about my own particular struggles with control and manipulation, "We are *all* daughters of Eve." Every woman alive struggles under the burden and pain of the curse of sin; *but*, praise God, if you know Jesus, and Jesus knows you, you are also a daughter of God, and that identity trumps all others, including your identity as a sinner. And God wants you and me and all of His daughters *to be free*! So let's get to work.

Turn once again to John 15:12–17.

I know we've spent a great deal of time in John 14–17, but these chapters are packed full of reminders of the Father's eternal, unconditional love and provide much healing and direction for the waiting, hurting heart.

Verses 12–17 begin and end with the very same command: what is it?

The Greeks used at least three different words in their vocabulary to talk about love in contrast with our one word. Three of those words are: *eros, phileo, and agape. Eros* was used to describe the sexual and romantic love between a man and a woman; *phileo* was used to describe the love between friends; and *agape* was used, primarily by the New Testament writers, to talk about the supernatural love that comes directly from the heart and character of God Himself.

Look in your Greek concordance or in the margin to see which word for "love" (#25) Jesus uses in His command to His disciples in John 15:12, 17. Write the word and its definition below:

agapao—"to esteem, love, indicating a direction of the will and finding one's joy in something or someone"[114]

I was a little surprised at Jesus' word choice—were you? I think I was expecting *phileo*, which would have meant, "I am commanding you to love others with a true, deep friendship kind of love." Instead, what He tells us is, "I am commanding you to love one another with a supernatural, God-given, God-like love, a love based on the character of God, rather than the character of the person you are loving." Ouch. Tough. And actually, impossible. Unless we learn to love others, pursue others, and base all of our relationships with others, including our friendships, on first receiving the *agape* love of the Lord ourselves.

While the commands in verses 12 and 17 are interesting, what really interests me is the information sandwiched between the two. For I believe in verses 13–16, Christ gives us the key to actually unlock and carry out verses 12 and 17.

We are going to save finding that key and unlocking that door to true friendship until tomorrow, but let's close today's study with prayer based on John 15:12 and 17. In order to be able to learn how to love one another, ask the Lord to come in and heal your hurts, restore your heart, and teach you how to build friendships based on His unchanging, unconditional love.

True, lasting friendship is waiting.

DAY TWO
Freedom in Friendship

Let's begin today with the same prayer from yesterday:

Father God, we know that You are not only the model for all fellowship, but You are the very center of all relationships and friendships. Heal the wounds that past friendships have inflicted, and free us to be the friends that you have called us to be. In learning to love others, let us first learn to love You. And in doing so, let our lives be so filled up with You that all other friendships are not our hope, our lifeline, or our identity, but simply the overflow of a heart satisfied with friendship with You. In Jesus' Name we pray, Amen.

Turn once more to John 15:12–17, and read the passage again for today.

Yesterday we talked about how in our search for identity and fulfillment in our friendships, what we are constantly seeking to fill is our own need to be loved. The ultimate problem in any relationship is that we seek to carry the commands in John 15:12–17 without allowing ourselves to be filled with the love described in the verses between. Because of that, the result that follows is always brokenness and hurt. So today, let's spend time trying to find the key and unlock the door to loving one another as Christ has commanded us in John 15:12–17.

Let's begin with verse 13. The word that Christ uses here for love is the same word in verses 12 and 17: agape. According to verse 13, what is the ultimate mark, then, of agape love?

What event is Christ referencing here? For further confirmation, read Ephesians 2:4–7:

How does the information given in John 15:13 enable us to live out the command in verse 12?

If any relationship, specifically friendship, is established outside of this knowledge of Christ's deep, sacrificial, abiding love for us, what then happens to that relationship?

My friends, we cannot conjure up agape love on our own. It must flow directly from the Source itself, first into our own lives, and then into the lives of the friends we have around us. Think about your closest friendships for a moment.

- Do you love these women primarily out of the self-sacrificing agape love you have first received from the Father? Or do you love your friends based on your own need to be filled, accepted, or made much of? Think about your answer for a moment and then explain below:

- Do you love others in hopes that they will heal your hurts or satisfy your own desires? Think for a moment and then explain below:

- Are your friends trophies on the walls of your heart to make yourself look important, or are they opportunities to lay your life down to serve others for the sake of Christ? Think for a moment and then explain below:

- What would change about your closest friendships if you loved out of the knowledge that you are already loved and served them expecting nothing in return?

Sounds great, right? If we could just learn to walk in the passionate, *agape* love our Father and Bridegroom have for us, our friendships would be beautiful reflections of that love rather than a hungry grasping to get love. But how do we get there?

John 15:14–16 shows us how. What new word does Christ use to identify His followers in verse 14?

Keep reading in verse 15; Jesus explains the difference between a slave and a friend. According to verse 15, what is the definition of each?

- Slave—

- Friend—

Why do you think Christ chooses to call His disciples "friend" for the very first time right after He gives them the command to love one another?

This principle of friendship with Christ goes hand-in-hand with what we talked about in "Waiting for Significance." Through His death on the cross, the love that Christ displayed demonstrated that He not only *forgives* us, taking care of our problem of guilt, but that He *likes* us and He accepts us, taking care of our problem of shame. In other words, we are not just given the identity of "free in Christ," we are given the identity of "friend of Christ"—a subtle but profound difference.

How does knowing we possess not only the love of Christ but the friendship of Christ enable us to truly love one another? Explain below:

Finish today by reading Job 29:1–4. From Job's own description, what were the "prime of his days" like?

Like Job, our sweetest seasons of life are when we become aware of our sacred friendship with God. As we begin walking in the light of the knowledge and reality of that friendship, our days are never the same, are they? Our journey takes on an intimacy we never knew existed; our circumstances become less and less of an issue and more and more of an avenue through which to communicate and walk with our very best of friends, God Himself. And the things of this earth become strangely dim as we walk in the knowledge of the greatest treasure ever to be found—the friendship of God.

This is what the cross of Christ proclaims; this is what the cross guarantees; and this is what the cross promises will never leave us, desert us, or forsake us—the very friendship of God.

Let's close today with prayer. Thank the Lord for the offer and continual availability of His friendship for those who obey His commands, and ask that you might learn to walk as one who is secure in her identity as the friend of God.

DAY THREE
The Friend of God

Begin today with the following prayer, and then turn back in your Bibles to John 15:12–17. I want to plumb the depths a little further today of what it means to be called the friend of God:

> *Father God, we know that You are not only the model for all fellowship, but You are the very center of all relationships and friendships. Heal the wounds that past friendships have inflicted, and free us to be the friends that you have called us to be. In learning to love others, let us first learn to love You. And in doing so, let our lives be so filled up with You that all other friendships are not our hope, our lifeline, or our identity, but simply the overflow of a heart satisfied with friendship with You. In Jesus' Name we pray, Amen.*

Look back at your definition of the word "friend" from John 15:15 from yesterday's study. Just for clarity's sake, write that definition one more time in the space below:

 "The mark that you are My friend," Jesus tells His disciples, "is that everything I have heard from My Father, I have made known to you. I haven't held anything back; I haven't hidden My heart; I haven't had a secret or selfish or manipulative agenda. I have spoken and communicated with you about the things I hold most dear."

Now turn to John 16:5–7.

What does Jesus tell His disciples in verse 5? Where is He going?

According to verse 6, what is His disciples' reaction?

Think back to John 15:14–15; why do you think they felt this way?

But Jesus actually tells them something astonishing in John 16:7, something that should help to alleviate their sorrow. What is it?

We've talked about this before, but where is the Helper going to take up residence when He comes to the disciples? Read Romans 8:11 before writing your answer:

Up until this point, every word that Christ has spoken to His disciples has been shared from the *outside in*. But there is a Helper coming who is going to share the very thoughts and words of Christ from the *inside out*. And that is why Christ says, "It is to your advantage that I go away."

Read John 16:12–15. What is the Helper, also known as the Spirit, going to speak to the disciples?

Look at verse 15 in particular; how does it parallel what Jesus says in John 15:15?

If the Helper, or the Spirit of God, is going to do the same thing for the disciples that Christ did while He was on earth, except this time it will be from the inside out, what does this tell us about the possibility of friendship with Christ? Did it disappear when Christ ascended and disappeared into heaven? Explain below:

So what exactly does Jesus mean in John 16:13 when He says that "whatever He hears, He will speak; and He will disclose to you what is to come"?

Let's turn to Psalm 25:12–14 for a closer look.

In Psalm 25:12-14, how is the person who fears the Lord described? I can see at least five different ways this person's life is described or characterized from these three verses. Write three of these characteristics below:

1.

2.

3.

Perhaps my favorite part of the definition of this person is found in the first part of verse 14. Fill in the blank below:

"The _____ of the Lord is for those who fear Him."

Look up the Hebrew word and definition for "secret" (#5475) used in this verse in the Hebrew section of your concordance or in the margin and write it below:

> *cowd*—"a session, i.e., company of persons (in close deliberation); intimacy, consultation, a secret"[115]

Turn back to Job 29:4 where we ended yesterday. The same Hebrew word used for "secret" in Psalm 25:14 is also used here in Job 29:4. What do you think the word is?

The "secret" of God can also be translated as the "friendship" of God. It is exactly what Jesus is telling us in John 15:15 and 16:13–15. Those to whom God reveals His secrets are those whom God calls "friend." Along with meaning "secret" and "friendship," *cowd* can also be defined as "a couch, cushion, or pillow, a friendly conversation among friends or a serious consultation among judges."[116] Each of those images provides a rich and beautiful picture of the word "friend." We reserve our hearts for our most intimate circle of companions. We save our deepest thoughts for consultation among

those we consider as wise as judges. And we save the deepest places of who we are for those we call our dearest "friends."

Our friendship with God is no different, yet I miss it so much of the time! I am so concerned about how I don't fit into a certain "inner circle" that I miss the inner circle of companionship of God. I weary myself through comparison and jealousy, envy and ambition, when what is offered to me is the cushion of God, an eternally secure, sacred, and elevated place that is to be coveted above any other "cushion" or friendship I know.

It is not just flippant, passing friendship that is offered to us through the inmost counsel of the Spirit of God; it is binding, eternal, significant, rich friendship that covers even the deepest of our wounds and the weightiest of our needs. And through this friendship we receive advice, consultation, and life-changing counsel offered to us from the inside out through the very Spirit of God, searching the mind of God, communicating the heart of God, to our very hearts.

So there the offer stands. Will you take it, each and every day, each and every hour, each and every circumstance, each and every circle, and to each and every friendship that you are given? For as long as you are on the Psalm 25 and John 16 cushion, your heart will be continually satisfied with the friendship of God.

End today by crying out for the cushion of God. Take time to *listen* to His Spirit from the inside out. Let Him speak to you through God's Word and guide you into all wisdom in the relationships where you need it most. His friendship is waiting:

Chosen Friend

Begin today with the following prayer, and turn once again to John 15:12–17:

> *Father God, we know that You are not only the model for all fellowship, but You are the very center of all relationships and friendships. Heal the wounds that past friendships have inflicted, and free us to be the friends that you have called us to be. In learning to love others, let us first learn to love You. And in doing so, let our lives be so filled up with You that all other friendships are not our hope, our lifeline, or our identity, but simply the overflow of a heart satisfied with friendship with You. In Jesus' Name we pray, Amen.*

We have discovered how to enter into friendship with others through all that is packed into John 15:12–17. We have learned how to love, and most importantly, how to receive the love and the friendship of Christ. Today I want to look closely at one last truth of friendship found in verse 16.

We looked at this verse in depth in "Waiting for Fruitfulness," but today we will look at it in the context of learning how to love one another.

There are several words in verse 16 that are important to understand as we move forward with today's study, so please fill in the blanks below:

> "You did not choose Me, but I _____ you, and _____ you, that you should ____ and bear _____, and that your fruit should remain."

While learning to love one another, there are still several things that are important to know. Thanks to Eve, at the core of every woman's sinful nature are several specific characteristics that dominate and control how we relate to both men and women. In John 15, I believe Christ addresses the tendencies of our sinful nature and commands us to begin to walk in a new nature and in a new way of love.

To understand what our tendencies are and where they come from, turn to Genesis 3:1–13, 16.

Just from a simple, clear reading of the passage, who, humanly speaking, was "in control" of the situation in Genesis 3:1–6? Adam or Eve?

According to verse 6, who convinced whom to eat what?

According to verse 6, what were the three things about the fruit that convinced Eve to go ahead and not only eat it herself but offer it to her husband?

1.

2.

3.

Now look at the curse God gives Eve in verse 16. What is the curse in regards to her husband? Be as specific as possible:

I don't know if you sensed it, but woven throughout the entire account of the fall of creation, and Eve specifically, is a continual sense of grasping and a desire to possess without ever gaining the ability to actually do so.

Paul tells us in I Timothy 2:12–13 that it is the man who has authority over the woman for "it was Adam who was first created, and then Eve," yet we see Eve as the one who grabs hold of the reigns of the relationship and charges full speed ahead as she leads both she and her husband into certain death. We see Eve grasping and desiring to become "wise," to become "like God," and to reach over and above her created order as she reaches for the fruit, yet she ends up only possessing the bitter fruit of death. And we see it in the weight of the curse God gives Eve, and all of her daughters after her, as she must continue to desire to control, manipulate, dominate, and possess, just as she did when she took the fruit.

Has anything changed since the fall in the Garden? Has any woman ever managed to elude or bypass the desire to control, manipulate, and possess what is not hers to take? I only have to look as far as my own heart to say, "No." The curse God placed on Eve is still alive and well today. Through the cross of Christ, that curse has been lifted, yes, but I still struggle with my desire to control day in and day out.

What about you? Can you see Eve's nature alive and well in you, specifically in the area of your friendships? If so, how?

How does your desire to "possess" others, to dominate (either through overt methods of being overbearing or through quieter methods of withdrawing and pouting), and to be the center of your friendships, tend to get in the way of developing truth and love in these same friendships?

Daughters of Eve, I have good news for you: through the subtle, yet powerful, language of John 15:16, Christ lets us know that we are no longer in subordination to the curse given in Genesis 3. We are under a new authority, the authority that comes through the fruit of Christ's redemptive work on the cross.

Go back to the first two blanks you filled in from John 15:16, "chose" and "appointed." What do those two words imply about the nature and authority of Christ?

Think back to your days on the elementary school playground. There were always two teams, and there were always two team captains who had the authority to "choose." I don't ever remember how those two team captains were chosen; I just remember them being the best, strongest, and most athletic guy or girl of the grade.

In a very "elementary" sense, Christ is letting us know in no uncertain language that *He* is the Team Captain. He is Possessor, Appointer, and Chooser all wrapped up into One beautiful Head. The days of the daughters of Eve are over, and the days of the daughters of Christ are here.

In our relationships with others, you and I will never find fulfillment if we try to be the "possessor," keeping everyone else out so we are the only ones in. We will never find fulfillment spending our lives frantically trying to make sure everyone is playing our game by our rules, while at the same time trying to fulfill others' expectations of us as well.

Christ, in no uncertain terms, is telling us *He* is all of those things. And obeying His command to love one another *requires* us to give up our role as "team captain."

Let's enter into a time of personal reflection and prayer about the roles we play in our personal relationships:

- How are you most tempted to play "team captain" in the relationships around you? (And remember, be honest here: no one is looking at your answers except you and the Lord.)

- What would it look like for you personally to let go of "choosing and appointing" everyone else in subtle and in not-so-subtle ways and to focus, instead, on how Christ has chosen and appointed you?

- Is there anything you need to repent of right now? A role you have played as "team captain" in a friendship or in a group of friends that has left you and/or others hurt?

- Now stop and ask the Lord to shift your eyes to Him. Ask Him to lift your hands off the choosing and appointing of those around you and to place your hands directly onto His, acknowledging He is the one in control.

- Finally, ask Him to keep your hands there, in that position, every time you are tempted to grasp or to reach beyond your God-given identity or authority.

- Close today thanking Christ for being Ultimate Chooser and Appointer over all. Thank Him for being the Faithful Friend we can trust.

DAY FIVE
Fruitful Friendship

Begin today with the following prayer one last time, and open back up one last time to John 15:16:

Father God, we know that You are not only the model for all fellowship, but You are the very center of all relationships and friendships. Heal the wounds that past friendships have inflicted, and free us to be the friends that you have called us to be. In learning to love others, let us first learn to love You. And in doing so, let our lives be so filled up with You that all other friendships are not our hope, our lifeline, or our identity, but simply the overflow of a heart satisfied with friendship with You. In Jesus' Name we pray, Amen.

Christ is so faithful, isn't He? He is always faithful to heal us through His love, to gently show us how we've gone astray, and to bring us back to a place of repentance, humility, and friendship with Him.

And because He is so good, He never stops at telling us "no." He always follows it up with a "yes," a "go," or a "do."

What is the "go" part of John 15:16? What is the command He gives us after letting us know He is the One in control?

Don't miss the allusion to "fruit" here, and don't think it's an accident either! Where does the word "fruit" immediately take us? (Think back to Genesis 3.)

Eve's poor decision with fruit left us barren and infertile in regards to our ability to have fruitful, productive relationships. But with all the talk about fruit in John 15, Christ makes the subtle shift from being under the authority of the barrenness of the curse of sin to being under the fruitful authority of the Possessor and Appointer of all of life. So as daughters of Eve, we are given a second chance! Through Christ, and Christ alone, we *do* have the ability to form fruitful, productive friendships.

Turn to Galatians 5:16–23.

In verses 19–21, what things from Paul's list stand out to you as those specifically belonging to friendships lived out in the flesh?

In verses 22–23, what fruit is Paul specifically looking for in friendships formed in the Spirit?

How do you get there? How do you bear and produce the fruit in verses 22–23 as opposed to verses 19–21? See verse 16 for your answer:

"Walking by the Spirit" is the same as "friendship with God." Do you see how John 15:12–17 comes full circle? We fulfill the command to love others by acknowledging and receiving the sacrificial *love* of Christ. And then we begin to walk in our identity as the *friends* of Christ, keeping in step with the *Spirit* of Christ, as He reveals to us, from the inside out, the secrets and intimate counsel of God the Father, Son, and Holy Spirit. As we keep in step with the Spirit of Christ, we come under the *authority* of Christ by taking our hands off possessing and controlling one another. And finally, we begin to bear the *fruit* of Christ, and the command of Christ to love one another is fulfilled. Beautiful, isn't it?

Turn back to the first page of homework from Day One of this week. Look back at your answers to the two questions that are on that first page. Now that you have thoroughly looked at and absorbed God's Word about relationships in John 15 and 16 and in other related passages, do you now understand why you react the way you do in certain relationships?

How will applying God's Word of Truth and Love in John 15 help you with those relational dynamics in the future?

Is there any woman, or group of women, in your life, who the Lord is convicting you to respond to differently? If so, work it out with the help of the Holy Spirit through the lens of John 15:

- First, ask Him for the supernatural ability to receive the ultimate, sacrificial demonstration of the love of Christ.

- Now ask for your focus, passion, and desire to shift from being the "friend of others" to being the "friend of Christ." Ask Him to teach you what friendship with Him truly means.

- Ask that in your friendships with others, you would keep in step with the Spirit of Christ, walking closely in His counsel, listening carefully to His secrets, always keeping in pace with His love.

- You may have already done this yesterday, but if you feel the need to do this again with a different relationship or in a different way today, repent for choosing, appointing, and possessing others in a way out of order with the authority God has given you. Relinquish all authority and possession of others to the authority of Christ.

- Now ask for fruit in your friendships, fruit that will remain. Ask for the ability to keep your eyes fixed upon Christ, the Author and Perfecter of your faith, rather than looking at everyone else around you, and to walk according to the appointed plan He has for you, without comparing yourself to any others.

- And finally, ask for the grace to fully embrace the friends He has given you without judgment and with His unconditional, agape love. Trust that as you walk in your friendships, daily embracing the Friend of all sinners and Lord of all truth, know the fruit He has appointed you to bear, and the friendships He chooses to give you, will last.

Waiting for Friendships

I. The Importance of Friendship

❑ In the English language, while we have one word for love, the ancient Greeks had at least three words for love that translate as: *Phileo*, *Eros*, and *Agape*.

- In Modern Times—_____, or romantic love, has taken precedent as the highest form of love; _____ is the "least necessary" of the loves.

- In Medieval Times—_____ was the most exalted of loves.

❑ Proverbs 8:12, 22–36—

- Friendship within the Trinity was the _____ through which the universe was established; and if wisdom and friendship were the medium through which the world was founded, they will also be how you and I live _____ within it.

II. The Model of True Friendship

A. The Definition of Friendship: "Lovers are normally face to face, absorbed in each other; Friends, _____ by _____, absorbed in some common interest."[117]

1. Friends look at a _____ _____.

2. Friends are not _____.

3. Friends are not focused on _____ _____.

- In our sinful nature, people can either become _____ on our walls or _____ _____ to market us to a watching world. True friendship loves someone for their _____ _____—not what they can give you.

4. Friends are defined by _____ and _____.

- James 3:13–18

B. The Focal Point of Friendship:

❑ "This is my commandment, that you love one another, _____ _____ I have loved you." John 15:12

❑ The quality of our friendships with _____ will always flow from the strength of our friendship with _____.

III. Friendship Gone Awry

❑ Scenario 1: _____ Creatures

❑ Scenario 2: _____ Creatures

❑ Scenario 3: _____ Creatures

IV. What is Needed

1. To _____ Up

2. To Put Our _____ Down and _____ _____ with One Another

3. To _____ Forward

❑ If others around you are still bent, independent, or co-dependent:

- Focus on _____, but _____ your sister.

- Pray for _____ and forgiveness in your heart toward her.

- Develop a spirit of _____ for your friends.

"In Friendship . . . we think we have chosen our peers. In reality, a few years' difference in the dates of our birthdays, a few more miles between certain houses, the choice of one university instead of another, posting to different regiments, the accident of a topic being raised or not raised at a first meeting—any of these chances might have kept us apart. But, for a Christian, there are, strictly speaking, no chances. A secret Master of the Ceremonies has been at work. Christ, who said to the disciples 'Ye have not chosen me, but I have chosen you,' can truly say to every group of Christian friends 'You have not chosen one another but I have chosen you for one another.' The Friendship is not a reward for our discrimination and good taste in finding one another out. It is the instrument by which God reveals to each the beauties of all the others. They are no greater than the beauties of a thousand other men; by Friendship God opens our eyes to them. They are, like all beauties, derived from Him, and then, in a good Friendship, increased by Him through Friendship itself, so that it is His instrument for creating as well as for revealing. At this feast it is He who has spread the board and it is He who has chosen the guests. It is He, we may dare to hope, who sometimes does, and always should, preside. Let us not reckon without our Host."[118] C.S. Lewis, *The Four Loves*

WEEK EIGHT

Waiting for Home

DAY ONE
Longing for Home

A s I sit here at my computer typing the last week of our study, I want to take this opportunity to say, "Thank you." Thank you for being such willing participants in this journey of waiting. I know many times in this study, you have had to be brave in order to face your *real* self, your *real* wounds, and your very *real* desires that lie at the core of all of your waits, and for that, I want to say, "Well Done." Your willingness to be real and honest with your Heavenly Father, along with your willingness to be dependent upon Him in all of your waiting, will bear much fruit in this life and the life to come. I am confident of the fact that this is the *beginning* of all that God is doing, not the end, and I look so forward to hearing how He uses your waits to further His Kingdom not only in your own life but also in the lives of those around you and around the world.

With that being said, I want us to turn our hearts toward home this last week of study. The word *home* means different things to different people. For some, memories or thoughts of home are pleasant; for others, thoughts of home only cause pain, disappointment, or regret. But whether the home you grew up in, or the home you live in now, was joyful, peaceful, and pleasant, or sad, tense, and chaotic, I think we all are still looking for a home where we can find our roots, a sense of belonging, and a place that we can say is fully and truly *ours* no matter where we've been or where we're headed.

Frederick Buechner says it this way in his book *The Longing for Home:*

> What the word *home* brings to mind before anything else, I believe, is a place, and in its fullest sense not just the place where you happen to be living at the time, but a very special place with very special attributes which make it clearly distinguishable from all other places. The word *home* summons up a place—more specifically a house within that place—which you have rich and complex feelings about, a place where you feel, or did feel once, uniquely *at home*, which is to say a place where you feel you belong and which in some sense belongs to you, a place where you feel that all is somehow ultimately well even if things aren't going all that well at any given moment. To think about home eventually leads you to think back to your childhood home, the place

where your life started, the place which off and on throughout your life you keep going back to if only in dreams and memories and which is apt to determine the kind of place, perhaps a place inside yourself, that you spend the rest of your life searching for even if you are not aware that you are searching. I suspect that those who as children never had such a place in actuality had instead some kind of dream of such a home, which for them played an equally crucial part.[119]

Think back to the place you would most consistently call *home*. Maybe it wasn't your parents' house but a grandparents' house, a vacation home, or even a place you created and dreamed about in your mind as a child if the home you grew up in was not a safe place.

Describe your childhood home. What about it made you feel unique, special, and as though you belonged?

Do you often think about that home? If so, what aspects of it do you miss?

What aspects of it have you tried to re-create in the home you live in today?

Do you feel as though you have successfully done so? If not, why not? What keeps your home now from being like the ideal home you lived in or wished for in your childhood?

When I think on my definition of home, I think of several different places that were very important to me during childhood. I think about the house I lived in with my family until I was eight years old, I think about my maternal grandparents' house, I think about my paternal grandparents' house, and I think about a piece of property known as "Mountain View Ranch" that my parents were part-owners of until I was eighteen. Each of these places plays a very important part in my definition of home, and each of these places brings up a very specific ache or longing when I remember or dwell on that place.

There was nothing particularly special or unique about the façade of the home where I lived as a child; it was what was on the *inside* that defined home to me. Inside was my mom's baking and the constancy of her presence. Inside was the daily triumphal and celebratory event of dad coming home after work when my brothers and I greeted him with hugs, shouts of joy, and kisses. Inside were the many books I read and the worlds I imagined. And inside our little backyard were the hours of exploration and imagination afforded by the wooden fort my dad built and the endless varieties of concoctions available from the pyracantha berries, plants, and flowers in the yard.

Inside my maternal grandparents' house was comfort to the core, "coffee milk" in the mornings, and a strong sense of tradition, theology, and rootedness. Being the seventh generation Houstonian on my mother's side gave me a deep sense of connectedness and belonging to the very city of Houston itself and to the church community in Houston, something I felt very deeply inside my grandparents' home.

Since my paternal grandparents' house was not far from Rice University, the Houston Zoo, and the Museum of Natural Science, that home represented to me constant knowledge and adventure. The park next door to the house was a constant call to go outside to play, and my grandmother, inside the house, had saved all of my aunts' old formals and ball gowns, costume jewelry, shoes, and hats, which provided hours of self-governed entertainment.

And last, Mountain View Ranch, situated on the Guadalupe River in the Hill Country of Texas, represented horseback-riding, hill-climbing, river-tubing, and beauty in those rolling hills. Approximately ten families owned this piece of property together, so whenever we were there, kids abounded, all of whom were older than my brothers and me. They all "adopted" us as siblings and took us under their wings, so time spent at our home in Mountain View represented the joy of being part of a huge family in a beautiful place.

But the common thread weaving all four of these homes together for me was the sense of belonging. I was intimately known and welcomed, expected and loved in each one. And to this day, each home holds something I try to go back to and recreate in my own life and in the home I have with my husband and children:

- A sense of significance
- A sense of Father
- A sense of beauty
- A sense of community, family, and togetherness
- A sense of adventure and exploration
- A sense of fruitfulness

Yet for all of my trying to re-create a sense of belonging, beauty and significance, an element of each always seems to elude my grasp. I am never quite as known, even in my own home today or with my closest circle of friends, as I would like to be. My home is never quite as beautiful as I remember my childhood home to be. My home is never quite as comfortable or familiar or warm as I remember my childhood home to be. And my home is never quite as exciting or adventurous as I remember my childhood home to be.

Do you think your home today will ever encompass all the things your childhood home, or dreams of your childhood home, had? Why or why not?

Do you think the things you long for in a home are similar to the things your neighbor, Christian or non-Christian, longs for in a home?

If believers and unbelievers alike long for the same things in home, what should that tell us about the nature of home?

Turn to Hebrews 11:1–3. According to verse 1, what is the definition of "faith"?

Verse three tells us something very interesting about creation. Was everything that you and I can see around us made from things visible or invisible?

So if the pattern for everything we see, including the created pattern for home and family as well as for trees and flowers, came from the invisible, then where should we look to when we are looking or longing for home?

Continue reading in Hebrews 11:8–10, 13. According to these verses, did Abraham ever find all of his longings for an earthly home fulfilled in the here and now?

According to verse 10, what was he ultimately looking for?

Did the home God promised and that Abraham was searching for have its roots in the visible or invisible? Who was its architect and builder?

Continue reading Hebrews 11:13–16. According to verse 13, did Abraham ever consider himself home while living here on the earth? What did he call himself?

Why do these verses tell us Abraham was content with never really finding home as long as he was on this earth?

Should this encourage us in our search for home? If so, how?

Here is an incredibly comforting and hopeful truth we learn from Hebrews 11: if your home here on this earth is never as you expected or hoped or dreamed it would be, *take comfort. It's not supposed to be.* Through our childhood homes or dreams, I believe that God gives us glimpses into the city or eternal home that is to come. But we were never meant to find all of what encompasses home here. At the same time, we were never meant to stop looking, wanting, or waiting for an eternal, secure home, a place where we feel like we belong. Like Abraham, we are to continually welcome home "from a long way off," confident in our knowledge that one day, like Abraham, we *will* be there.

Does this mean that we are destined to live unfulfilled, rootless lives in the here and now? Read Genesis 25:8. Describe Abraham when he died. Did he die a vagrant as an unsatisfied, restless old man?

The Lord God created us to live full, purposeful lives here on His incredible earth. He just didn't create us to be completely *fulfilled* here. This earth is a mere pattern of the invisible heavenly home that is to come. And until we go to be with the Lord in the original home, the original pattern and place from which all else was created, we will always be longing for more.

Once again, Frederick Buechner states, "What is the connection between the home we knew and the home we dream? I believe that what we long for most in the home we knew is the peace and

charity that, if we were lucky, we first came to experience there, and I believe that it is the same peace and charity we dream of finding once again in the home that the tide of time draws us toward. The first home foreshadows the final home, and the final home hallows and fulfills what was most precious in the first. That, at least, is my prayer for all of us."[120]

It's a beautiful way of saying it, isn't it? "The final home hallows and fulfills what was most precious in the first." The homes we lived in as children, and the homes we live in and create now, are not the final word on home, dear friends. There is a final home coming that will satisfy and fulfill all of our longings from our past, present, and future. Until then we wait with our eyes and our hearts fixed eagerly on the heavenly home that is to come.

Close today in prayer by reading Hebrews 11:8–10 one last time and then taking a few moments to thank the Builder and the Architect of all that was the best from your childhood, all that is good and true in your current home, and all that will be fulfilled; and go beyond even your furthest imaginings in the Home that is to come.

DAY TWO
Sojourners

*B*efore we begin to look at what our heavenly home will look like, today I want to examine how we should live in the here and now if we are confident of the fact that this is not home.

What I want us to keep in mind throughout this lesson is that you and I were *created* for home. We all, believers and non-believers alike, sense it. We all yearn for it, from the beauty of Martha Stewart's creations for every room, to the savory, homemade dishes from our mother and grandmother's kitchens. From our common desires for nurturing, loving, family-centered havens for our children to grow up in, to adventurous, fun, exciting platforms from which they can stretch their wings. We *all* long for home. What we all do not understand is that in the here and now, as much as we want this to be our forever home, it simply cannot be—we are *sojourners*.

Turn to Ecclesiastes 7:1–2. Why would the author of Ecclesiastes say that "the day of one's death is better than the day of one's birth"?

Several years ago, friends of ours bought the house directly across the street from us. The first few weeks before they moved in, they spent time and expense renovating the house, readying it to accommodate their family of five. One afternoon, I walked over and met Kathy, my neighbor, in her garage. I asked her how all the work was going, and her reply is something I will never forget. "It's interesting," she said. "We bought this house knowing that it is a tear-down. When the time is right, in a few months or even a couple of years, we want to completely tear this house down and build a new one. So every renovation we make, everything dollar we spend, I have to remind myself, 'This house is just a tear down.' It puts a whole new spin on everything. Because it's a tear-down, I want to pour the least amount of time, energy, and money as possible into this house. We are saving our budget for the house that is to come."

She went on to tell me how renovations on the "tear-down" house had revolutionized her views about houses in general, even the house they one day want to build. "Ultimately," she said, "that brand new house is a tear-down too! They're *all* tear-downs, no matter how much time or money you pour into them. They will all be torn down one day to make room for something new, just like our lives here on this earth."

That mindset changes things, doesn't it? Like Kathy said, *all* of our homes are tear-downs. The only thing that will last is our home to come and the people who will dwell there.

With this in mind, turn to Psalm 39, a prayer of David, and read all thirteen verses.

How does David start his cry to the Lord? Write verse 4 in the space below:

Have you ever prayed something similar to David's prayer? Have you ever cried out to the Lord to show you just how transient you are? To be honest, I'm not sure if I've ever prayed that, for it seems to me a rather frightening prayer to pray. At times, I'm not sure I actually *want* to understand how very transient I am.

Think for a moment—why would David pray that prayer? What are the benefits in knowing how very transient you are?

Look at verse six; in light of the knowledge of his very own transience, what view does David take of riches?

After acknowledging the foolishness of amassing riches, what is David's very next thought in verse 7? Write it below:

The knowledge of our transience helps us to put the whole weight or burden of our "wait," so to speak, upon God alone. When we know we are here today and gone tomorrow, we stop waiting for earthly fame; we stop waiting for earthly riches; we stop caring about our earthly reputation; we

care less and less about our earthly homes, earthly possessions, earthly stresses, troubles, trials, and heartaches; for the knowledge of our transience reminds us that *this is not home.*

Think about your own life for a moment. How would really knowing and being convinced of your transience enable you to care less about your earthly trials, troubles, and possessions, and keep your eyes fixed upon your true home?

I love the phrase that David uses for himself in his prayer in verse 12. Fill in the blank below:

"Hear my prayer, O Lord, and give ear to my cry;

Do not be silent at my tears;

For I am a stranger with Thee,

A _____ like all my fathers."

Sojourner. Isn't that a beautiful word? It has a rather exotic sound to it, like it has come from the lips of someone who has traveled to the ends of the earth and back, seen it all, yet still knows this is not home.

Just so that we are all on the same page as David himself, look up the Hebrew word and definition for sojourner (#8453) in your concordance or in the margin and copy it below:

> *towshab*—a temporary inmate or mere lodger; resident alien, foreigner, inhabitant, sojourner, stranger[121]

According to its Hebrew definition, a sojourner isn't someone who doesn't have roots anywhere; *a sojourner is simply someone who knows his roots are not in his present country.*

I love how my *Key Word Study Bible* phrases the definition: "A *towshab* [sojourner] was to be distinguished from a temporary visitor or a mere lodger. Essentially, *towshab denotes a squatter who could not possess land.* He was a sojourner in a foreign country where he was not naturalized" (emphasis mine).[122]

It's not that a sojourner *couldn't* possess land—it's just that he couldn't possess land in the country where he was temporarily living. His citizenship was elsewhere; his home was elsewhere; his rights to own property and to dwell as a citizen were elsewhere. It's not that he wasn't a citizen; it's just that he was not a citizen *there.*

That definition changes things, doesn't it? It's one thing entirely to be unable to own land or to have rights as a free citizen anywhere you go; it's quite another to be unable to claim citizenship only in the place where you are sojourning.

As women, we love to have our roots go down deep into a particular house, a particular neighborhood, city, or project. We love to nurture, nourish, and to cause living things to grow. We

just need to remember that our roots are not to go down *here*. They are to extend into the soil of a far vaster, deeper, and greater Kingdom, the Kingdom that we will one day know as home.

So then, how are we supposed to live on a daily basis? If our nature is to nurture, settle, and establish, yet the Biblical call is to sojourn, where do the two meet?

Turn to the book of Exodus, a book that outlines one of the most famous sojourns in all of history. Read about the events in Exodus 3:1–9.

When the Lord calls to Moses out of the burning bush, what is His command to Moses in verse 5, and what is the reason He gives it?

What is the name He gives Moses for Himself in verse 6?

In verses 7–8, why does the Lord tell Moses He has come down to his people? Be as specific as possible: where and what is He delivering them from and where is He taking them to?

Continue reading Exodus 3:10–14.

What does God call Moses to do?

In what name is the Lord sending Moses to complete his task?

The weekend my grandmother passed away, I remember being all alone in our townhouse. Jason was gone for the weekend, one of my dear friends had just moved from Houston to Dallas, and I had just come home from the hospital after a very unexpected turn of events where I watched my grandmother take her last breath. I came home, collapsed on the couch, and felt a black sense of grief and despair. I felt . . . rootless. One of the only people on the planet who had known and loved me since my birth, welcomed me in the good and bad seasons alike, and had represented, in some way, what I called "home," was gone. And the "rootlessness" of my situation stretched before me as I really

understood, perhaps for the first time, that everyone I loved and who loved me and who represented home to me was sure to die. It was just a matter of time.

And ever so quietly, like He always does, the Lord spoke to my heart and led me to His name in Scripture, "I AM."

"Susannah," He quietly whispered, "your roots are not in this earth. For you are right; one by one, the people you love will die. Your earthly roots will fade and disappear. But your eternal roots are safe and everlasting in I AM. You never have to fear My death or My disappearing. You will always have a home in Me, the Great I AM."

And I was comforted. I mean, I was really comforted. I was not alone without roots, family, or purpose, for I was held and known by the Great I AM.

The name the Lord gives Moses is a holy name, and the place where He gives it to him is even called "holy." I AM is a name that defies the ebb and flow of time, centuries, epochs, and earthly governments and systems. It is a name that always is, always was, and always will be.

And it is not a coincidence that He first gives His Name to a group of sojourners. On the road from Egypt to Canaan when everything familiar had been left behind, God's people followed "I AM." When the journey was frightening and the enemies overwhelming, God's people followed "I AM." And when the tents got old, and the desert was hot, and the Israelites were tired of being rootless, homeless sojourners, they continued to follow "I AM." For God's promise to God's people was a country, a home, a place away from suffering and slavery, groaning and bitterness, deserts and sands, diseases, and death. He was taking them to *His* country, *His* place, the home of the Great I AM.

And so it is for us today. I AM is a name and a promise to all sojourners who are weary with the trials and groanings of this world and who are longing for the next. I AM promises to lead us out of this country and into His.

So are we to have roots? Yes.

Are we to let them go down deep? Yes. Are we to nurture, love, help, and establish the people God has placed around us? Yes.

But through time with the Lord in His Word and in prayer, we are to root ourselves and others in the name of the Great I AM. We are to be planted in the soil of His Kingdom. And we are always to remember we are sojourners here, but we have a country, a citizenship, and an eternal home with our great, good God.

Is there a situation in your life right now that has made you feel rootless, sad, or, in a sense, homeless? If so, what is the situation and why has it made you feel this way?

How does knowing that the Lord reveals Himself to you as I AM give you hope and comfort?

In this season of your life, what are some practical ways you can choose to root yourself in the Lord? Maybe it's through consistent time in His Word, a more consistent prayer life, or adding a weekly time to fast and pray in an attempt to focus and draw closer to Him. Choose one way to root and strengthen yourself in the Lord, and your write out your commitment to Him below:

Choose today to place your hope and trust in the Lord. Choose today to remember and live as though your citizenship is in the country of the Great I AM. Let's finish our time together by turning Hebrews 11:13–16 into a prayer to the Lord. Thank Him for delivering you out of slavery and bondage into the freedom of His country. Thank Him for allowing your roots to go down deeply and eternally into Him. And thank Him for allowing you to be a sojourner in this life so that you can be a citizen of His country in the next.

> "All these died in faith, without receiving the promises, but having seen them and having welcomed them from a distance, and having confessed that they were strangers and exiles on the earth. For those who say such things make it clear that they are seeking a country of their own. And indeed if they had been thinking of that country from which they went out, they would have had opportunity to return. But as it is, they desire a better country, that is a heavenly one. Therefore God is not ashamed to be called their God; for He has prepared a city for them."
>
> Hebrews 11:13–16

The Reality

W̲e've had a chance to think about our longing for Home through the lens of our childhood homes and dreams and all that they foreshadow in our Home that is to come. And we've also had the opportunity to think about that same longing in terms of our identity as sojourners here on earth but as citizens in the eternal city that is to come.

Today I want to start thinking about our eternal home. What is it like? Who will be there? Will all of our longings really be met? If you are like me, you've probably spent very little time contemplating what will one day be our eternal home. Most of us have very little idea about what really awaits us in the place where we will see Jesus face-to-face. Why is this? Especially when one considers that the lines of Scripture are constantly whispering the secret to those who choose to listen that we will one day stand inside the door of our one, true home. C.S. Lewis says it so well: "Most of us find it very difficult to want 'Heaven' at all—except in so far as 'Heaven' means meeting again our friends who have died. One reason for this difficulty is that we have not been trained: our whole education tends to fix our minds on this world. Another reason is that when the real want for Heaven is present in us, we do not recognize it."[123]

So over the next few days, I want to spend some time searching the Scriptures for an accurate picture of Heaven, our true home, what really awaits us, and how our desires here point us to the reality waiting for us there.

This naturally leads to the first and foremost question about Heaven: is Heaven really a physical, tangible place, or is it only symbolic, spiritual, without any physical boundaries or properties? Are we just floating around on clouds in space somewhere, or is Heaven a place upon which we can firmly plant our feet?

Turn to Revelation 20:11–15. In your own words, briefly describe the events in these five verses:

Now continue reading in Revelation 21:1–5.

In verse 1, what happens to the "first heaven and first earth," meaning the heaven and earth that we are living in today?

What, then, is created that is "new"?

In verse 5, God says something full of hidden riches and promise. Fill in the blanks below:

"Behold, I am making _____ things _____."

When God says "all things," what kind of things do you think He is referring to?

Turn back in your Bibles to Genesis 1:24–31. Briefly skim these eight verses, and focus on the last one.

In verse 31, what does it say God "saw"?

And how does God describe it?

In "Waiting for Beauty," we looked at how God created the heavens and the earth, finished His work, stepped back, and then described it all as *tov*, very good, or beautiful. God *loved* His creation; He took delight and joy, and found great beauty and perfection in all that He had made, from the lowliest earthworm to the stateliest lion to the height of His creation in man and woman.

So, in Revelation 21:5, when He says He is making "all things" new, after reading Genesis 1:31, now what do you think He is referring to?

It only stands to reason that God does not just throw away His original concept of beauty and perfection in His creation; rather, He remakes it. He does away with the curse of sin that Adam and Eve brought in, and He makes the heavens and the earth anew. But this time, He ensures sin is unable to do its deadly work ever again. For the curse has been broken and paid for, all accounts have been settled, and all is "finished" through Christ's redemptive work on the cross (John 19:30).

So for just one moment, I want you to think about home, the heavens and the earth, in terms of the absence of the curse of sin. What would earth be like if sin was not present?

Look back at Revelation 21:3-4. How does it describe a heaven and an earth made new?

Who, or what, is at the center of this new heaven and earth?

For a further glimpse of what the new heaven and earth will be like, turn to Isaiah 11. This chapter includes prophecy not only about the birth of the Messiah, but also about the reign of the returning Messiah when the earth is made new.

Read Isaiah 11:1-5. According to verses 2-3, what is the character of the reigning Messiah like?

Verses 4-5 describe this coming Ruler's actions. According to these two verses, what kind of Ruler is He?

What does this infer about poverty, injustice, starvation, war, and slavery of all kinds on the renewed earth?

Now turn to Isaiah 11:6–10. In verses 6–8, because of the character, righteousness, and justice with which the Messiah reigns, what are the actual results of His reign?

Keeping one hand in Isaiah 11, quickly turn back to Revelation 21:1. Is there any sea or ocean in the new heaven and new earth?

Now turn back to Isaiah 11. Verse 9 says that when the Messiah returns to rule and reign, the earth will be full of something. What is it? And how will cover it the earth?

To the ancient Hebrews, the sea or the ocean always represented the chaos and fear of the darkness of the unknown. Just when life seemed to be "smooth sailing," so to speak, you never knew what could come out of the depths of the waters and bite you on the leg, taking you under. What Revelation 21 and Isaiah 11 tell us is that the fearful unknown is gone forever. Gone is the chaos of living in a sin-cursed world when at any moment death, disease, pain, mourning, or grief could strike at any moment. Peace, righteousness, and justice reign. Even a lion that would normally devour a lamb and certainly would tear apart an innocent child lies down next to both in safety and peace.

I don't believe these images in Revelation and Isaiah are merely symbolic. I think what they are telling us is that the animals we would only dare to behold behind a glass window or the bars of a cage will be walking among us. The very same hills and valleys and towns where poverty and injustice now reign will be full of the righteousness and justice of the coming King. Earth will not just be done away with; earth will be *made new*. And all that represents chaos and fear and the dark unknown will be gone. Instead of the dark water of the sea covering the earth, what will grip us, grab us, pull at us, and even cover us is the knowledge and glory of the Lord Himself. He will dwell among us and be in the very midst of the His people (Revelation 21:3).

In the book *The Last Battle*, part of C.S. Lewis' children's series *The Chronicles of Narnia*, Lewis describes the end of the world of Narnia as well as its re-making as an eternal home for all of the inhabitants who loved Aslan, that world's equivalent of Jesus. When Aslan shuts the door on a judged, blackened, and destroyed Narnia and opens the door to the new home he has created for those who love him, Lucy, one of the primary characters in the series, is saddened. She loved Narnia, its people and its lands, and although she is excited about being in a new place with Aslan, she still misses all that she knew as home. But as she and her fellow companions go "further up and further in" to this new country, they make an amazing discovery—Narnia is not dead. The country they are in now is the *real* Narnia.

One of Lucy's companions explains:

> When Aslan said you could never go back to Narnia, he meant the Narnia you were thinking of. But that was not the real Narnia. That had a beginning and an end. It was only a shadow or a copy of the real Narnia which has always been here and always will be here.... You need not mourn over Narnia, Lucy. All of the old Narnia that mattered, all the dear creatures, have been drawn into the real Narnia through the Door. And of course it is different; as different as a real thing is from a shadow or as waking life is from a dream.[124]

Another creature declares as he gazes around, "I have come home at last! This is my real country! I belong here. This is the land I have been looking for all my life, though I never knew it till now. *The reason why we loved the old Narnia is that it sometimes looked a little like this*" (emphasis mine).[125]

What a tremendous and powerful statement! Pause for a moment and think about the things on this earth that you love the most (i.e., specific places, people, foods, and so on). Write at least three of those things down below:

Now how do you think those things point you to the home, or the new heaven and earth, that is coming? In other words, how does this world sometimes look a little like the one that is to come?

My friends, we have no idea of what truly awaits us in the new heaven and earth. It is all of the things that we love about this earth—the people, the land, the mountains, the rivers, the adventures, the foods, the animals, the beauty, the joy—remade into an even truer, deeper, richer, and more real form. And all of the things of this earth that have to do with sin and sickness, pain and sadness, will be no more. Sin has no part in the reality of God's design for His eternal home.

Our job now, as Lewis says, is to recognize when the desire for Heaven arises within us. We must learn to discern what we are really longing for.

🌱 Close today with reading Revelation 21:22–27 and ask the Lord to stir within you a longing and a desire for Heaven, your true home, along with the ability to recognize the longing when it comes and the courage and faith to believe that all of your deepest, truest longings shall one day be satisfied:

The Feast

I want to have a little fun together today. As we talked about yesterday, so often when we imagine or talk about what Heaven will be like, we do not think or imagine much of anything—just wispy images of everyone we love dressed in all white walking around on clouds. And inwardly we cringe at the information we think we have. If we are honest with ourselves, much of what we know, or at least think we know about heaven, seems rather boring.

In reality, the more we know about heaven, the more we should desire to be there. In fact, our longings should be so intense, so overwhelming, that sometimes we feel as if we will never survive the wait. Our hearts should identify with the apostle Paul when he says, "For to me, to live is Christ, and to die is gain. But if I am to live on in the flesh, this will mean fruitful labor for me; and I do not know which to choose. But I am hard-pressed from both directions, having the desire to depart and be with Christ, *for that is very much better*" (Philippians 1:21–23, emphasis mine).

So why is being with Christ in our eternal home so much better? I think it goes back to what we talked about yesterday. As Lewis states so powerfully, all that is real and good and true in this world points us to the next. Our best days, our best visits with friends, our best meals, our best walks, our best adventures, and our best moments of beholding beauty are but shadows of the *real* visits, the real views, the real meals, the real friendships, the real walks and adventures and beauty and joy and satisfaction to come.

So let's begin with an aspect of this world with which every person can identify—meals. At the center of every home, every culture, and every community stands the symbol of the table. The table is where meal times, feasts, conversations, celebration, and bonding occurs. And even if meal times were unpleasant or non-existent in your family or community where you were raised, I believe the longing exists in every human heart for a nurturing *table* around which to celebrate life.

Turn to Psalm 23 and read all six verses.

There are many beautiful images woven throughout this Psalm, but we are interested today in one in particular. What is the image David gives of God's care for him in verse 5?

Why do you think David uses this particular image? What does the symbol of a table imply?

David connects the image of the table in verse 5 with certain characteristics of the Lord in verse 6. What are those characteristics?

 1.

 2.

David ends the Psalm by stating where he will dwell: where is it? And how long will he dwell there?

Do you think David is just "waxing poetic" in this Psalm when he describes a table prepared for him by the Lord in the presence of his enemies? Or do you think he is painting an accurate picture of what actually goes on in God's House?

Think back to the "table" in your home growing up, or to a place of feasting, meals, and conversation that has meant a great deal to you in this life. What about that "table" has brought you great comfort and showed you the personal care and concern of your host or hostess?

How do you think the very best "tables" here on earth point to the deeper and greater reality of the Lord's Table prepared for us in His House?

When I think of my childhood home, one image is predominant in my mind—my mother's table. My mom is an excellent cook, and growing up, meal times were sacred in the Ince household. The table was set with placemats and cloth napkins, a creative, seasonal centerpiece adorned the center, the

television was turned off, all homework and projects were set aside, and every member of the family was invited to sit down to his or her place at the table. Our greatest family bonding occurred around that table. Stories were shared, laughter flowed freely and eased tension from a stressful day, manners were modeled and taught, and meal time always ended with a family devotional. The older my brothers and I grew, the richer and more meaningful our dinner times became.

One of the aspects about heaven that excites me most is the reality of the table of the Lord and all of the great meals and feasts to come. I firmly believe that Scripture tells us the Lord Himself is not only preparing a great meal for us, but that we will enjoy many meals together over many heavenly tables in our eternal home. But I want you to be convinced for yourself.

Turn with me to Revelation 19:7–9. We have read this Scripture before in this study, but I want to read it again today in the context of our feast awaiting us in our heavenly home.

In verses 7–9, why is the command given to "rejoice and be glad"? What is going on?

Who does verse 9 tell us is "Blessed"?

Before answering this next question, turn to Ephesians 5:25–27. Who is the bride?

Turn back to Revelation 19:8. What is the bride wearing?

Now turn to Revelation 19:11–16; who is the groom?

Unlike many of our wedding celebrations today, Jewish wedding feasts in ancient Israel were long, extravagant, expensive, and incredibly celebratory affairs. A friend of mine who lives in Jerusalem says that still today in Israel, wedding feasts and celebrations usually last for a week, and a "small" wedding is considered to be around 350–450 guests. An average wedding size is usually around 1000 guests. And the focus isn't so much on the formality of clothes or the creativity of the floral centerpieces; the focus is on the food.

The great news for us (especially the part about the food!) is that the Wedding Feast in Revelation 19 takes on many of these same characteristics, for the groom is of Jewish, Israeli descent. The picture painted for us in Revelation 19 is of a tremendous, joyful, extravagant, family feast where all those who love and serve King Jesus are not only the guests but also the honored, beloved bride. And the groom is, of course, the Lord Jesus Christ.

Is this just a symbolic feast, or is it real: real joy, real laughter, real reunions, real meetings, real friends, and real food? I believe it is real, more real than we could ever possibly imagine. In his excellent and eye-opening book *Heaven*, Randy Alcorn says, "The resurrected Jesus invited His disciples, 'Come and have breakfast.' He prepared them a meal and then ate bread and fish with them (John 21:4–14). He proved that resurrection bodies are capable of eating food, *real* food."[126]

For one more Scripture on eating and drinking in Heaven, turn to Revelation 7:14–17.

According to verses 16–17, give the specifics of our coming heavenly home:

How do you think verse 16 ties in with the promise of great feasting, celebrating, and joy?

If you are like me, I have always read that passage and thought, "This must mean we do not eat or even have any hunger pains in heaven. Food must be a thing relegated to earth (which is a bummer, especially when it comes to my friend Kimberly's chocolate Molten Lava Cakes)." But I love what Randy Alcorn shares in his observations on this passage:

> Will we get hungry on the New Earth? Some people say no because we're told, 'Never again will they hunger; never again will they thirst' (Revelation 7:16). But this doesn't mean that we'll lack an appetite or desire; it means our desires will be met. We will never go hungry or go thirsty. To find pleasure in eating assumes we desire to eat. Hunger and thirst are good things if food and drink are freely available, and God assures us that on the New Earth they always will be.... God created hunger and thirst, and he intends for them to be satisfied, not obliterated.[127]

So bring on the feasting! In John 14:1–4, Jesus promises His disciples that He is leaving to go to prepare a "place"—a house, a mansion, a dwelling place—for them, promising that "[i]n My Father's house are many dwelling places" (John 14:2). Now, can you imagine any decent dwelling place, any mansion for that matter, without an incredible kitchen? Like Alcorn says, the desires God created in us He does not mean to obliterate; He means to satisfy! So, for those of us who are not that fond of cooking in the kitchen, does this mean for all of eternity, we will be slaving away over a hot stove? Heaven help us—no way! But what it does mean is that meal times, food, and hospitality will be a thing of great joy; every house will be a place of great feasting; every table will share wonderful stories, rich laughter, and deep conversation. And even the best of our feasts here are only glimpses of all the

feasts to come. So, my friends, get ready! Our kitchens await! And I, for one, cannot wait to be guests at one another's tables.

Think back over your life and remember your favorite "feasts." Maybe they were birthday celebrations, family dinners, picnics, fireside campouts, or wedding celebrations. Take a moment and write down three of your favorites:

1.

2.

3.

Now think of those that you cannot wait to feast with in Heaven. Perhaps they are friends and family members who have gone on ahead of you; perhaps they are friends and family still here on earth; perhaps they are saints who lived and died long before you ever stepped foot on this earth but whom you hope to meet. Who are those you are longing to feast with?

1.

2.

3.

Now take a moment to imagine your table:

- Where is it?

- What is it set with?

- Who is sitting around it?

- How long do you stay visiting? You get the picture.

Perhaps you are thinking that the previous few questions about feasting weren't quite theological enough; I hear you. I wondered the very same thing. But the objective in the previous page was this: I want you and I to start thinking about Heaven *more*, not less. I want our excitement and our longing to go home to be with the Lord to *increase*, not to decrease, wax, or wane. In order to do that, we must spend the time and the creativity to really imagine what awaits us there according to the clues given to us in God's Word.

Heaven isn't a bunch of stiff-necked people walking around saying "No" to every joyful whim or desire; nor is it a purely spiritual, wispy, cloud-filled, harp-playing place. It is a *real* place, more real than your taste buds, or your sense of smell, sight, hearing, or touch on this earth can possibly fathom.

Until we have the pleasure and the privilege of sitting down at the Table of the Lord, we are to feast with Him as much as we can in the here and now. To finish our time today, let's read two more places in Scripture. Read Luke 22:14–20, and keeping one hand in Luke, turn to and read Revelation 3:19–20.

In Luke 22:15–16, Jesus says something significant about the table. When is the next time He will eat with His followers?

Until then, according to verses 19–20, what table are we to eat and drink from in remembrance of our Lord and Savior Jesus Christ until we can sit with Him at His table in the Kingdom that is to come?

Revelation 3:19–20 gives us another picture of the table Jesus longs to dine at with His followers until He can sit with us face-to-face in our heavenly home. What table is described in Revelation 3?

As followers of Christ, how do we open the door of our hearts so that we may sup and dine with King Jesus on a day-to-day basis? (Verse 19 gives us the clue.)

To feast at the table with Christ in the here and now, we must be diligent eaters and drinkers of His body and blood through time in His Word and prayer through the fellowship of His Holy Spirit. We must be zealous to repent of our sins, knowing that the time we spend sitting and supping at the Table of the Lord in the here and now is never wasted; it prepares and keeps our hearts ready for the Table that is to come.

Close today in prayer, and if there is anything that stands between your heart and His, "be zealous therefore, and repent" and let the feasting begin. It will only be a taste of the Table to come.

Inside the Door

"At present we are on the outside of the world, the wrong side of the door. We discern
the freshness and the purity of morning, but they do not make us fresh and pure.
We cannot mingle with the splendours we see. But all the leaves of the New
Testament are rustling with the rumour that it will not always be so.
Some day, God willing, we shall get *in*."[128]

C.S. Lewis, *The Weight of Glory*

As I sit here at my desk, I long to get in to that other side of the door with all that I am. It is a longing that will never be satisfied while I am living here on earth. For this is not my real home. At times, I see glimpses of my real home. At times, the presence of King Jesus is so close I can almost sense Him standing beside me. I can almost feel His touch, and I can almost pull out the chair that sits opposite mine at our table. But it is always an "almost," and when the moment passes, I am still on the wrong side of the door. But not for always. Not forever. One day, sooner than I realize, I will be *in*. And on the inside is all that I have ever wanted, wished, ached, cried, and waited for. Because inside is Him. Inside the door is the place where Jesus dwells.

And when we walk through those doors, we will find on the other side great significance and acceptance; a loving father; deep and lasting beauty; a faithful, beloved spouse; healing from all of our aches, sicknesses, and pain; safety from the curse of sin and brokenness; children; a lasting legacy; fruitfulness and productivity; the atmosphere and environment where wisdom reigns supreme; a refreshing place to drink from the fountain of living waters away from all arid, broken conditions; redemption from sinful choices we have made and from the pain of horrid circumstances; justice and kindness; fairness and a sharing of God's wealth and resources; fulfilling relationships and friendships without control or envy; and, finally, a place at the table of God's house signifying that we are accepted, joyfully welcomed, seriously heard, and intimately loved. Home is the place where all of our waits are fulfilled and all of our longings are satisfied.

As we have discussed, we have glimpses of this home here on earth through our families, memories of a childhood home or table, and certain aspects of our earthly father, earthly spouse, earthly children, earthly ministries, earthly jobs, and earthly relationships. But they are all just glimpses. And they all serve to remind us that fulfillment is coming in *all* aspects of home when we finally walk through the doors of our heavenly one.

As we finish this last day of study, I want us to take a moment to pause and remember where we were in our stories eight weeks ago and where the Lord has brought us now. This awakening in our hearts, this knowledge of who He is and what He longs to give us and how much He loves us every step of the way, even at the hardest moments of our waits, gives us great reason and cause to celebrate. We not only celebrate all that God has done over the past eight weeks, but all He is going to do in all of our waiting in the days and seasons ahead. And we celebrate and rejoice for the satisfaction and healing that is coming one day, for all of us who love King Jesus, in our eternal home.

On the first day of the first week of this study, I asked you to write down what you thought you were waiting for in this season of your life. Go back to your answer from the first day, and write it again in the space below:

Now I want you to think back on all of the topics we have covered in the past eight weeks of study. They include the wait for recognition, resurrection, and deliverance; the wait for significance; the wait for a father; the wait for beauty; the wait for a spouse and a wedding day; the wait for healing; the wait for fruitfulness, legacy, and children; the wait for fulfilling friendships; the wait for a home; and the ultimate wait for God Himself.

Now I want you to answer the question again. After all you have learned over the past eight weeks, what are you waiting and longing for during this season of your life?

Has your answer from Day One changed in any way? If so, explain below:

Has your view of the purpose of waiting and how God uses waiting in your life changed at all over the last eight weeks? If so, explain below:

How is God using the waiting in your life to draw you to Himself?

Is there any doubt in you as to whether or not your wait or desire will ever really be fulfilled? Do you still fear not getting in, like Lewis talks about, on the other side of the door? Explain:

We have learned a great deal the past eight weeks, haven't we? Many of us began this study with great heartache and many tears, wondering if God cared or had forgotten about us and the desires of our hearts. Others of us began this study thinking we were not waiting for anything at all. Life was on autopilot, and we were simply going through the motions. We had forgotten how to wait and desire the great, good things God created us for and waits to give us. Or some of us were simply numb; at some point along the way, we decided that the wait for unfulfilled desires was simply too painful, so we ignored the desires, numbed our hearts, and lived as though we served a God who had stopped knocking at the door to our hearts.

Wherever you were when you began this study, my prayer is that you are now somewhere new, somewhere different in your journey and understanding about the purpose of waiting on the Lord. My hope is that you have begun to see the process and purpose of all the waiting in your life, all the unmet expectations and all the disappointment, as the means God has used to draw you to Himself. My prayer is that you now see that God has been waiting for the desires of your heart to change, to long for and turn to Him, so that He can say, "Yes, I am who and what you have been waiting for every step of the way." And my prayer is that you have begun to desire, ask, and wait again for things deeper and truer than you ever thought possible.

In our very first week of study in our Introductory Session, we talked about how at the core of every wait lies the desire for four main things: recognition, resurrection, deliverance, and God Himself.

Turn to Hosea 6:1–3, the very place we started in Scripture so many weeks ago.

What is promised us between the lines of Hosea 6:1–3? Recognition? Resurrection? Deliverance? God Himself? None of the above? All of the above? Explain specifically below:

- Recognition—

- Resurrection—

- Deliverance—

- God Himself—

The Lord cannot be more specific than He is in Hosea 6: healing, redemption, resurrection, recognition, significance, deliverance, and hope in the form of *God Himself* is coming to those of us who choose to wait on Him. And His coming is as certain as the dawn—a sure and stable symbol in an ever-changing world.

So in light of the certainty of the promise of the coming of the Lord, what is Hosea's admonition to us in the beginning of verse 3?

Think back to what you are waiting and longing for in this season of your life. Now look at that thing, whatever it is, in light of the promises of Hosea 6. As you do so, remember Lilias Trotter's quote from the book Until the Day Breaks:

> We creatures say, 'While there is life there is hope,' but our Creator will never suffer himself to be so limited. . . . With Lazarus [Jesus] deliberately stayed away until death had established its reign, so that Martha and Mary might know him as resurrection life. So the first answer to many prayers may, therefore, be the reign of death. The last spark of life may be quenched and faith and hope left alone with the dead—and with the God who raises the dead. Do not be dismayed if the first answer to some of your prayers is a revelation, not of the power of God to make alive, but of his might to slay every hope outside of himself.[129]

As we have talked about so often over the last eight weeks, the Lord may have slain every hope outside of Himself as you wait, but that is because He knows the answer to every wait, every longing, and every hope *is* Himself.

So will your wait be fulfilled? Will you ultimately be satisfied? Will you one day step inside the door you have been knocking on for so long?

Yes, yes, and yes.

But until then, until we are finally and ultimately *home*, dear sister, press on to know the Lord. For His going forth is as *certain* as the dawn, and He *will come* to you like the rain, like the spring rain watering the earth (Hosea 6:3).

Until then, I wait expectantly with you, ready to swing wide the door, step across the threshold, and run straight into the arms of King Jesus who waits to fulfill all of our waits once we are finally Home. Until that day, let us be a generation of women who wait well together, faithful to remind one another that we are not home yet. But one day we will be.

"My soul waits in silence for God only;
from Him is my salvation."
Psalm 62:1

Waiting for Home

There have been times when I think we do not desire heaven but more often I find myself wondering whether, in our heart of hearts, we have ever desired anything else.[130]

~C.S. Lewis~

Let not your heart be troubled; believe in God, believe also in Me. In My Father's House are many dwelling places; if it were not so, I would have told you; for I go to prepare a place for you. And if I go to prepare a place for you, I will come again, and receive you to Myself; that where I am, there you may be also. And you know the way where I am going.

~Jesus, John 14:1–4~

I. Waiting for Home

❑ Home is the longing for a _____ _____, a place where you are _____, a place where you can _____, a place where you _____, and a place where the perfect _____ is the central figure.

❑ All of our longings here for Home, longings for _____, a _____, a _____ _____, _____, _____, _____, _____ are fulfilled in the Home to come or, in other words, in _____ _____, who is our Home.

- Psalm 90:1–2—"Lord, _____ have been our dwelling place in all generations, before the mountains were born, or You gave birth to the earth and the world, even from everlasting to everlasting, You are God."

❑ All of our "homes" here are a taste of our _____ to come.

"At present, we are on the outside of the world, the wrong side of the door. We discern the freshness and purity of morning, but they do not make us fresh and pure. We cannot mingle with the splendours we see. But all the leaves of the New Testament are rustling with the rumour that it will not always be so. Some day, God willing, we shall get in."[131] C.S. Lewis, The Weight of Glory

❑ The Challenge:

#1—To _____ the _____ when it comes.

#2—Rather than _____ the ache, _____ _____ to the ache, in joy, weariness, and sorrow, and let it lead you into _____ _____ with Jesus.

II. Standing Inside the Door

A. The Reality of Heaven—Revelation 20:11–15; 21:1–8

❑ "And He who sits on the throne said, 'Behold, I am making all things _____.'" Revelation 21:5

"Some day you will read in the papers that D.L. Moody of East Northfield is dead. Don't you believe a word of it! At that moment I shall be more alive than I am now."[132] D.L. Moody

B. The Reality of Redemption

❑ Luke 6:20–23—"He doesn't merely wipe away tears; he replaces those tears with corresponding _____."[133]

❑ The worst that the curse can do, _____ _____.

C. Redemption in the Book of Joel

❑ An Army of _____ Destroys _____ (1:1–6, 16–20)

❑ We Wait for 2 Types of Redemption:

1. Redemption from our _____

2. Redemption from our _____

❑ The Way to Restoration: Consecrate a _____ (2:12–13)

• Repentance and Redemption is Returning to the _____ _____ (Matthew 22:34–40).

❑ Redemption _____ (2:18–19, 21–27)

• "make up"—_____

"To be _____, to be _____, to be _____, to be uninjured, to make secure, to be peaceful, to live in harmony with God, to be complete or finished, to give back, to repay, to _____, to _____ . . . the principle meaning is _____ and _____. It is the desirable state of wholeness in which relationships are restored."[134]

❑ The _____ of Redemption is the _____ of the _____ (2:28).

• Redemption is _____ (Acts 2:38–39) and it is _____ _____ (Ephesians 1:13–14).

• "In Him, you also, after listening to the message of truth, the gospel of your salvation—having also believed, you were sealed in Him with the Holy Spirit of promise, who is given as a _____ of our _____ with a view to the _____ of God's own possession, to the praise of His glory" (Ephesians 1:13–14).

• The reality of the _____ of the Son of God guarantees our redemption from our deadly _____ and our deadly _____ (Romans 8:32).

III. While We Wait—Standing Outside the Gate

❑ Hebrews 13:12–14

Small Group Guide

(Reminder: Questions come from either the weekly homework or audio or video sessions. If a question is taken from the homework, it will have the correct page number beside it to help you find your answer.)

Listen to or watch the Introductory Session, *Why the Wait*, found at www.susannahbaker.com and then meet with your small group to answer the following questions:

- Go around and introduce yourself and tell everyone what brought you to this study.

- Where are you in the journey of "pressing on" right now? What does your wait look like?

- Have you ever been in a situation where God has slain every hope outside of Himself? If so, what did that look like?

- Have you ever had the chance to taste the fruit of resurrection in your own life, either in your heart or in your circumstances?

- How can your group be praying for you in the week ahead?

- Read over the section "How to Use This Study" and make sure everyone is clear on the instructions. Encourage everyone to do the homework for the following week, and then close in prayer.

SESSION ONE:

Listen to or watch Session One, *Waiting for Significance*, found at www.susannahbaker.com and then meet with your small group to answer the following questions:

- What things outside of yourself do you rely on to make yourself significant, and is there anything specific you are waiting upon to give you significance (i.e., a job, spouse, home, relationship, friend)? (p. 10)

- Read Jesus' words in Matthew 16:24–26. What is the main message found in these verses, and how does Jesus' definition of significance compare to the world's definition? (p. 13)

- If shame can be defined as a fall from your models, then what models or heroes do you feel like you fail most often? Do you agree that not measuring up to your models brings about an inherent sense of shame?

- Look back to your outline from the audio session at the ways guilt and shame relate (p. 28). To which way can you most often relate?

- When you battle the enemy of shame, what is your most common "knee-jerk" reaction? To make an inadequate covering? To retreat? To shift blame?

- When are the times you struggle with thinking too much of yourself, and why do you think that this is? (p. 20)

- Read Psalm 103:13–18. How does this Psalm help us in battling the enemy of pride? (p. 21)

- When are the times you struggle with thinking too little of yourself, and why do you think that this is? (p. 21)

- Read Psalm 8:4–9. How does this Psalm help us when we are tempted to think too little of ourselves? (p. 21)

- Look back at your outline from the audio session. What remedy for shame most specifically and clearly speaks to you?

- This week, how can you specifically go about making God your Hiding Place and your covering?

- Look back in homework from Day Five on Tim Keller's prayers showing us how to "use the gospel of grace" when certain enemies show up on the land of our souls. Which prayer most resonated with you and why? How do you plan on using it to battle the enemies of true, godly significance in the days ahead? (pp. 27)

- How can your group pray for you this week?

SESSION TWO:

Listen to or watch Session Two, *Waiting for a Father*, found at www.susannahbaker.com and then meet with your small group to answer the following questions:

- Were there any observations from John 14–17 from Day One of your homework this week that changed the way you thought about your Heavenly Father? If so, what were they, and how did they change your perception of the Father? (pp. 34–38)

- Look back at Day Three of your homework. Were you able to see seasons of God's discipline in your life as good and fruit-bearing? Where would you be today without your Heavenly Father's discipline? (pp. 47)

- Look back at p. 57 on Day Four. What aspect of "sonship" do you need to embrace most—the robe, the ring, or the sandals? Why?

- Are you believing the lie that you do not have a good Father because of a particular trial you are undergoing or because of a season of waiting? If so, what is the lie? (p. 61)

- Can you say with confidence, just as the Psalmist in Psalm 73:28, "The nearness of God is my good"? Why or why not? (p. 62)

- Think back on the lesson you just heard. What part of the orphan spirit do you see most often played out in your life—over-activism or passivity? How do you see it played out in your life on a regular basis?

- Which remedy are you most in need of from the Father's Hands—turning you in for nurture and encouragement or turning you up and out for blessing and purpose?

- Look at the outline from the lesson and pick one of the four things from the list of what "Learning to Listen Takes." (p. 65) Which of those four steps are you committed to embracing this week and in this particular season of your life?

- Last, how is the Spirit prompting you to step out of an orphan mentality and into the spirit of adoption and the waiting arms of your Heavenly Father?

- How can your group pray for you this week?

SESSION THREE:

Listen to or watch Session Three, *Waiting for a Wedding Day*, found at www.susannahbaker.com and then meet with your small group to answer the following questions:

- Look at p. 73 from your Homework. Where are you in your wait for a wedding day? Are you, like Jacob, searching with many, many tears? Are you completely content? Explain.

- Look at p. 76 from your Homework. Do you think most people's search for a spouse stems from wilderness areas in their hearts and lives? From the vacuum of a parental blessing or a stony wilderness area physically, emotionally, or spiritually? If so, how?

- Look at p. 80 in your Homework. In Genesis 28:20–22, Jacob builds a memorial to the Lord and gives the place where the Lord appeared to him a name. Then he promises the Lord three things if the Lord faithfully carries him through his journey. What are those three things and what is their significance to someone who is waiting for marriage or who is waiting in a difficult marriage?

- Look at p. 81 in your homework. If appropriate and you feel comfortable doing so, share with your group how the Lord prompted you this week, like Jacob, to create a memorial to Him to acknowledge His provision and faithfulness in this season of your journey in your wait for a spouse or a wedding day.

- Now look at the outline from the lesson. (pp. 102-103) What Fixed Element from Jesus' encounter with the Samaritan Woman in John 4 surprises you the most? What Divergent Element about the identity of the bride surprises you the most?

- In what ways do you need to *become* Christ's Beloved instead of just knowing intellectually that you are His Beloved?

- Turn to Ephesians 5:25–27 and read those verses once more. What is Christ's role as the church's Groom? And what is our role as His bride? With those two roles in mind, do you allow your Groom to apply the cleansing water of the Word to you on a regular basis? Why or why not?

- Think for a moment about the circumstances of your own unique brokenness. In your particular season of life, what do you think it means to embrace your unique brokenness? How can you learn to see your brokenness as a blessing, allowing it to propel you out into a world that needs to hear the good news of the Gospel of Christ?

- What are ways you can stop hiding behind your brokenness and using your brokenness instead to invite others to sit at the table as the Bride of Christ?

- How can your group pray for you this week?

SESSION FOUR:

Listen to or watch Session Four, *Waiting for Beauty*, found at www.susannahbaker.com and then meet with your small group to answer the following questions:

- Turn once again to Psalm 27 and read verses 4–6. Once David gains a vision of the beauty of the Lord, what happens to him?

- Now turn to p. 108 in Day One of your homework and read the two paragraphs beginning with "The very first thing that happens to us" and ending with "the midst of mundane or very difficult circumstances." Have your ever had an experience like that, where the beauty of the Lord gives you strength over your surrounding enemies? If so, explain.

- When you are waiting on the Lord in the midst of painful or mundane circumstances, how much of your time do you spend meditating on the beauty of the Lord in comparison to the amount of time you spend focusing on your own beauty? (p. 110)

- Have you found that spending an inordinate amount of time on your physical appearance has the power to defeat your enemies or pull you out of the pit of despair? If not, why do you think this is so? (p. 110)

- Read Hebrews 13:12–14. What fears or excuses keep you from living "outside the camp" with Christ? (p. 122)

- Has God stirred your heart to go "outside the camp" with Him in any specific way and to get your hands dirty in serving Him? If so, how? (p. 122)

- If you have children who are still at home, think about their schedules for a moment. As their parent, what are ways you can help them "redeem the time" and learn to focus on things that are eternal and that will last? (p. 133)

- Now look at the outline from the lesson. (pp. 135-136) Out of the enemies of beauty discussed, which enemy do you most identify with and why?

- Turn to Ephesians 1:18–23. In what ways do you need to close your eyes so that you can really see? Not the things that are unreal, but the things that are unseen?

- Share one way in which your group can pray for you this week.

- Close by, as a group, getting on your knees and asking the Spirit of the Lord to lift your gaze above the culture around you and to focus your gaze upon the cross of Christ, truly making you beautiful people.

SESSION FIVE:

Listen to or watch Session Five, *Waiting for Fruitfulness*, found at www.susannahbaker.com and then meet with your small group to answer the following questions:

- What in your culture, even in your family, neighborhood, or group of friends, tells you, "Unless you have _____, you are barren"? (p. 141)

- What does the "knock" of barrenness sound like to you right now? In other words, what barren situation is God using to knock on the door of your heart?

- Turn to John 12:23–25. In these verses, Jesus is speaking about His upcoming death, but He is also speaking of a spiritual law or principle He wants His followers to remember and obey. What is it (v. 24)? (p. 146)

- How do you think this principle applies to the area of your life where you feel the most barren? (p. 146)

- Read the quote from Chuck Colson's book *Loving God* on page 147 of your homework and the paragraph immediately following the quote. Does this bring encouragement or discouragement into your season of barrenness and waiting? Explain.

- Think back to the lesson to the illustration of Eve vs. Christ. How can you handle your barren situation like Christ handled the tempter in the desert as opposed to how Eve handled Satan in the garden?

- Turn to Jeremiah 17 and read vv. 5–6 and 7–8 once again. Discuss the differences between someone who trusts in people verses someone who trusts in the Lord. What does a "fruitful" person look like?

- How can you bring your barrenness to Lord and allow Him to turn it into fruitfulness? How can you turn from trying to control the circumstances of your life to surrendering your circumstances to the Lord?

- In a barren area of life where I was waiting and had been waiting for years, I had a wise friend tell me, "You can trust God with your waits because you serve a fruitful God." Even though it may be hard to do so, can you choose to trust God in this season of waiting in the specific area of your barrenness simply because you know that you serve a fruitful God? Explain why or why not.

- Close, as a group, by asking the Lord to come in and heal the barren, hurting places in each group member's heart. There may be some tears or a greater need for silence or quiet, but that is OK. Take time to allow the Spirit of the Lord to minister to each group member through the comfort of His presence and prayer.

Small group leaders, this session is a special one and the format is different from the other talks. While there is a lesson to listen to, the emphasis is on prayer. Consider making this study or gathering different from all the others. Prepare your group to enter and leave in a more reflective, serious mood. While I have provided prayers for groups and individuals to pray through concerning repentance and healing, be prepared to pray individually over women in your group who are waiting for specific things. Before, during, or after the time of prayer, worship together as a group through music, and involve as many of the senses as you can. Light sweet-smelling candles, play worship music that draws your group into God's presence, and be willing agents of God's healing, comforting presence. At the end of the lesson, consider having a packet of seeds to give to each group member with the verse Psalm 126:6 attached: "He who goes to and fro weeping, carrying his bag of seed, shall indeed come again with a shout of joy, bringing his sheaves with him." Let your time together be a time of worship and prayer for women to lay all they are waiting for at the feet of Jesus through repentance, healing, and expectant hope and joy.

Listen to or watch Session Six, *Waiting for Healing*, found at www.susannahbaker.com and then meet with your small group to answer the following questions:

- Take a moment to think about the past six weeks of Bible study and the topics we have covered. Is there any area of your life in which you are specifically waiting for healing—physically, emotionally, mentally, or spiritually? (pp. 160–161)

- Perhaps you are not waiting for healing for yourself as much as you are waiting for healing in the life of your spouse, child, extended family member, or friend. If you feel comfortable doing so, or if it is appropriate, please share ways in which you are waiting for healing for someone else. (p. 162)

- In your wait, how can the promises of God give you hope for healing that is "now" and for healing that is "not yet"?

- In the weakness that God has allowed to remain (2 Corinthians 12:9), what do you need Him to do in you and for you that you could never do on your own?

- How do the enemies of despair and pride try to rob you of hope for the healing that is yours in Christ?

- In Day Three of your homework, we talked about the different "houses" we enter to try to find healing and rest from our aches and pains. What houses have you been visiting to dull the aches and pains in your own life? (p. 172) What do you think makes this house(s) so appealing to you? (p. 173)

- How can you get out of the world's houses of "healing" and into the House of the Lord? Use scriptures that have been meaningful to you in your own journey of healing to support your answer.

- Close today by turning to the "Prayers for Healing" on page 202 at the end of the Session Six outline and pray through those prayers together.

- After you finish praying, share the one house of this world you know you need to exit because it is preventing you from receiving the true healing that only God can provide. Go home and make copies of these prayers and put them in a place where you will see them often. As you begin to recognize when your soul is tempted to enter the houses of this world, which offer nothing but sickness, hopelessness, and pain, use these prayers to give you the language of repentance and the heart of obedience to straighten up and enter the only house that heals, the House of the Lord.

SESSION SEVEN:

Listen to or watch Session Seven, *Waiting for Friendships*, found at www.susannahbaker.com and then meet with your small group to answer the following questions:

- What kind of value or worth does our society place on friendship? How are women told to "make" friends or maintain friendships?

- Read aloud John 15:12–17. How does our cultural definition of friendship hold up against the Scriptural definition of friendship?

- Look at C.S. Lewis's definition of friendship found at the beginning of your outline. (p. 229) Do you agree or disagree with his definition?

- Think about the friends in your life that mean the most to you. Are you all friends because you are "side by side, absorbed in some common interest"? Have you ever been in a season of life where your friends were "trophies on your walls" or "art dealers to market you to a watching world"?

- What is your most natural tendency in friendships? How do you typically respond to women around you?

- Is Christ calling you to "straighten up", "put your arms down", or "face forward" today? If so, what is He asking you to do?

- Think back to John 15:12–17. Instead of grasping for friendship with women, how is the Lord calling you to walk in friendship with Himself? How will friendship with Him enable you to "straighten up" out of your natural tendencies and responses in friendships?

- Are there areas of your heart where "the adult is a child" in regards to your friendships with other women? If so, close your small group time by praying for one another, asking the Lord to come and heal those broken places in each of your hearts.

SESSION EIGHT:

Listen to or watch Session Eight, *Waiting for Home*, found at www.susannahbaker.com and then meet with your small group to answer the following questions:

- Read Frederick Buechner's quote from his book *The Longing for Home* on Day One, pages 233-234 of your homework. Think back to the place you would most consistently call home. Maybe it wasn't your parents' house but a grandparent's house or even a place you created

and dreamed about in your mind as a child if the home you grew up in was not a safe place. Describe your childhood home. What about it made you feel unique, special, and as though you belonged? Do you often think about that home? If so, what about it do you miss, and what aspects of it have you tried to re-create in the home you live in today? (p. 234)

- Do you think the things you long for in a home are similar to the things your neighbor, Christian or non-Christian, longs for? If believers and non-believers alike are longing for the same things, what should that tell us about the nature of home, and where should we look to when we are longing for it? (p. 236)

- Read Hebrews 11:8–10, 13. According to these verses, did Abraham ever find all of his longings for an earthly home fulfilled in the here and now? (p. 236) Read the paragraph on p. 237 that begins with "Here is an incredibly comforting and hopeful truth." Does this encourage or discourage you about the nature of home here on this earth?

- What is the one thing about home you are longing for/waiting for the most?

- Think back to the homework and audio session from this week. How will that desire be met and your wait completed once you reach your eternal home?

- How does the knowledge of the reality of heaven change how you live in the here and now? Does it change the way you wait?

- Is there anything you feel like is too big for the Lord to "make up," like He promises to do in Joel 2? If so, why? Has your view changed at all in light of the promises of redemption woven throughout Scripture?

- Has this study changed your view of waiting and what you are waiting for? If so, how are you different? How will you walk through the different "waits" in your life differently? (pp. 258-259)

- Close by reading Revelation 21:22–27, and close in prayer, asking the Lord to stir within each of you a deep longing and desire for your true home. Ask for the ability to recognize the longing for home when it comes and the courage and faith to believe that one day, all of your deepest, truest longings will be satisfied.

Appendix

The following six steps are taken from Jack Frost's book, *Experiencing Father's Embrace*, and are based off the story of the prodigal son in Luke 15. I share these steps with you in the hope that they will help you come to your senses as a child of God. Take time to process through each one:

1. Come to your right senses.

"If you have received Christ as your Savior, you are a son or daughter of the Father of creation. Even if you are living in a pigpen of impurity and sin, understand that this is not where you belong. Come to your senses! Your Father loves you and is eagerly awaiting your return to His house. If you are afraid to approach an angry God who is pointing His finger of judgment in your face, you don't have an accurate understanding of God's love."

2. Confess your sin.

"Declare as the rebellious son declared, 'I have sinned against heaven and in your eyes.' His attitude changed from one of self-love to one of humility."

3. Forgive your earthly father (or mother) for any hurts or issues of the past.

"Our earthly parents are only human, and they are bound to make mistakes. Often these mistakes color our later views of God and affect our ability to perceive Him as a loving and forgiving heavenly Father. By practicing a lifestyle of forgiveness and releasing your parents to God, you will actually free yourself from your past and begin a journey of experiencing unhindered intimacy with God."

4. See Father's house as your source of love.

"The lifestyle of the pigpen could not meet the needs of the discontent son. Even with the inheritance he had received, he was still left wanting when he lacked a relationship with his father. You will not find true fulfillment in counterfeit affections, no matter how appealing they may seem at first. Don't expect your husband or wife, your career, hobbies or religious activities to satisfy you if you aren't also fostering an intimate relationship with God that is evidenced by intimate relationships with others."

5. Anticipate Father's embrace.

"Most Christians expect the rod of judgment when they fail. Even if they do summon up the courage to approach God with their sin, they do so while cringing in fear or shame. *But they don't realize that their deepest moment of failure is when Father most desires their homecoming.* He grieves for their pain, and His compassion is endless. He is waiting with open arms to embrace His wayward sons and daughters as they return to Him (emphasis mine)."

6. Return to the presence of the Father.

"The spirit of adoption was released over you when you were born again (Rom. 8:15). You became God's child, and He will not deny His name that was stamped on you through Christ. The . . . Father eagerly awaits your return. He is waiting for you to exchange your fig leaves of shame and for His love to cover your sin (I Pet. 4:8)."[135]

Endnotes

Introductory Session

1. Warren Baker and Eugene Carpenter, *The Complete Word Study Dictionary: Old Testament* (Chattanooga, TN: AMG Publishers, 2003), #7291, 1037.

2. Patricia St. John, *Until the Day Breaks: The Life and Work of Lilas Trotter Pioneer Missionary to North Africa* (Bromley, Kent: OM Publishing, 1990), 71–72.

3. Spiros Zodhiates ed., *The Hebrew-Greek Key Word Study Bible: New American Standard Bible* (USA: AMG Publishers, 1990), #2280, 1723.

4. Zodhiates ed., *The Hebrew-Greek Key*, #3045, 1731.

Week One and Session One

5. A.W. Tozer, *The Knowledge of the Holy* (San Francisco: Harper & Row, Publishers, 1961), 25.

6. Warren Baker and Eugene Carpenter, *The Complete Word Study Dictionary: Old Testament* (Chattanooga, TN: AMG Publishers, 2003), #779, 100.

7. James Strong, *Strong's Exhaustive Concordance of the Bible* (Grand Rapids, Michigan: Word Bible Publishers, Inc., 1986), #567, 17.

8. Spiros Zodhiates, ed., *The Complete Word Study Dictionary: New Testament* (Chattanooga, TN: AMG Publishers, 1993), #4137, 1176.

9. Tim Keller, *Gospel Christianity-Course 3*, "Unit 4-Humility and Self-Image," p. 2. Downloaded off of www.redeemer.com.

10. Spiros Zodhiates ed., *The Hebrew-Greek Key Word Study Bible: New American Standard Bible* (USA: AMG Publishers, 1990), #936, 1815.

11. Ibid., #4240, 1869.

12. Tim Keller, *Gospel Christianity—Course 3*, "Unit 5—Self-Control and Emotions," 12. Downloaded off of www.redeemer.com.

13. Tim Keller, *Gospel Christianity—Course 3*, "Unit 5—Self-Control and Emotions," 12–13. Downloaded off of www.redeemer.com.

14. Dick Keyes, *Beyond Identity* (Eugene, Oregon: Wipf and Stock Publishers, 1998), 51.

15. Spiros Zodhiates ed., *The Hebrew-Greek Key Word Study Bible: New American Standard Bible* (USA: AMG Publishers, 1990), #954, 1714.

16. Dick Keyes, *Beyond Identity*, (Eugene, Oregon: Wipf and Stock Publishers, 1998), 51.

17. Ibid., 51.

18. Ibid., 52.

19. Ibid., 52.

20. Ibid., 52.

21. Ibid., 81.

22. F.B. Meyer, *Love to the Uttermost* (Charleston, South Carolina: BiblioBazaar, 2007), 20.

23. In his book, *Beyond Identity*, Dick Keyes says it this way: "By no longer hiding his sin from God (v. 5) he was able to find a hiding place in God (v. 7). When he hid his sin from God, God seemed an enemy. When he acknowledged his sin, God became the one in whom he could hide from the trouble in the world." Dick Keyes, *Beyond Identity*, (Eugene, Oregon: Wipf and Stock Publishers, 1998), 97.

24. For more on understanding the necessity of putting God alone in the holy place of your heart, listen to Tim Keller's sermon, "Adoration: Hallowed Be Thy Name," (sermon, Redeemer Presbyterian Church, New York City, NY, February 18, 2015).

Week Two and Session Two

25. For more information on the specific roles of a father and mother, see Leanne Payne's book, *Restoring the Christian Soul* (Grand Rapids, MI: Baker Books, 1991), pp. 41–42 and, 99–101;, and Henri J. M. Nouwen's book, *The Return of the Prodigal Son* (New York: Doubleday, 1994), 96.

26. http://www.challies.com/articles/counterfeit-detection-part-1.

27. Spiros Zodhiates ed., *The Hebrew-Greek Key Word Study Bible: New American Standard Bible* (USA: AMG Publishers, 1990), #3438, 1856.

28. Jack Frost, *Experiencing Father's Embrace* (Conway, South Carolina: Father's House Productions, Inc., 2002), 46.

29. www.judaism.about.com/od/shabbatprayersblessings/f/bless_kohanim.htm.

30. Sometimes the passivity of a parent who never takes steps to appropriately discipline his or her child can be just as painful or harmful as the actions of a parent who consistently disciplines out of anger or wrath.

31. G.K. Chesterton, *Orthodoxy* (San Francisco: Ignatius Press, 1995), 72–75.

32. Ibid., 76–77.

33. Spiros Zodhiates ed., *The Hebrew-Greek Key Word Study Bible: New American Standard Bible* (USA: AMG Publishers, 1990), #26, 1796.

34. Joseph Stowell, *Christianity Today: God's Compassion for Sinners (1888C)*, Talk 3 of 4 in Series.

35. If you would like further help in learning how to move from an orphan mentality to one as a daughter of the King, please turn to the Appendix at the back of the study.

36. C. S. Lewis, *The Weight of Glory* (New York: Simon and Schuster, 1996), 36.

37. Josef Pieper, *Faith, Hope, Love* (San Francisco: Ignatius Press, 1997), 119.

38. Henri Nouwen, *The Return of the Prodigal* (New York: Doubleday, 1992), 96.

Week Three and Session Three

39. James Strong, *Strong's Exhaustive Concordance of the Bible* (Grand Rapids, Michigan: Word Bible Publishers, Inc., 1986), #3290, 66.

40. Timothy J. Keller, "The Gospel According to Jacob: The Problem of Blessing," (sermon, Redeemer Presbyterian Church, New York City, NY, October 28, 2001). For this week of "Waiting for a Wedding Day," I am very grateful and indebted to Dr. Keller for his insightful and rich teaching on the life of Jacob. His sermon series, "The Gospel According to Jacob," helped me understand and apply the truths found in Genesis 25–35 in entirely new ways.

41. Timothy J. Keller, "The Gospel According to Jacob: The Openness of Heaven" (sermon, Redeemer Presbyterian Church, New York City, NY, November 4, 2001).

42. James Strong, *Strong's Exhaustive Concordance of the Bible* (Grand Rapids, Michigan: Word Bible Publishers, Inc., 1986), #1008, 25.

43. Timothy J. Keller, "The Gospel According to Jacob: The Openness of Heaven" (sermon, Redeemer Presbyterian Church, New York City, NY, November 4, 2001).

44. Ibid.

45. Warren Baker and Eugene Carpenter, *The Complete Word Study Dictionary: Old Testament* (Chattanooga, TN: AMG Publishers, 2003), #3372, 470.

46. In his commentary on the book of Leviticus, Dr. John Currid remarks that the oil used in the purification ceremony in Leviticus 14 was a symbol of "wholeness and union." Pouring oil over the top of someone's head was a "sign of full acceptance. Full and complete restoration between the man and Yahweh is being signaled by these rituals." I believe that the same symbolism with the oil Jacob uses on the rock can be inferred in our study of Genesis 28. John Currid, *Leviticus* (Faverdale North, Darlington, England: Evangelical Press, 2004), 193.

47. C.S. Lewis, *Mere Christianity* (New York: HarperCollins, 2001), 135.

48. Spiros Zodhiates ed., *The Hebrew-Greek Key Word Study Bible: New American Standard Bible* (USA: AMG Publishers, 1990), #1288, 1716.

49. Timothy J. Keller, "The Gospel According to Jacob: The Fight of Your Life" (sermon, Redeemer Presbyterian Church, New York City, NY, November 18, 2001).

50. Gordon J. Wenham, *Word Biblical Commentary*. Vol. 2, *Genesis 16-50* (Nashville, TN: Thomas Nelson Publishers, 1994), 297.

51. Dick Keyes, *Beyond Identity* (Eugene, Oregon: Wipf and Stock Publishers, 1998), 97.

52. Henri J.M. Nouwen, *The Way of the Heart* (New York: HarperCollins, 1981), 52-53.

53. Gordon J. Wenham, *Word Biblical Commentary*. Vol. 2, *Genesis 16-50* (Nashville, TN: Thomas Nelson Publishers, 1994), 294, 297–298.

54. Ibid., 294.

55. Timothy J. Keller, "The Gospel According to Jacob: The Meaning of Free Grace" (sermon, Redeemer Presbyterian Church, New York City, NY, November 25, 2001).

56. Spiros Zodhiates ed., *The Hebrew-Greek Key Word Study Bible: New American Standard Bible* (USA: AMG Publishers, 1990), #2734, 1727–1728.

57. Timothy J. Keller, "The Gospel According to Jacob: The Meaning of Free Grace" (sermon, Redeemer Presbyterian Church, New York City, NY, November 25, 2001).

58. Spiros Zodhiates ed., *The Hebrew-Greek Key Word Study Bible: New American Standard Bible* (USA: AMG Publishers, 1990), #2617, 1726.

59. Robert Alter, *The Art of Biblical Narrative* (United States of America: Basic Books, 1981), 47.

60. Ibid., 47.

61. Ibid., 52.

62. Ibid., 52.

63. Ibid., 47.

64. Henri J.M. Nouwen, *Life of the Beloved* (New York: The Crossroad Publishing Company, 2002), 44.

Week Four and Session Four

65. Leigh McLeroy, *The Beautiful Ache* (Brenham, TX: Lucid Books, 2010), 13.

66. Warren Baker and Eugene Carpenter, eds., *The Complete Word Study Dictionary: Old Testament* (Chattanooga, TN: AMG Publishers, 2003), #2898, 400.

67. Leigh McLeroy, *The Beautiful Ache* (Brenham, TX: Lucid Books, 2010), 232.

68. Peggy Noonan, *"Cold Standard,"* *The Wall Street Journal*, Saturday/Sunday, April 21-22, 2007, 16.

69. Noonan, 16.

70. Oswald Chambers, "Is Your Imagination of God Starved?: February 10th," *My Utmost for His Highest* (Uhrichsville, OH: Barbour and Company, Inc., 1935), 41.

71. Ken Gire, *The Work of His Hands: The Agony and the Ecstasy of Being Conformed to the Image of Christ* (Ann Arbor, MI: Servant Publications, 2002), 38–41.

72. Gire, 39–40.

73. Timothy Keller, *King's Cross* (New York: Dutton, 2011), 190.

74. In ancient Roman myth, Proserpina was stolen by Pluto, the god of the underworld, and forced to live with him in the underworld of Hades. Proserpina's mother, Ceres, diligently searched for her daughter until she found her and brought her back home to live with her once again. www. en.wikipedia.org/wiki/Proserpina.

75. Meg Harris Williams, *Inspiration in Milton and Keats* (London: Macmillan, 1982), 76.

76. Spiros Zodhiates ed., *The Hebrew-Greek Key Word Study Bible: New American Standard Bible* (USA: AMG Publishers, 1990), #2537, 1844.

77. Spiros Zodhiates ed., *The Hebrew-Greek Key Word Study Bible: New American Standard Bible* (USA: AMG Publishers, 1990), #2537 and #2538, 1844.

78. C.S. Lewis, *The Weight of Glory* (New York: Simon and Schuster, 1996), 37.

79. Spiros Zodhiates ed., *The Hebrew-Greek Key Word Study Bible: New American Standard Bible* (USA: AMG Publishers, 1990), #5375, 755.

Week Five and Session Five

80. Warren Baker and Eugene Carpenter, eds., *The Complete Word Study Dictionary: Old Testament* (Chattanooga, TN: AMG Publishers, 2003), #6135, 865.

81. Timothy J. Keller, "The Gospel According to Abraham: Real Joy and the Laughing Woman" (sermon, Redeemer Presbyterian Church, New York City, NY, May 27, 2001).

82. Beth Moore, *The Patriarchs: Encountering the God of Abraham, Isaac, and Jacob* (Nashville, TN: LifeWay Press, 2005), 46.

83. James Strong, *Strong's Exhaustive Concordance of the Bible* (Grand Rapids, Michigan: Word Bible Publishers, Inc., 1986), #85, 8.

84. James Strong, *Strong's Exhaustive Concordance of the Bible* (Grand Rapids, Michigan: Word Bible Publishers, Inc., 1986), #8282, 160.

85. Moore, 46.

86. Spiros Zodhiates ed., *The Hebrew-Greek Key Word Study Bible: New American Standard Bible* (USA: AMG Publishers, 1990), #6485, 1766.

87. Chuck Colson, *Loving God* (Grand Rapids, Michigan: Zondervan, 1987), 24.

88. Moore, 96.

89. Spiros Zodhiates, ed., *The Complete Word Study Dictionary: New Testament* (Chattanooga, TN: AMG Publishers, 1993), #2590, 820.

90. Leigh McLeroy, *The Beautiful Ache* (Brenham, TX: Lucid Books, 2010), 14.

91. Spiros Zodhiates ed., *The Hebrew-Greek Key Word Study Bible: New American Standard Bible* (USA: AMG Publishers, 1990), #954, 1714.

92. James Strong, *Strong's Exhaustive Concordance of the Bible* (Grand Rapids, Michigan: Word Bible Publishers, Inc., 1986), #6131, 120.

93. Spiros Zodhiates ed., *The Hebrew-Greek Key Word Study Bible: New American Standard Bible* (USA: AMG Publishers, 1990), #954, 1714.

94. James Strong, *Strong's Exhaustive Concordance of the Bible* (Grand Rapids, Michigan: Word Bible Publishers, Inc., 1986), #3586, 67.

Week Six and Session Six

95. Dick Keyes, *Beyond Identity* (Eugene, Oregon: Wipf and Stock Publishers, 1998), 97.

96. Spiros Zodhiates ed., *The Hebrew-Greek Key Word Study Bible: New American Standard Bible* (USA: AMG Publishers, 1990), #2451, 1725.

97. James Strong, *Strong's Exhaustive Concordance of the Bible* (Grand Rapids, Michigan: Word Bible Publishers, Inc., 1986), #7291, 142.

98. Warren Baker and Eugene Carpenter, *The Complete Word Study Dictionary: Old Testament* (Chattanooga, TN: AMG Publishers, 2003), #4947, 4951.

99. C.S. Lewis, *The Weight of Glory* (New York: Simon and Schuster, 1996), 36–37, 38.

100. C.F. Keil and F. Delitzsch, *Commentary on the Old Testament.* Vol. 5, *Psalms,* trans. By Francis Bolton (Peabody, MA: Hendrickson Publishers, 2006), 368.

101. C.S. Lewis, *The Problem of Pain* (New York: Simon & Schuster, 1996), 48.

102. Ibid., 83.

103. Timothy Keller with Kathy Keller, *The Songs of Jesus* (New York, New York: Viking, 2015), 253.

104. Spiros Zodhiates ed., *The Hebrew-Greek Key Word Study Bible: New American Standard Bible* (USA: AMG Publishers, 1990) #5055, 1881.

105. Ibid., #1411, 1827.

106. Ibid., #1680, 1831.

107. Ibid., #6960, 1771.

108. Josef Pieper, *Faith Hope Love* (San Francisco: Ignatius Press, 1997), 91.

109. Ibid., 91.

110. Ibid., 113.

111. Ibid., 113.

112. Ibid., 119.

113. Spiros Zodhiates ed., *The Hebrew-Greek Key Word Study Bible: New American Standard Bible* (USA: AMG Publishers, 1990) #982, 1714.

Week Seven and Session Seven

114. Spiros Zodhiates, ed., *The Complete Word Study Dictionary: New Testament* (Chattanooga, TN: AMG Publishers, 1993), #25, 64.

115. James Strong, *Strong's Exhaustive Concordance of the Bible* (Grand Rapids, Michigan: Word Bible Publishers, Inc., 1986), #5475, 108.

116. Spiros Zodhiates ed., *The Hebrew-Greek Key Word Study Bible: New American Standard Bible* (USA: AMG Publishers, 1990), #5475, 1753.

117. C.S. Lewis, *The Four Loves* (London: HarperCollins Publishers, 2002), 73.

118. Ibid., 107-108.

Week Eight and Session Eight

119. Frederick Buechner, *The Longing for Home* (New York: Harper San Francisco, 1996), 7–8.

120. Ibid., 3.

121. James Strong, *Strong's Exhaustive Concordance of the Bible* (Grand Rapids, Michigan: Word Bible Publishers, Inc., 1986), #559, #8453, 163.

122. Spiros Zodhiates ed., *The Hebrew-Greek Key Word Study Bible: New American Standard Bible* (USA: AMG Publishers, 1990), #8453, 1791.

123. C.S. Lewis, *Mere Christianity* (San Francisco: HarperSanFrancisco, 2001), 135.

124. C.S. Lewis, *The Last Battle* (New York: HarperTrophy, 1984), 211–212.

125. Ibid., 213.

126. Randy Alcorn, *Heaven* (Wheaton, Illinois: Tyndale House Publishers, Inc., 2004), 292.

127. Ibid., 293-294.

128. C.S. Lewis, *The Weight of Glory and Other Addresses* (New York: Simon and Schuster, 1996), 37.

129. Patricia St. John, *Until the Day Breaks: The Life and Work of Lilas Trotter Pioneer Missionary to North Africa* (Bromley, Kent: OM Publishing, 1990), 71–72.

130. C.S. Lewis, *The Problem of Pain* (New York: Simon and Schuster, 1996), 130.

131. C.S. Lewis, *The Weight of Glory and Other Addresses* (New York: Simon and Schuster, 1996), 37.

132. Quote from D.L. Moody found on http://www.wholesomewords.org/echoes/moody.html.

133. Randy Alcorn, *Heaven* (Wheaton, Illinois: Tyndale House Publishers, 2004), 416.

134. Spiros Zodhiates ed., *The Hebrew-Greek Key Word Study Bible: New American Standard Bible* (USA: AMG Publishers, 1990), #7999, 1785.

Appendix

135. Jack Frost, *Experiencing Father's Embrace* (Conway, South Carolina: Father's House Productions, 2002), 74–75.

DON'T FORGET TO PURCHASE THE BIBLE STUDY VIDEO SESSIONS FOR GROUP USE OR DOWNLOAD THE AUDIO SESSIONS **FOR FREE** WITH COUPON BELOW.

JUST FOLLOW THESE EASY STEPS.

1. Go to http://susannahbaker.com/shop/

2. Add "All Sessions" to your cart

3. Click "View Cart"

4. Enter the code **waiting1** as the coupon code on the left, and click "Apply Coupon"

5. Check out

Don't forget to sign up for Susannah's email newsletter to get your free copy of her ebook Known, and never miss a blog post or product announcement.

CPSIA information can be obtained
at www.ICGtesting.com
Printed in the USA
BVHW010545130320
574846BV00009B/696

9 781632 961938